FUR-EVER LOVED

A LETTER TO MY DOG

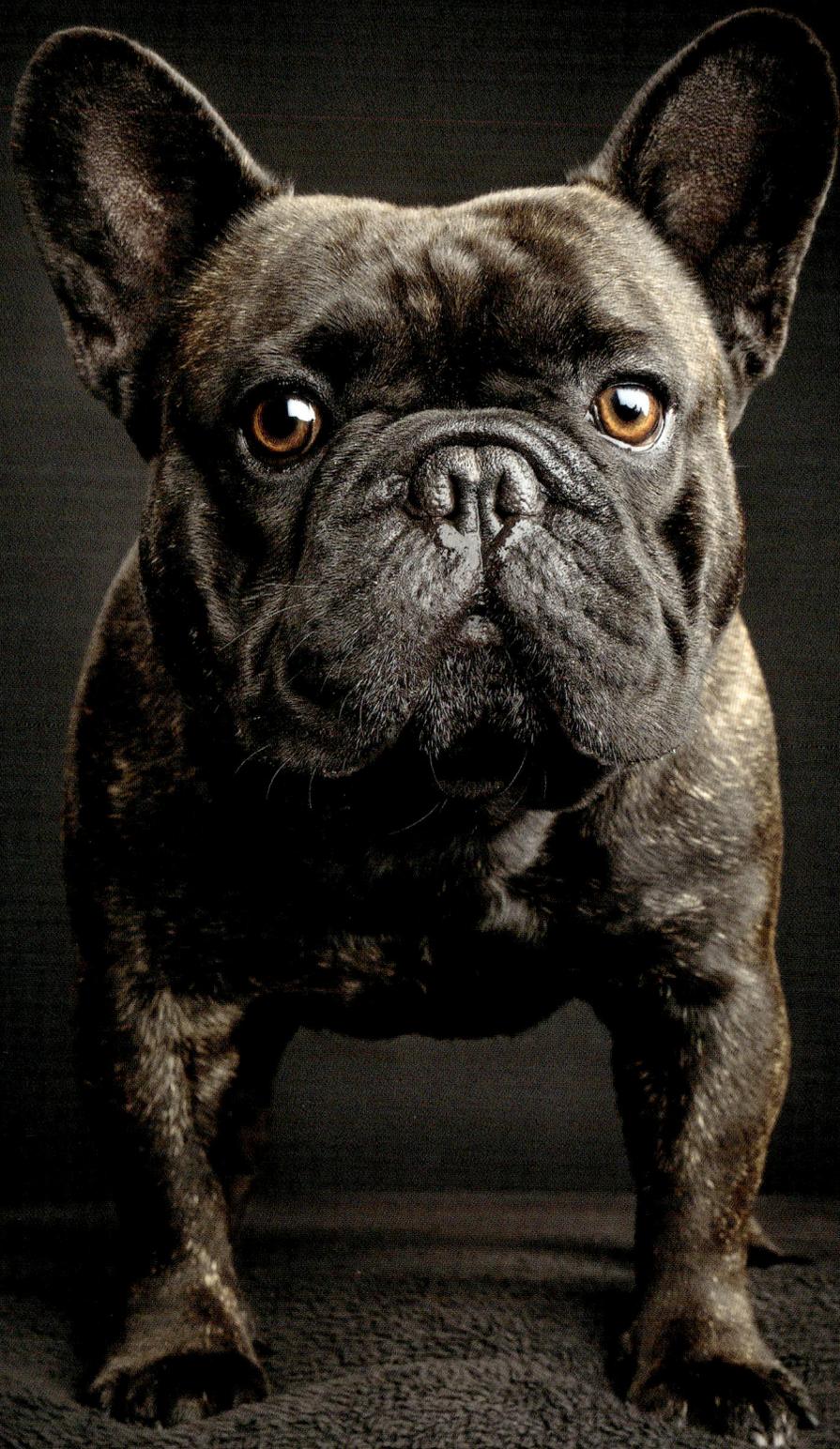

KEN DRAKE

FUR-EVER LOVED

A LETTER TO MY DOG

NH
NEW
HOLLAND

To every parent who has a dog who will be
Fur-Ever Loved

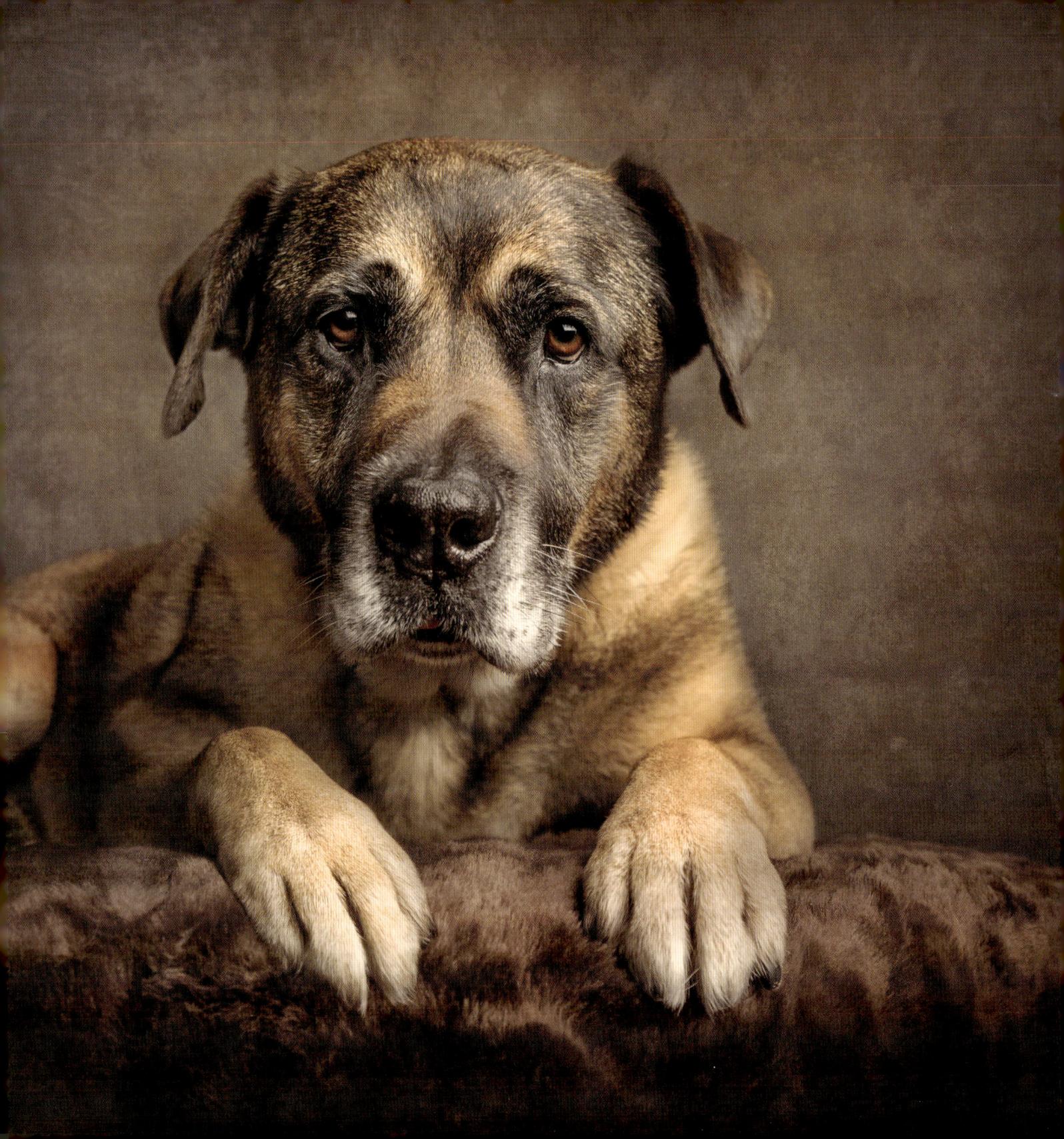

Introduction

In our first book, Pawtraits, we celebrated all the different personalities of our favourite friends, our dogs – big dogs, little dogs, young and old dogs, pedigree and bitzer, playful puppies and sleepy oldies and indeed, playful oldies and sleepy puppies.

As an animal photographer, I am fascinated by the unique bond people have with their dogs and the different ways that dogs play such an important role in our lives. This is the focus of our second book and who better to tell us just how important their dogs are than the owners themselves? Welcome to *Fur-Ever Loved, A Letter to my Dog*.

As you read the letters and look at the photographs, it becomes evident that for a lucky few of us, dogs have become a fundamental part of our lives. We rely on them for love and support in much the same way that we rely on our human friends and family.

It is also evident that the favour is returned; each of us becomes our dog's family and friend. Our relationship is a two-way street just as it is with human friends. Some of us think of our dogs as our fur kids, and for some of us they are best mates, but none of us would do without them.

A word of warning – this book is an emotional journey. You will laugh and you will cry so perhaps it's not a book for reading on public transport or in the doctor's waiting room. It's more a book for curling up with at home with a fine wine, a finer dog, and time to savour the wonderful stories of people and the love of their dogs.

I have met all the letter writers and all the dogs, and I know this collection will move you in the same way as I was moved when I first heard these stories in my studio.

I hope you too enjoy the read.

Ken

PS For those who don't know, 'bitzer' is an affectionate Australian term for the mixed breed dogs, those that have 'bitzer (bits of) this and bitzer that' in their family tree.

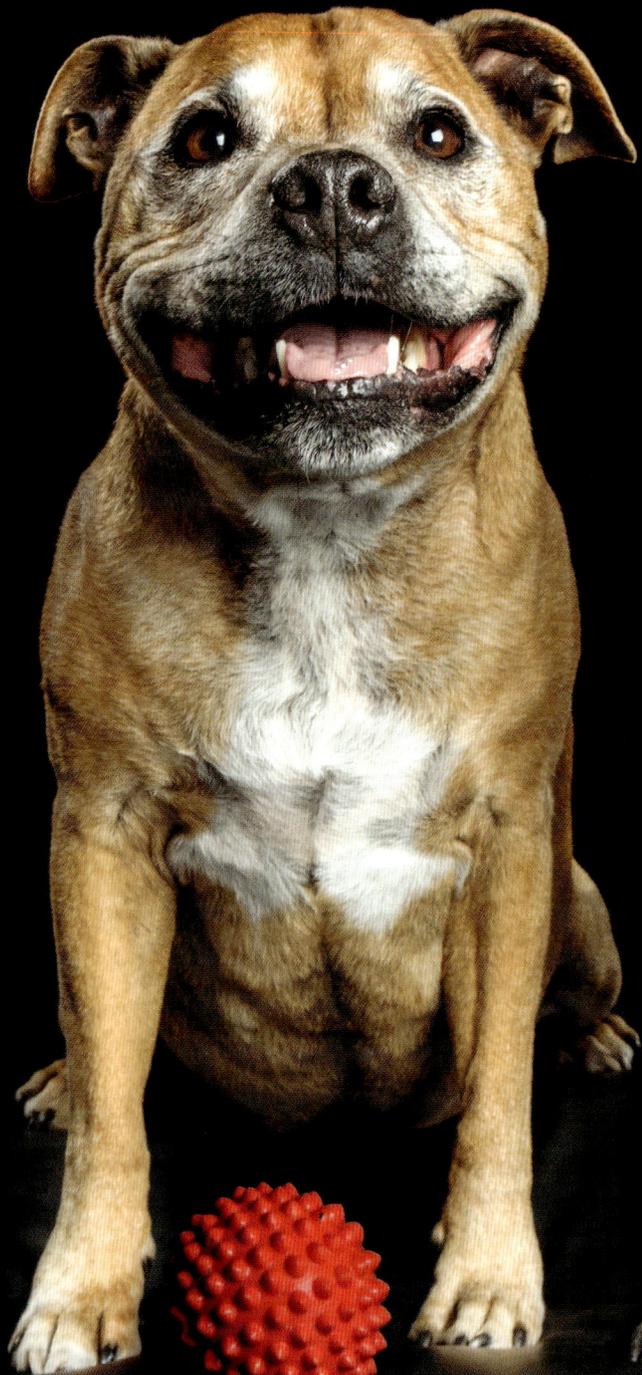

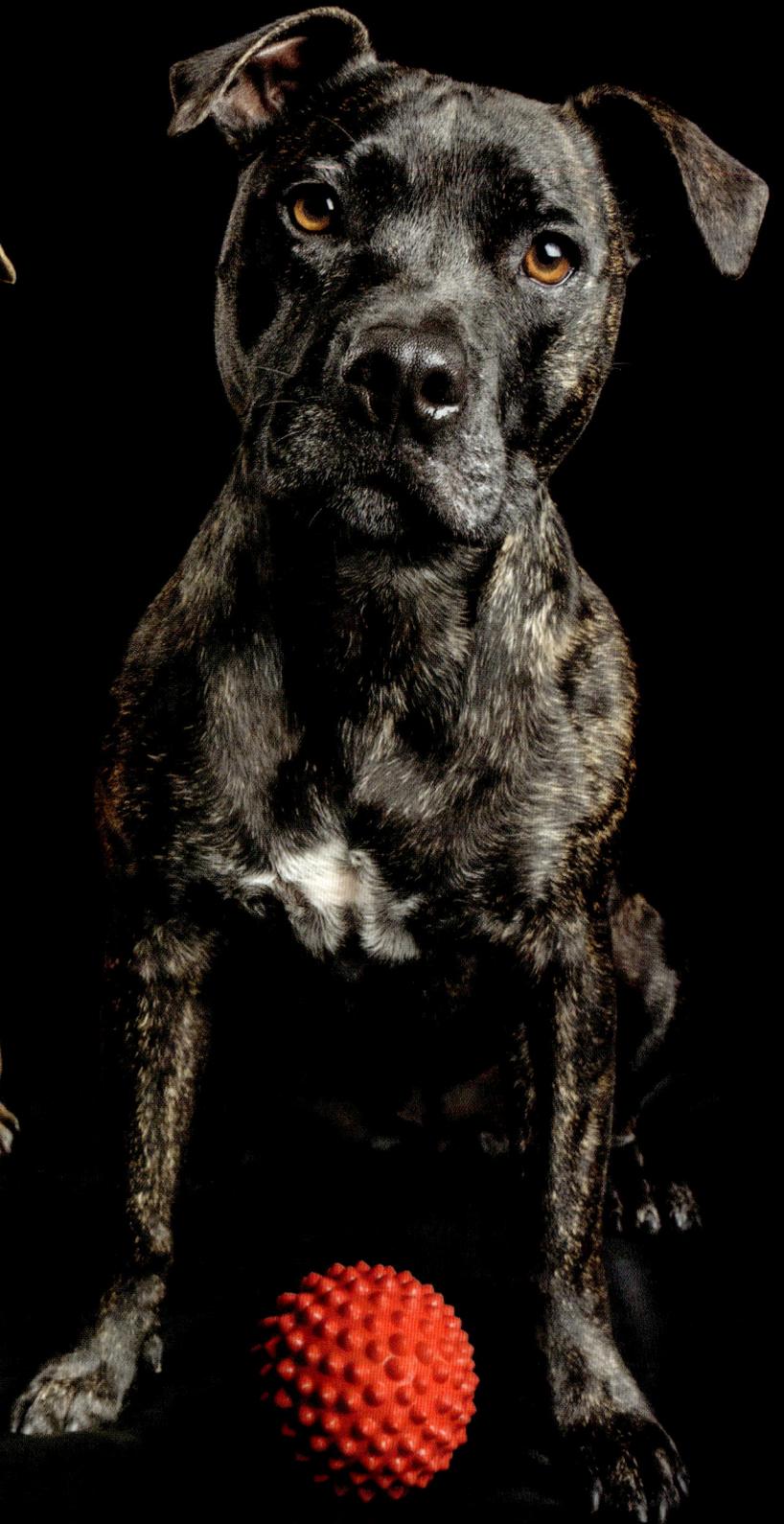

To Ty and Lulu,

Ty, you were the cutest little bundle of red fur I had ever seen. You were puppy number nine; runt of the litter and the sweetest, quietest puppy – my little shadow.

At six months old you got a big sister, Cassie, the toy poodle. You being the big scary 'staffy' quickly put her in her place; she learnt you were the boss. Then nine years later came Lulu, I thought for sure I had another Ty in the making; quiet, docile, easy to train. Boy was I wrong.

Lulu you turned out to be the most mischievous puppy ever. You ate all the skirting boards in the house, numerous pairs of dad's glasses and I feared you would not make it to your first birthday, but you did.

Ty ignored you for the first two months so you learnt everything from Cassie (who is now over the rainbow bridge) like how to annoy Ty. You are both obsessed with the red balls and are obsessed with saving the toy chickens in the swimming pool, but again Ty always lets you win.

Though I could never have children for medical reasons, you two are the reason I still smile, the reason I sometimes shake my head in disbelief. But most of all, I'm lucky to have you in my life.

Ty you are my sweet old soul, my smiling assassin, now 10 but I see no signs of you slowing down and Lulu you are only two and have so much growing in front of you. You have the best attributes of your brother and your own cheekiness that is out of this world – your eyes light up everything.

Thank you for picking us to be your human slaves.

Aimee

Dear Betsy,

We always knew you were a little wild child; the stories we heard made us laugh and smile.

We got updates and photos every week, seeing those white patches that make you unique; from the tip on your tail and your little white toes, to those big shiny eyes and perfect wet nose.

You came home to us one cold Monday in June. You settled right in deciding the whole house was your room.

You met your mum and dad, your toys and your bed. Your soft cry predicted the long night ahead.

The first week home you showed your fun side, and took every milestone proudly in your stride.

You could sit on command and knew when to stay, and boy, did you know when it was time to play.

You do have some moments when you're placid and sweet, like when you tilt your head to people you meet.

But when they think they have seen the real you, Betsy, that's when your identity really shines through.

You run and jump and leap and dive, you really are the craziest fun-loving pup alive.

You have no fear for a pup that's so small, when you run up to big dogs to steal their best ball.

Yes Betsy, you are fast on your feet, but with legs half the size you just can't compete.

You love cuddles and kisses and rubs on your belly, and leaving us gifts that are a little bit smelly.

Every odd sock you find in the house is now yours, and apparently now you set down the laws.

There's no other way we would rather be, than with you by our side, you're our family.

These little things are what make you extraordinary; if life were a cupcake Betsy you are the cherry.

Ainsley and Jonathan

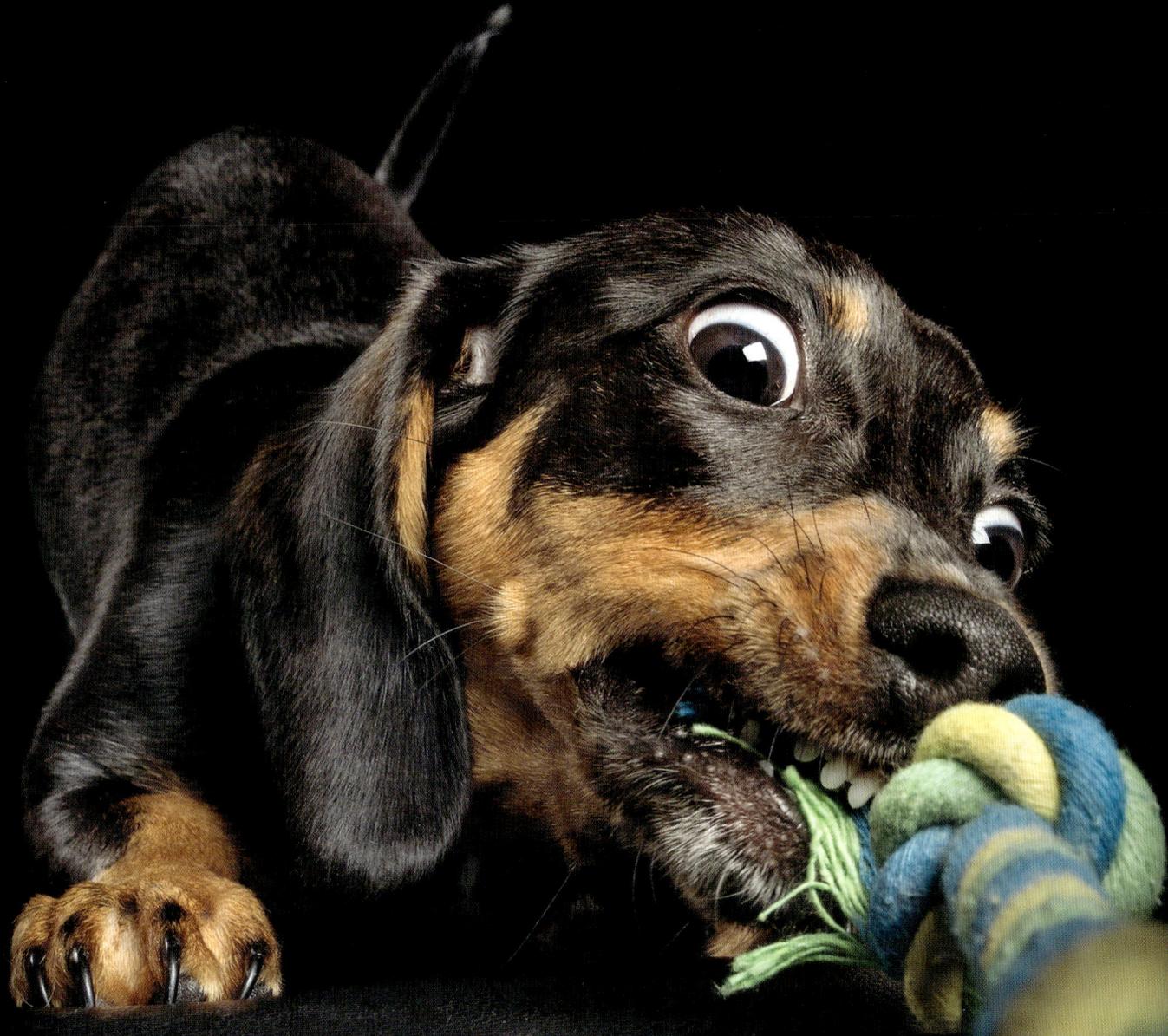

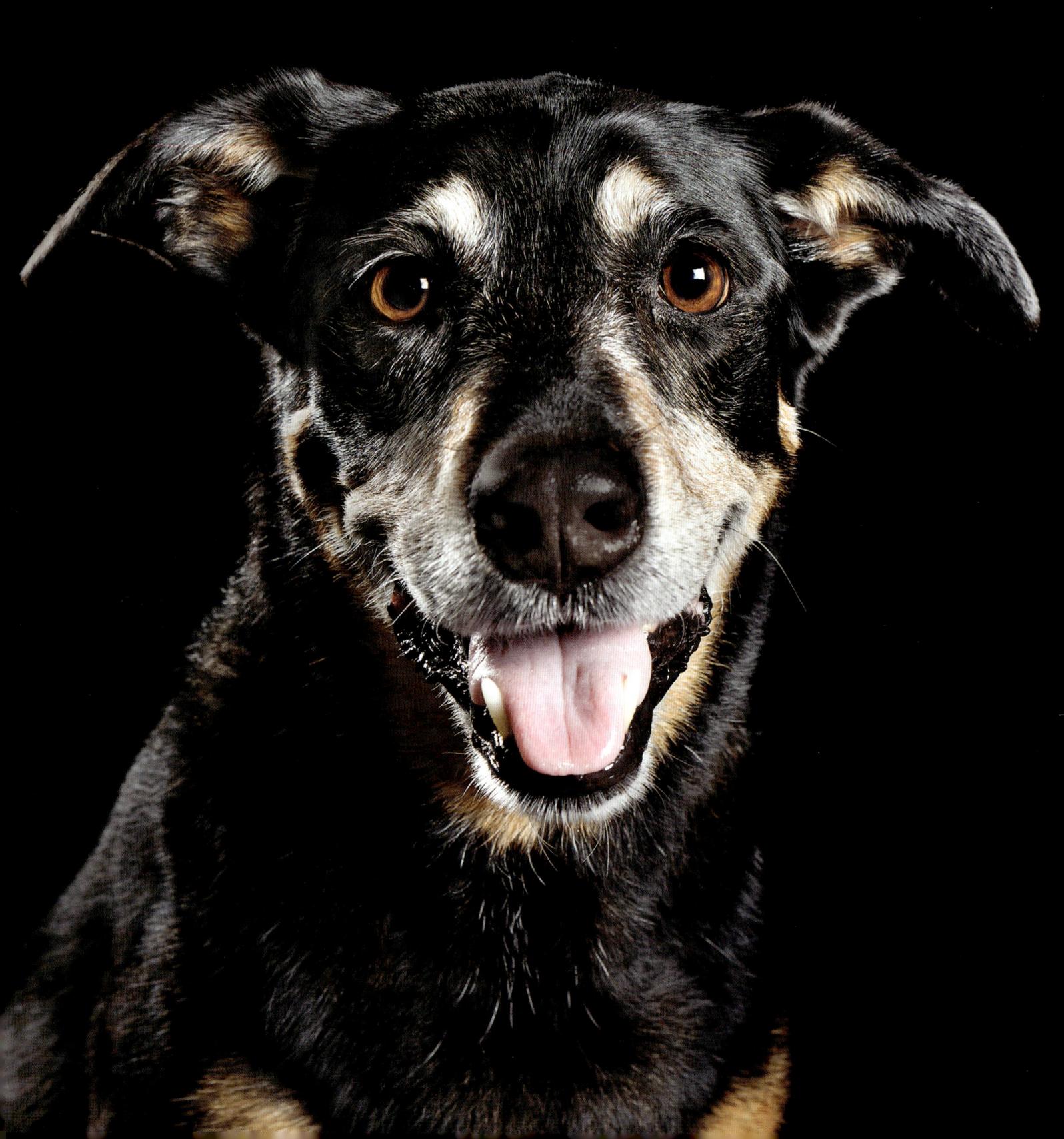

Dear Chloe,

My beautiful 'puppy girl', where do I start? You have been gone for a little over two years as I write this letter and it hasn't gotten any easier not having you here.

My heart was not ready to say goodbye, but I knew you had fought enough. The thing I miss most is your smile; that silly smile of yours. I remember the day, when I was 10 years old, when my mum took me to pick out a puppy and I was instantly drawn to you.

Over the next 13 years we grew up together and you were always by my side. You were there with me through so many life experiences and so many tough times.

I became an adult. I graduated high school and university. We moved houses. We adopted more fur babies (Domino and Nala), and I even got engaged. There is so much more I would've loved for you to see, but we humans have always known that a dog's life is unfairly too short.

You know I don't believe in heaven, but it gives me comfort to think that you are somewhere where you can go on endless car rides with your favourite people and eat cheese and ice-cream until you can't eat anymore.

I am so lucky to have had 13 years with your beautiful soul. Even though the pain of losing you was tremendous, I want you to know that I would do it all over again, all of those 13 years, because I couldn't imagine not having you in my life.

I want you to know that I will always miss you, and I will always love you. You were the best friend and partner in crime a 10-year-old girl could've ever asked for. For that, I thank you for loving me so unconditionally.

Love from your best friend

Alana xox

Dearest Romeo,

Our first furry baby, the one who broke all the rules and for whom we would break the world.

An ever-present shadow, a soft snore in the corner, a snuffing lick in the morning, a warm ball under the desk.

You know adventure waits in the car's backseat and never let us leave without you.

You refused to give in when your body hurt, or when others might have given up on you. You accepted children and felines and other wriggly dogs; none of them with any manners. You taught puppies to dig and chew and delight in destruction and taught me not to care for things that are broken in the name of fun.

You are Black Dog, the Grey Wolf, and the Silent Gas Evacuator.

You cannot hear me call you for a bath but sense the depression of the toaster lever from one hundred paces – food that falls to your domain is never safe from the attention of your tongue.

One day the Red Emperor, the one who feeds you his scraps and lays in your bed, will ask us where you are and we won't know what to say. We'll stare at him and try to find the words to fill the void you'll leave behind. We'll ache for your sounds and your smell and your mess and will be lost without it to fill our days. We'll look for you and miss you, then smile, for you have not left us at all.

There you are in brilliant colour, watching us with your Staffordshire grin, from the walls we live within.

With all our love

Mumma, Daddy, the Red Emperor, His Lordship the Cat and the Red Princess

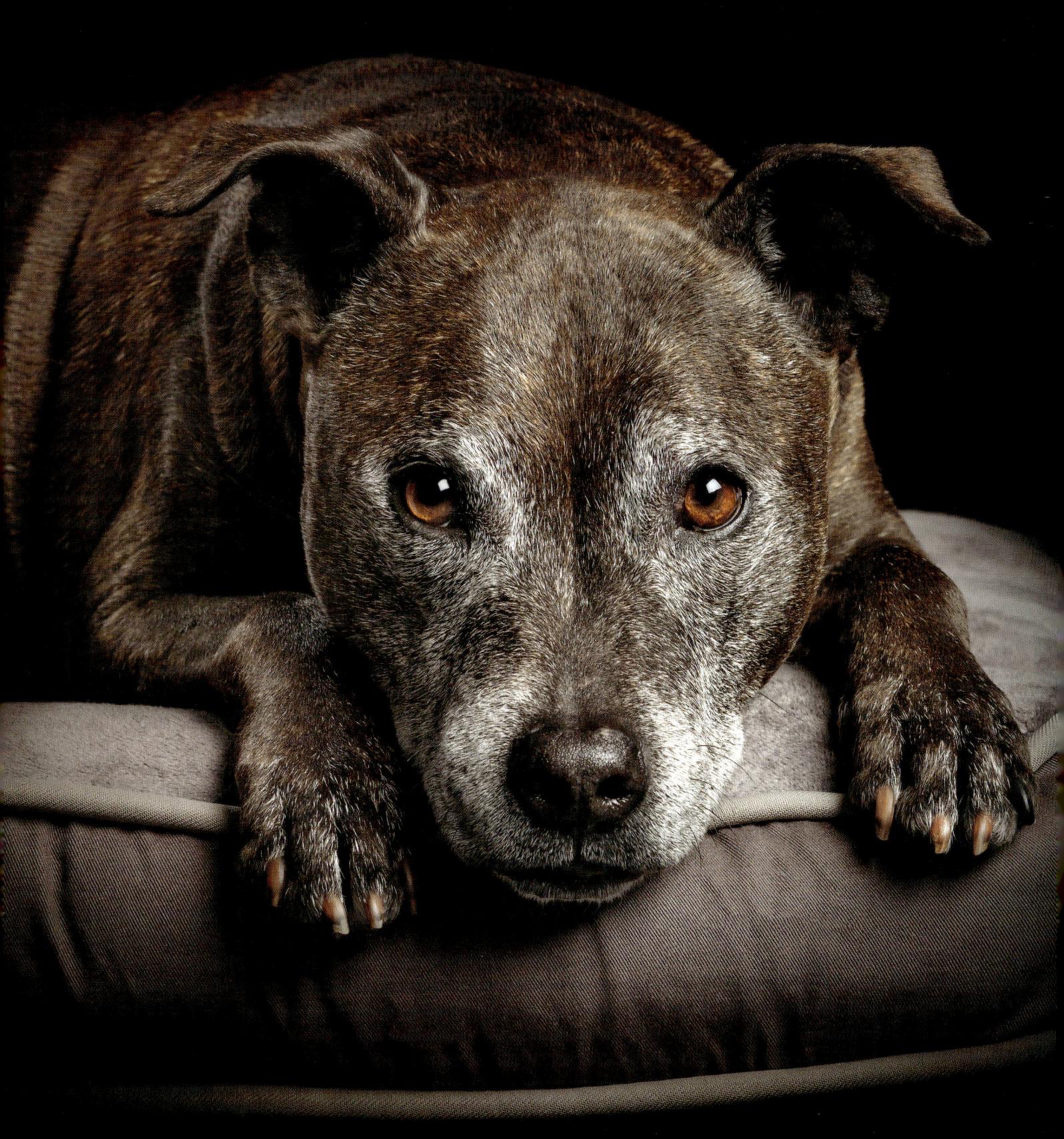

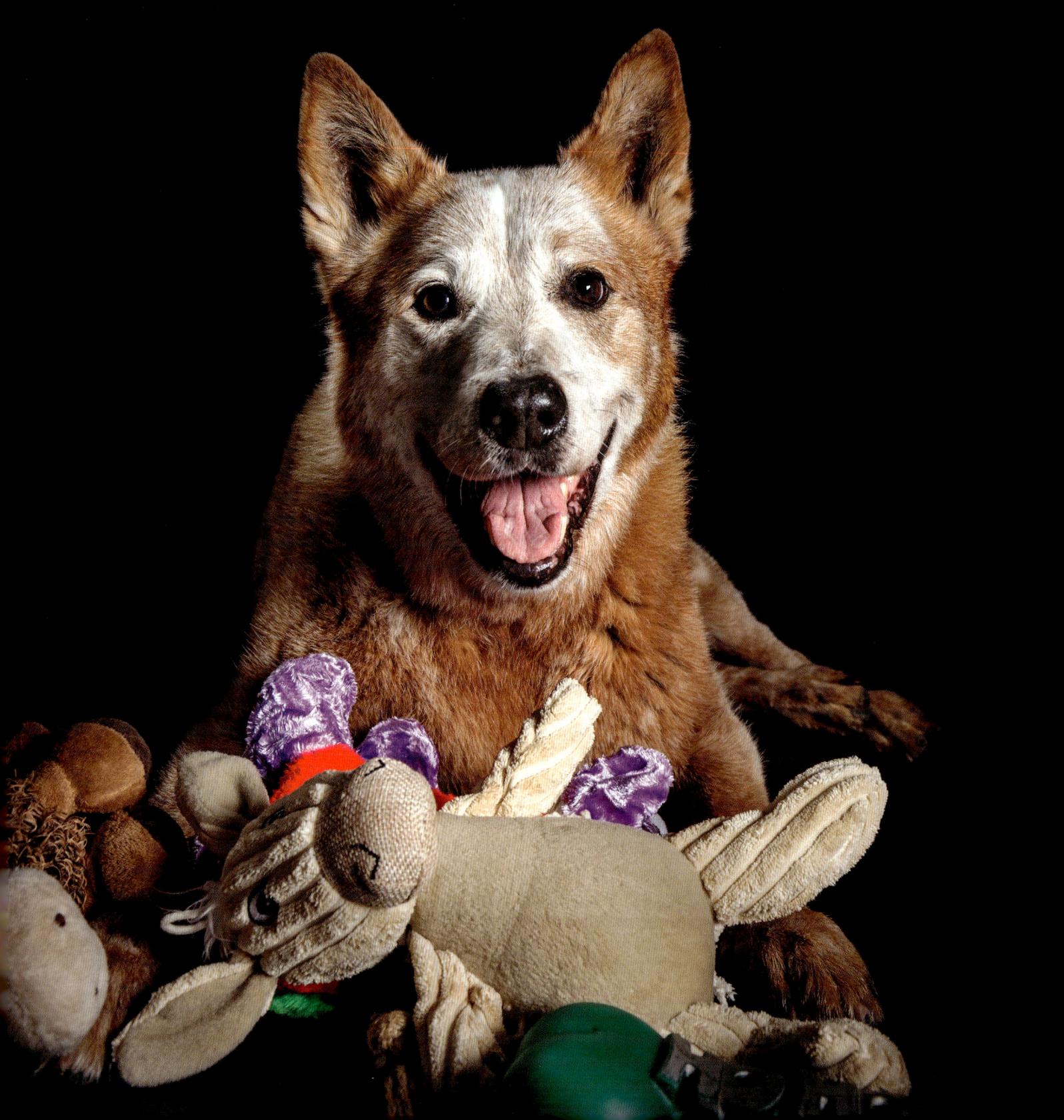

To my best pal, Astro,

How can I write a love letter when all that I have to tell you about the endless joy you brought to my life would fill a novel?

Remember that day, fourteen and a half years ago? We'd both travelled far from our homes when serendipity dictated our paths cross. You were only eight weeks old. I was 'just passing' and almost walked away with one of your sisters instead of you! Serendipity intervened again, thankfully.

Then what an amazing journey you took us on. You became my glue, the constant in my life, the one with the tireless smile, owner of the waggiest tail, and always embracing life.

And boy, could you belt out a tune whilst accompanying yourself on a squeaky toy. Remember how you used to harmonise with Georgie boy?

Your specialness even facilitated a day's filming in our home with Cesar Millan and his crew. I think we both failed the Dog Whisper's training, but you shone on the small screen.

With big brother, George, you saved us from a house fire. Four months later we lost George. But you made me laugh when I didn't want to, and gave me purpose when I felt I had none.

And now you have gone, our home has become a house without your presence. Its soul is missing. There's no one to 'help' me vacuum, to protect me from those vicious wheelie bin wheels; no one to 'help' me make my bed (it's just not the same trying to bite the sheets myself); no excited barking come walk or car-ride time.

Astro, when you and I agreed it was 'time' for your journey across the rainbow bridge, it was a comfort to afford you the respectful and peaceful release that you so deserved, and in the tranquility of our own home.

However, your release has created a crevice in my heart that continues to defy repair.

I will always love you, miss you, and cherish all that you were — and still are from afar.

Until we meet again Poo Bear; my hero, my shadow, and my life.

Mama

Love letter to my Griffin,

Born on Sunday 19 April, you chose me on Thursday 16 July 2015.

From our first cuddle I was so in love and knew you were special. Your big brother, Wentworth, could not wait to meet you although you were tiny for your age. He was desperate to be a pug big brother.

February 2016 you had soft palate surgery. Then mid-march you went for a checkup and more surgery — there were complications, you had a temporary tracheostomy inserted. Each time the trachy was taken out, you would gasp after a short time and it would have to be reinserted. It was after quite a while in ICU that you were diagnosed with Stage 2 Laryngeal Paralysis. Your stay in ICU was extended. I visited you every day and cried ocean of tears. I had to make the heartbreaking decision to either let you go over the rainbow bridge or take a huge risk and give you a permanent tracheostomy. I chose to take the risk, go with the tracheostomy, and I am so glad I did.

You have been back to ICU so many times with pneumonia, suspected pug meningitis, surgery to remove excess skin so your trachy hole could be clear for you to breath and some breathing problems but each time you fought to be with me.

Each checkup you had to go to, you'd say hello to everyone who cared for you. Nurse 'Aunty' Lisa made you a Superman cape when you were last released from ICU.

You will always need extra care and your mumma will always be the one to provide you with that care. I kiss your little forehead each night and tell you, 'I love you and I am grateful for this one more day with you.' I don't know how long we will have but know you make mumma happy each 'one more day'.

Dedicated to Dr Anthony, Dr Ray, Adjunct Professor 'uncle' Phillip Moses and Aunty Zoë. You each provided expert medical care for my little Griff.

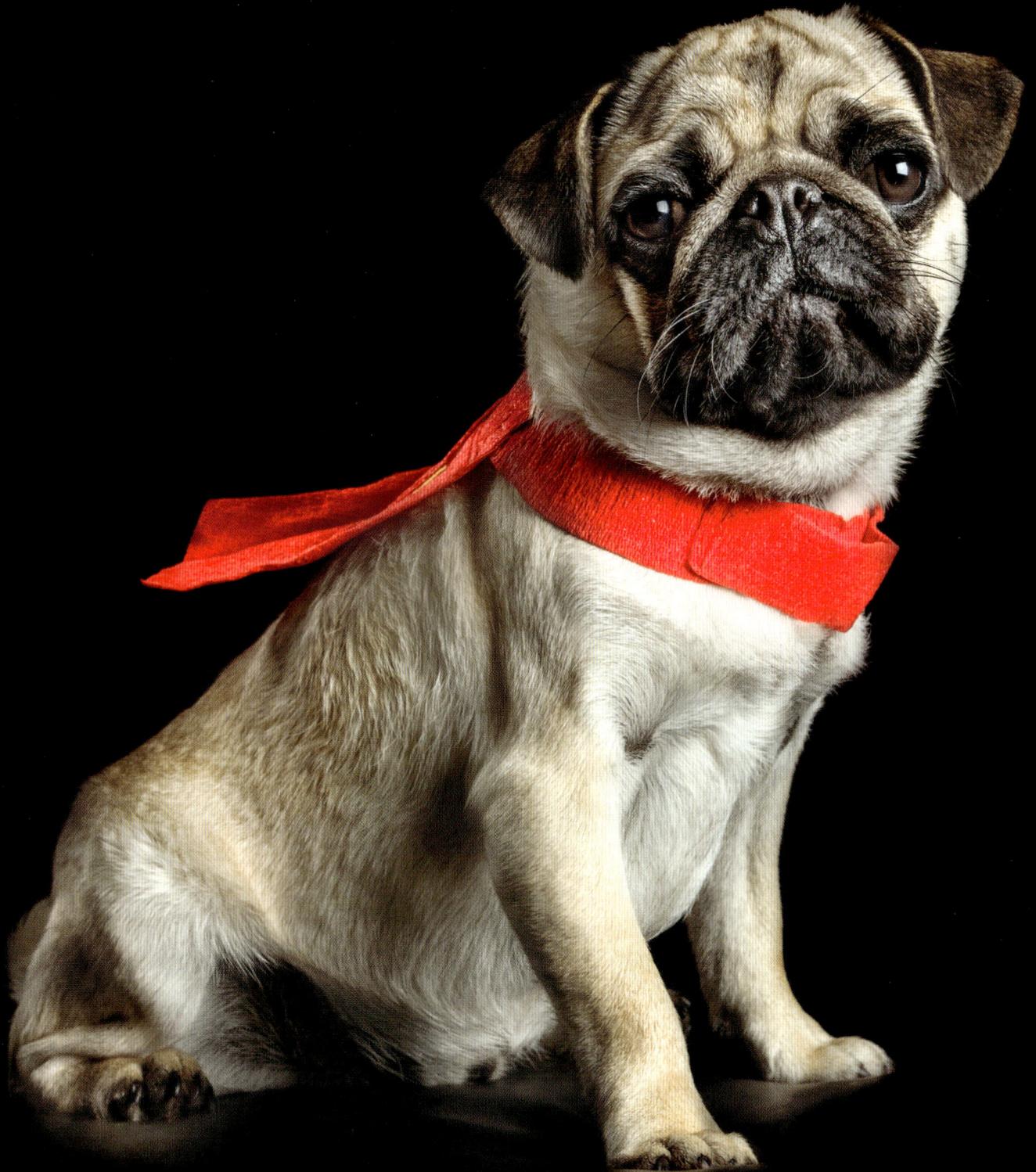

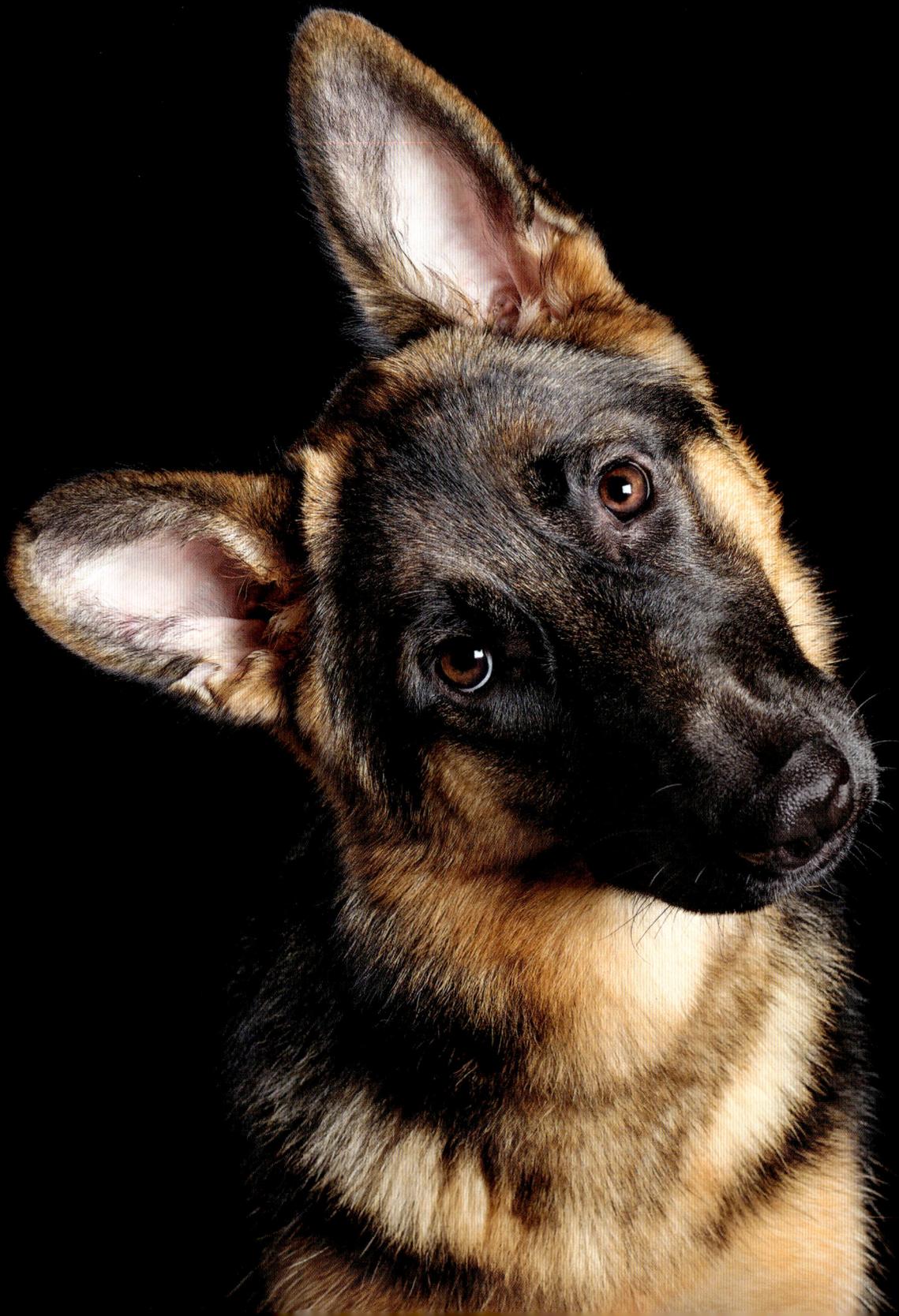

Hey, my sweet Soze,

Kaiser and I miss you so much. We ended up adopting a female German shepperd who was no longer wanted. I know! How is that possible?

Her name is Honey. She is now 20 months old; three months younger than you, when you were taken from us.

I wish you could meet her. You and Honey could have teamed up and finally beaten Kaiser in a play fight. :)

We went back to Ken to get some more photos. It brought back strong memories of you. We miss you so much.

I had a memorial for you and our closest friends came. There was a song on the radio at the time that was so apt...

 I will never forget you; you will always be by my side.

 From the day that I met you, I knew that I would love you til the day I die ...

I know I gave you all the love possible in your short time on this earth and you the same to me.

You paw print is embedded permanently on my heart. We love and miss you every day.

Mum and Kaiser

xoxo

Dear Charlotte,

I had always considered myself a 'big dog' girl until I meet you. You melted my heart into tiny little pieces. Four years ago your daddy and I were taking a break in Byron Bay and my birthday surprise that weekend was a teeny tiny little pink collar with a letter from your daddy saying you were waiting to meet me. Oh, how the happy tears flowed that day when I met you. You were so small and delicate, I could not wait to have you in my life and share our world with you.

Zoom forward to today and you are still teeny tiny for a pug and that is one of the many things I adore about you. I love your big beautiful eyes, the little greys on your chin (goodness knows how you got those so quickly – you live the life of luxury). I love your cute delicate black ears and your adorable curly tail that gives that happy wiggle when you greet me.

Although you might be small in stature, you have a big personality. You rule 'the bed', well, my side of the bed at least and no cat would ever be allowed to snuggle in your spot by my side (sorry kitties). One of the most precious times of the week for me is my Sunday morning sleep ins when you are snuggled in my arms and we are both snoring our heads off or I am sharing my English breakfast tea with you. Sometimes I whisper in your ear how much I love you and I honestly believe you understand me with your little snort of a reply.

I don't have 'human' kids. I guess that part of life was never part of my destiny, however you are my darling girl, my child and I love you in the same way. I will always protect and cherish you, my darling. You are everything to me.

Love from Mummy (who wrote this letter) and love from daddy too.

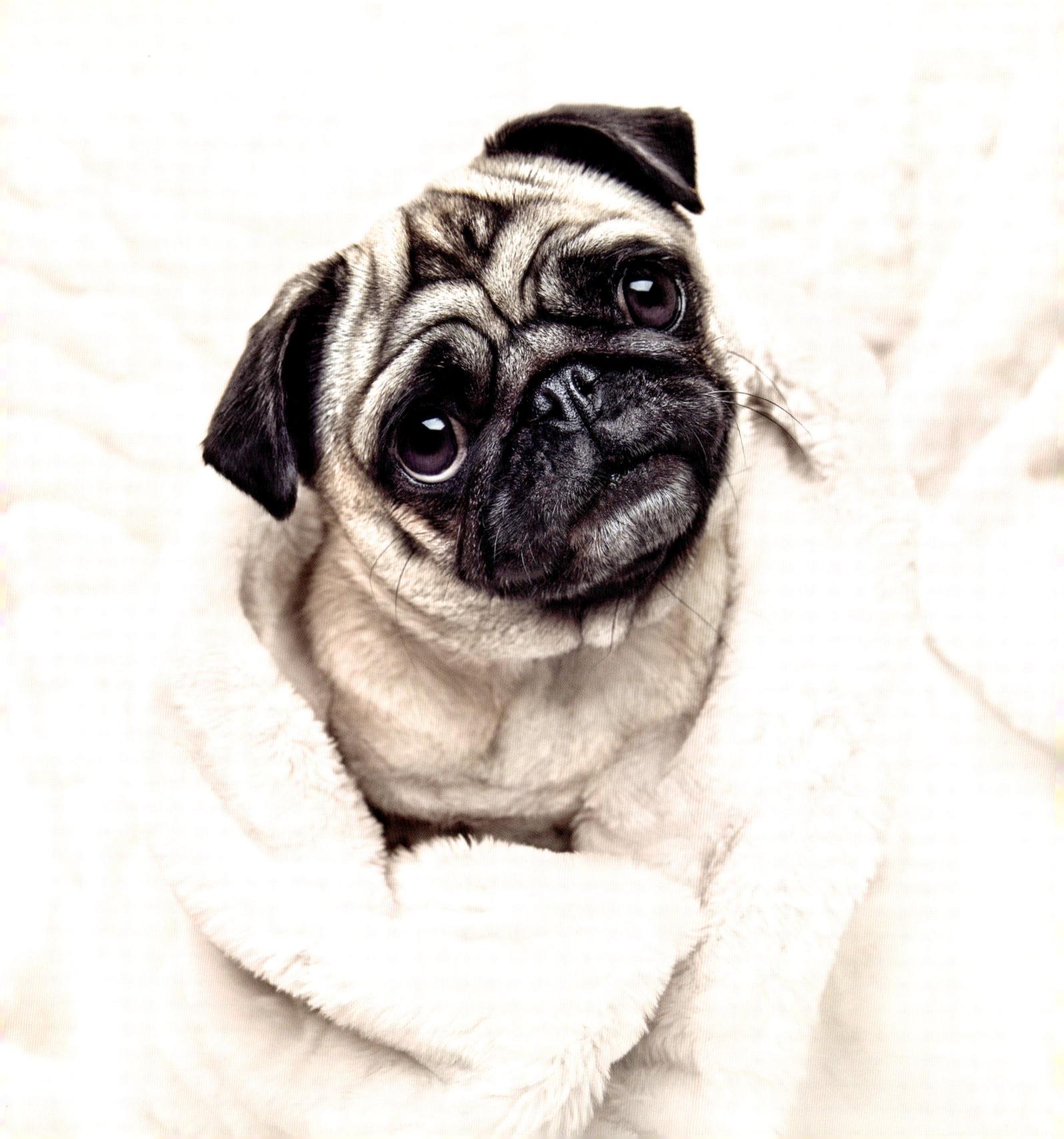

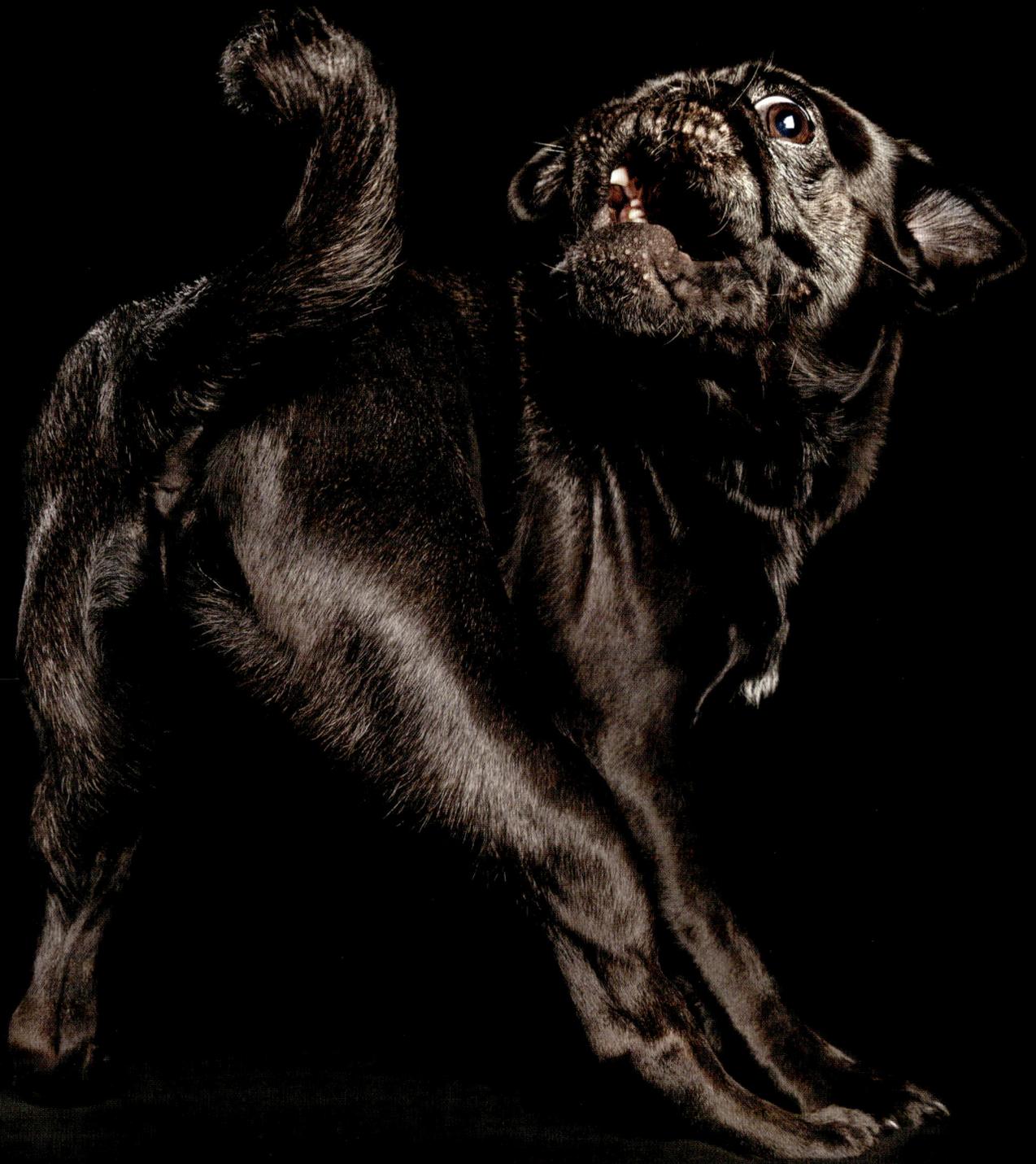

My dearest Harold,

Well what can I say? 'They broke the mould when they made you' comes to mind. You are my cheeky monkey, my cuddle monster, my larrikin, my crazy little man and I would not have you any other way.

Thank you for always making me laugh. You are forever putting a smile on my face with your funny expressions and little quirks. You love chasing your tail and it never fails to make me chuckle. You love getting cuddles any time and there is nothing more comforting to me than when you are snuggled on my lap, snoring your head off. Oh, and that teeny little under bite, it makes my heart melt. Add in that little poking-out tongue – well, that look gets you anything you want and I think you know that!

We first met you when you were only seven days old. You and your little brothers and sisters were cute bundles of fluff. I picked you (or did you pick me?) from that very first moment.

Thank you for always letting me pick you up and shower your head with kisses. Thank you for being patient and understanding with that – your mummy is a very huggie person and you are my cuddle monster.

I am writing this whilst you are snoring on my lap which kind of makes it awkward to write, but that is just the way we roll, right? I have become used to working on my laptop with you on my lap. You are my lapdog.

You are so different to your fur-siblings, Harold. You have made your own mark in our little fur-family and I love you to the moon and back. Thank you for just being you! Oh, and thank you for chewing Daddy's shoes not mine. I am sure they tasted better. Hehehehehehe!

Love from Mummy and Daddy Drake

Dear Earl and Midge,

First of all we want to tell you how much we love you.

The difference you make in a day is huge. From feeling your whiskers on our cheeks before we open our eyes of a morning, to watching the sunlight shine on your coats as you sniff around the garden. From the little beads that settle on your jowls after you sneeze to your beautiful smiles that show off your tiny little teeth, we love every inch of you.

There are so many things that you both do makes our lives so much better. When you nudge the sheets to snuggle into us in bed of a morning, you put us at ease. The worries of the day ahead seem to just disappear. If only we could spend our days with the both of you by our sides. The only thing that keeps us going through the day is knowing that you will both be waiting at the door, and great us with those beautiful happy faces. You are both so understanding and we pity people who have never experienced the unspoken connection between man and dog.

Through the hard times you have been by our sides. You don't tell us everything will be ok, you simply stay by our sides. You know just how to cheer us up. Whether it's a paw on our cheeks or just parking your cute little bums on our laps, that love you give makes all our troubles seem to disappear.

We have never experienced a friendship where words are not needed because you say and do so much in unspoken ways. To us, what you both do, each and every day means more than words could ever possibly say.

We love the way you get excited over the smallest things, like going for a drive or coming on holidays with us. You are always so excited to go places and meet new people. We love your soft little ears, your black button noses that snore and grunt, our little chats, your pretty little eyelashes, and the twinkle in your dark brown eyes.

Your little round bodies drop so much hair, but snuggle in so tight. We love to watch you sleep, the way you rest your heads on our legs or the couch arm. We love your little feet and the way your nails click on the floor as you go about your little missions, your perfectly curled tails wiggling with delight.

When we see your tails straighten, we know you are peaceful and dreaming, yet when we see them wiggle we know that you are happy. That is all we could ever ask for.

The two of you are our world.

Love from Mummy and Daddy

xxx

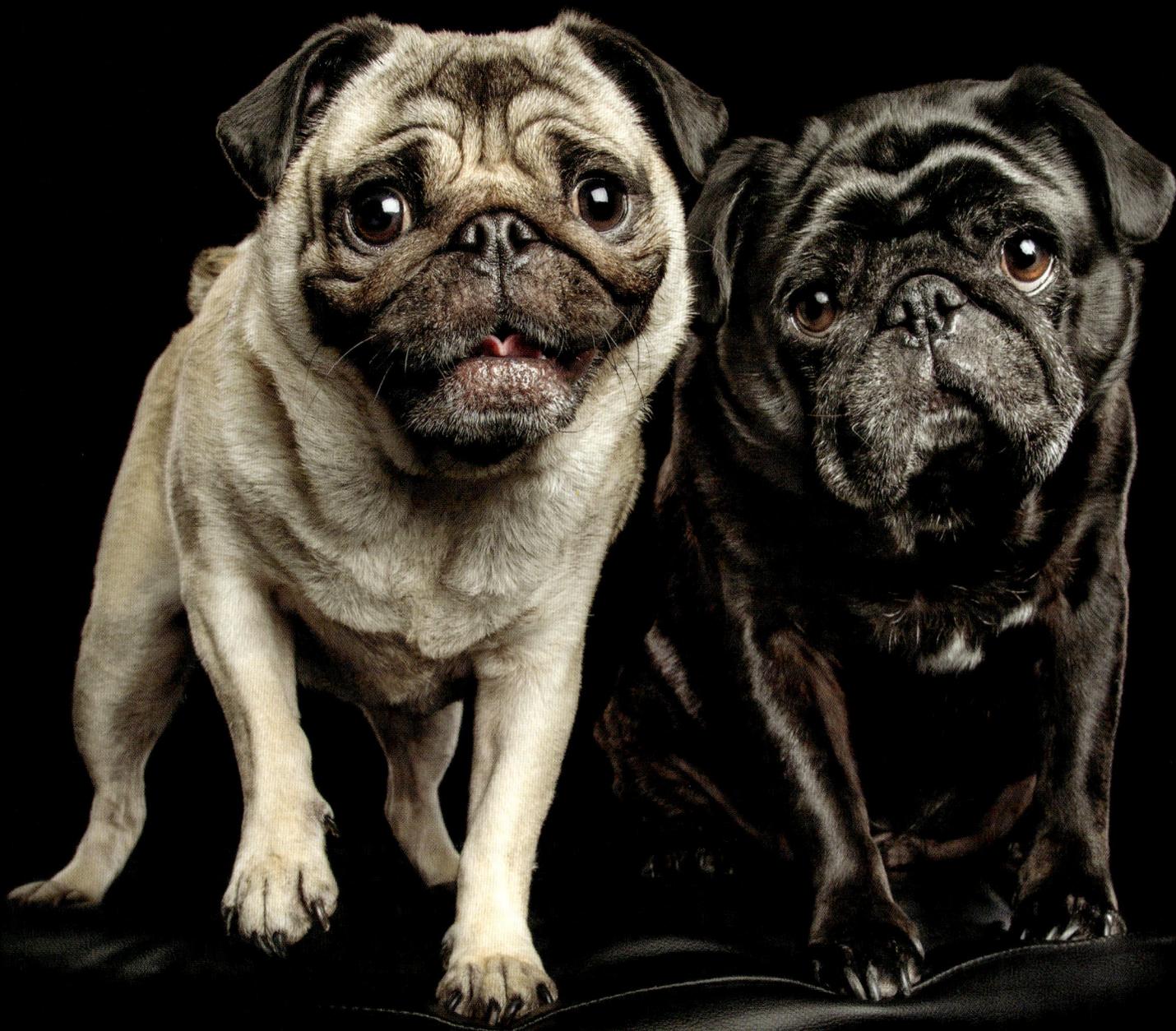

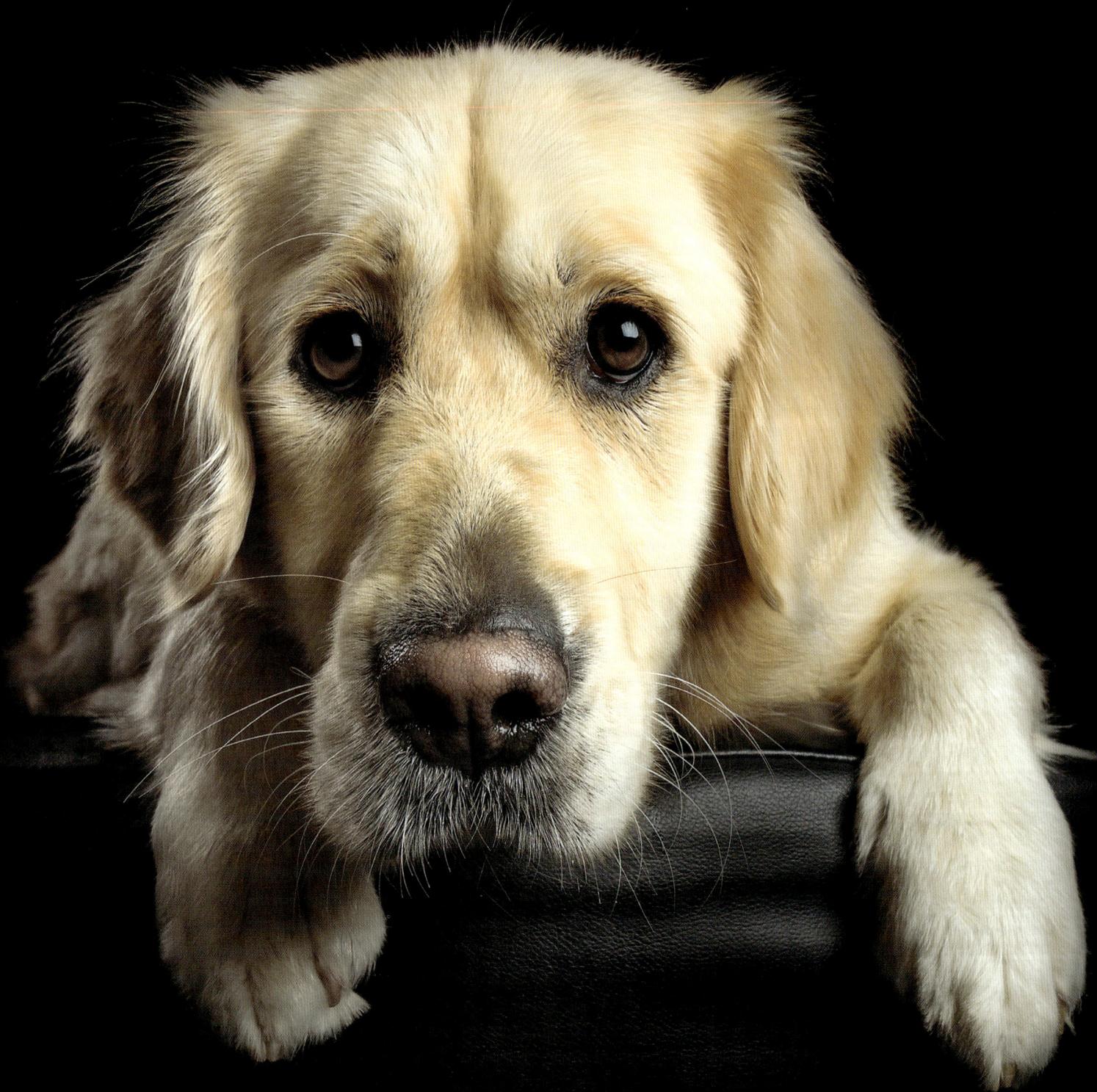

Dearest Douglas,

I'm writing you this letter to let the world know how special you are. It's been two years now since you came into our lives and I want to thank you for the unconditional love and affection you have shared with all of us. The vet might say you have a dodgy heart, but I think it's the biggest one ever!

You are the gentlest soul in this entire world, and you leave a lasting impression on everybody who has the pleasure to meet you. Barely a conversation goes by without people wanting the latest update on your recent adventures. Photos of your beautiful face are also a common request.

You've been our shoulder to cry on throughout the hard times, our reason to get out of bed in the morning, our source of well-needed exercise and recreation, and the provider of warmth and energy to our home.

You were the one thing in this world that brought joy to my brother, Richard, and I cannot express how grateful I am for the extra time you gave us with him. You were his best friend and closest support.

I am so proud of the young man you've grown up to be, Douglas. You are mature beyond your years and you are always ever so polite ... well, almost always!

I can't wait to share the rest of our lives together and watch you nurture and protect our children. Here's to another 15 years with our beautiful pooch.

I love you, Douglas!

Ben

A letter to my fur baby!

My little sugar, what do I love most about you?

Is it the way you greet me so enthusiastically when I come home, even if I have only just gone outside to check the mail? Or is it the way you know when I am feeling happy and bounce around me joyfully? Or when I'm feeling sad, and you quietly climb into my lap and nuzzle me.

Maybe it is the way you still love me when I'm cranky and don't want to talk to anyone – you know that and just sit with me silently. Or is it the way you listen knowingly when I want to sound off about something? Hmmm, I think it could be the way that you pat me with your little paw when you think I should be paying you more attention. And the cute little groany noises you make when we scratch your belly. But then, it could be the way you have to sleep lying against me. For such a little being, you take up a huge chunk of room of my bed at night. But then, you also take up a huge chunk of room in my heart as well, so I don't mind.

You are such a precious and valued part of our family, even though you play with your food and flick it all over the floor for us to step on.

You came to me when I needed you most to help mend my broken heart, and I am so grateful to have you in my life. You make our house a home.

Beth

xo

PS So what do I love most about you? It's everything – I love everything about you. You are perfect!

My dearest Mateo (Potato),

You came to me in a time of grief. I had just lost my best friend of 12 years and you had come along and supported me. You taught me that grief was not the end and life can always be found.

I took you on as my own son and our bond was instant. Now you have a permanent place in my heart. You are my other eyes that can see above the clouds; my other ears that can hear above the winds. You are the part of me that can reach out into the sea.

You have told me a thousand times over that I am your reason for being; by the way you rest against my leg; by the way you wag your tail at my smallest smile; by the way you show you're hurt when I leave without taking you with me.

When I'm wrong, you're delighted to forgive. When I'm angry, you clown around to make me smile. When I'm happy, you are joy unbounded. When I'm a fool, you ignore me. When I succeed, you brag.

Without you I'm just another person. With you I'm everything I can be and more.

You are loyalty itself; you have taught me the meaning of devotion. With you, I know a secret comfort and a private peace. You have brought me understanding where before I was ignorant.

Your head on my knee can heal my negative feelings. Your presence by my side is protection against my fears of the dark and the unknown.

You have promised to wait for me ... whenever ... wherever ... in case I need you. And I expect I will. I always have. You aren't just my dog.

xox

Dear Jordan,

It is amazing how an animal can bring so much unconditional love to your life. You have given us so much and more. Nothing mattered to you; all that you cared about was greeting us at the door, and that we gave you love and affection.

If we weren't feeling well, there you were, 'Nurse Jordan' and through all the breakdowns, you were there, nuzzling our arms as if to say 'Head up, it's okay I'm here.' Unconditional love, pure and simple.

Jordan, you were definitely a one in a million dog; we could trust you 100% when a child entered the room. You were more focused on their welfare than anyone else and if they cried, you ran to them to make sure they were ok.

We loved your constant 'talking' and need to tell us to 'wake up', 'feed me' or 'play with me'. Hide and seek was your absolute favourite game with everyone, and your excitement when you found the hidden person showed when you would bark uncontrollably whilst your tail was wagging so hard it looked like it would fall off. Or it would take off like a helicopter hence the name 'helicopter tail'.

We went without when you needed major medical attention and never regretted it. I have no doubt you would have given your life to protect us and we would gladly give up any materialistic item in exchange for you to be here right now. Value life!

Jordan we love you so much, even more than we realised. Thank you so much for the 15 years you dedicated to us. Your heart was so pure and good. You have taught us so much and we hope we could be half the kind soul you were. We truly hope we gave you the best life we could and we miss you so, so much.

We love you and miss you terribly 'dog dog'.

Mummy and Daddy Natolo

Our dear Ella Girl,

We still remember clearly that October day six years ago when your patchy little body waddled into our house like you had always lived here. As smelly and unloved as you looked, you still smiled and wagged what there was of your tail, which caused your whole body to move — what we called 'shakin' dat ass'.

You let us know immediately we had been chosen to provide you with your love of snacks and pats, humping our legs with your stumpy little body if we didn't comply with the latter, earning your nickname of 'Mrs Beefy'.

Your first weekend with us involved a brush with the law — what a silly constable thinking it was odd your new human sister, Diandra, was asleep on the back seat of the car and you were my co-pilot. We showed him when he tried to tell us off because he thought you weren't restrained too! You're always safe with us, Ella. And you have been an amazingly tolerant big sister to Brucey who adopted us two years ago.

You love greeting visitors too, especially Uncle Sean who always has a snack for his 'beefy dog'. You have had countless play dates with friends, particularly Winston and Mushu. Your first beach trip was made into a story book we will always treasure.

Even though you were getting old and had some health issues, we had some great adventures. And you've put up with all the annoying things we do like bathing you, cleaning and nail clipping too.

You've always had a zest for life and a capacity to love that we marvelled at, knowing your previous life wasn't so happy. We know you won't be with us forever but you've given us more than a lifetime of love, fun, snores and farts we'll always be grateful for.

Thank you for choosing us.

Love always

Mum and Dad

To my dearest Sophie,

As a puppy you were a quick learner, mostly staying out of mischief and so much fun to be around. You aced puppy preschool and basic dog obedience and we later went onto to advanced dog obedience. You weren't really keen on affection like most other puppies and dogs I knew and people would comment on this but I knew deep in my heart that you and I had a special connection and understood each other. We jokingly called you '2 foot' as you didn't like to be touched but always wanted to be near.

As you grew a little older your personality started to develop. Whilst you were smart, you were also stubborn and defiant. I loved this about you and knew that you'd be the best dog I'll ever have.

At around five years of age you had your first seizure. I remember it like it was yesterday. You were in the back of the car with your fur brother but you were jumping around and fitting. I quickly pulled the car over to the side of the road, placed you gently on the nature strip not knowing what to do and feeling helpless. I tried to give you mouth to snout. I thought you couldn't breathe. The specialist said you'd basically had a dog version of epilepsy.

I am convinced that you know the spilt second before you're about to have a seizure as you try to run to us for comfort. We know exactly what to do now. Cuddling you, stroking you, letting you know that everything is going to be all right, all the while your little body is contorting in ways that I didn't know was possible; your back arching and your paws curling over while you were screaming in pain. Thankfully this doesn't happen too much these days and we are so pleased as sometimes it would take days for you to bounce back.

We have been through a lot together you and I, Sophie. Many visits to the vet for pancreatitis and epilepsy amongst other things and through it all you take it all in your stride, endure whatever they do to you and seem to know we are helping. You've taught me so much in this respect.

You are now a tired senior in the twilight of your life and I know you won't be with me much longer but I just want to thank you for sharing your time with me, teaching me and allowing me to be part of your life.

You are a fighter, sweet girl, and a very loyal companion. I treasure you everyday as you now walk so close to me that I can feel your beard on the back of my legs. We are so close, I see your face light up when I come home and your whole body shakes with your tail wagging when you see me. You are now my shadow and you're always there with me and trust me. I adore this.

Love you furvevermore, Momma

To Lass,

You understand me and I understand you — it's as if we were made for each other. Your happiness and wellbeing is so reliant on me — I am your world and I try my very best not to put your trust at risk. You talk to me in so many ways — from the tilt of your head when you catch my eye to waving at me when it's time to go to your bed at night. You seem to know what I am thinking almost before I do. No way are you 'just a dog'.

You and I have a connection that I can't explain in words. We are best friends who play and live together; we are companions and soul mates. Your face lights me up every time I see you.

From the minute you snuggled into John's shoulder and licked his ear, it was a definite that you were going to join our family. You had already convinced me that I was the one for you however John took a little more convincing but you saw to that. You were my baby then and you still are today.

You have introduced me to what being owned by a border collie is all about — such intelligence, loyalty, a willingness to learn and a keenness to please me and only me. You are a one-person dog — you know where I am every minute of the day. When we line up at the agility start line, your excitement is palpable. We have had so many fun times together and the day you gained your Agility Champion title I was so proud — to you however, it was just another fun game we played together that day.

I loved you as a pup, but your beautiful soul makes me love you more and more each day. My one and only heart dog, Lass.

xx

Dear Cooch and Gieves,

How lucky we feel to be your humans.

Our little family has changed so much since a man became 'a man and his dog' in 2009 whilst living in Townsville. Stewart was looking for a four-legged companion and he knew he'd found the one when he met Cooch. Stewart and Cooch had many adventures learning tricks, going for swims and runs and hanging out on the couch together.

Then our family grew when Stewart met Ciara in Brisbane in 2011 and lots of things happened all at once. Stewart went away to Afghanistan for his work with the army, you went to stay with your grandparents in Adelaide for a year of cuddles and bacon sandwiches which meant Ciara didn't get to meet you until 12 months later.

At first you weren't too sure but after lots of pats and cuddles, you decided she could stick around. Then it became your job to keep Ciara company and make her smile everyday when Stewart was away on his work trips.

Cooch, having two humans who work a lot, we thought you might like to have a little brother to keep you company, so in 2014 our family grew with the addition of Gieves.

Gieves, when you arrived you really shook everything up. You were the tiniest puppy running circles around us all. You are such a joy and a cheeky chops all at once. We love you for your desperate need for attention, never ending kisses and your hilarious wookie growl when you are impatient.

We love being greeted at the door by both of you and your unbridled joy and excitement when we get home after work, nearly as much as you both love walkies and din-dins. You are the best family members anyone could ask for and we love you more than words.

Ciara and Stewart

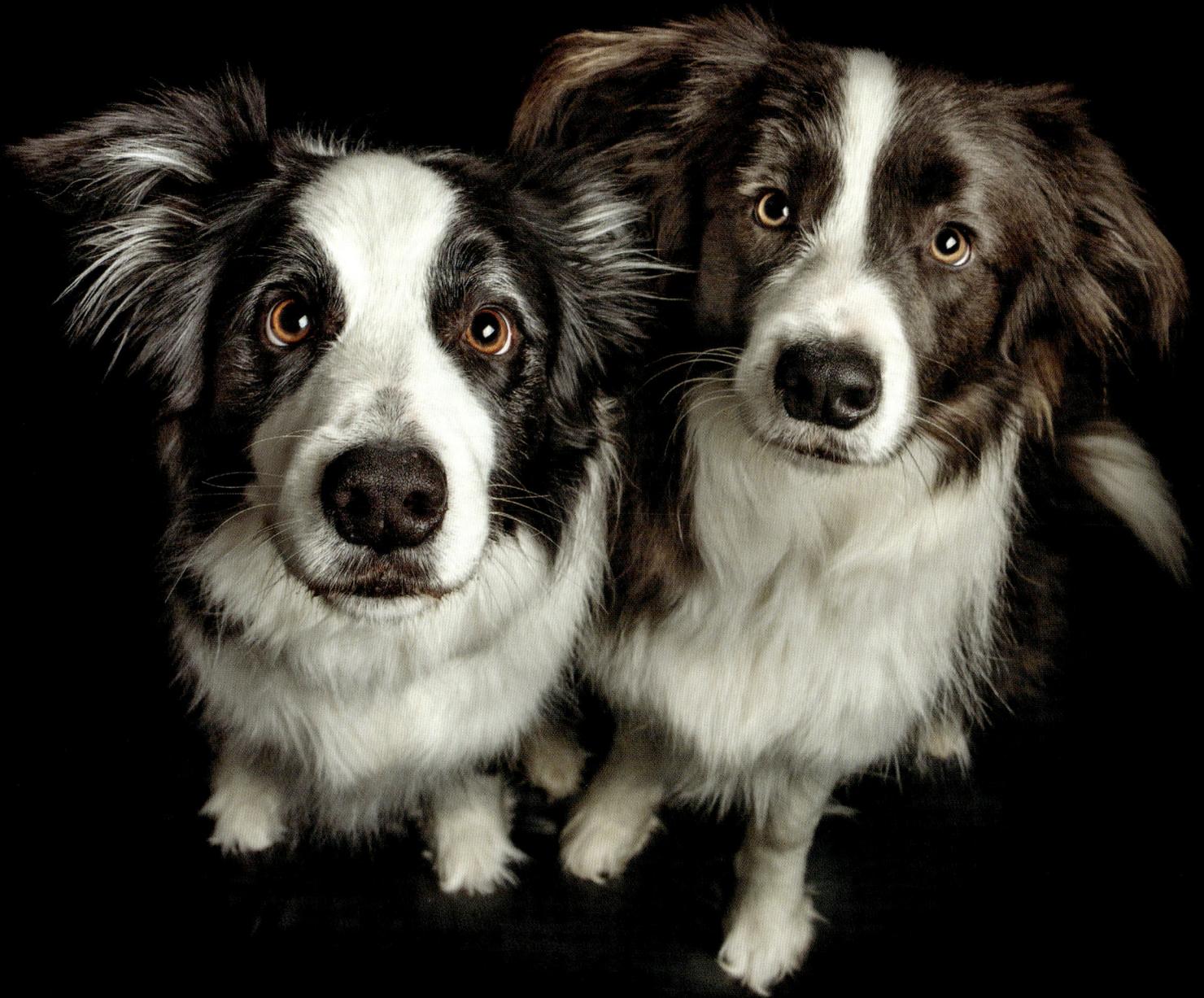

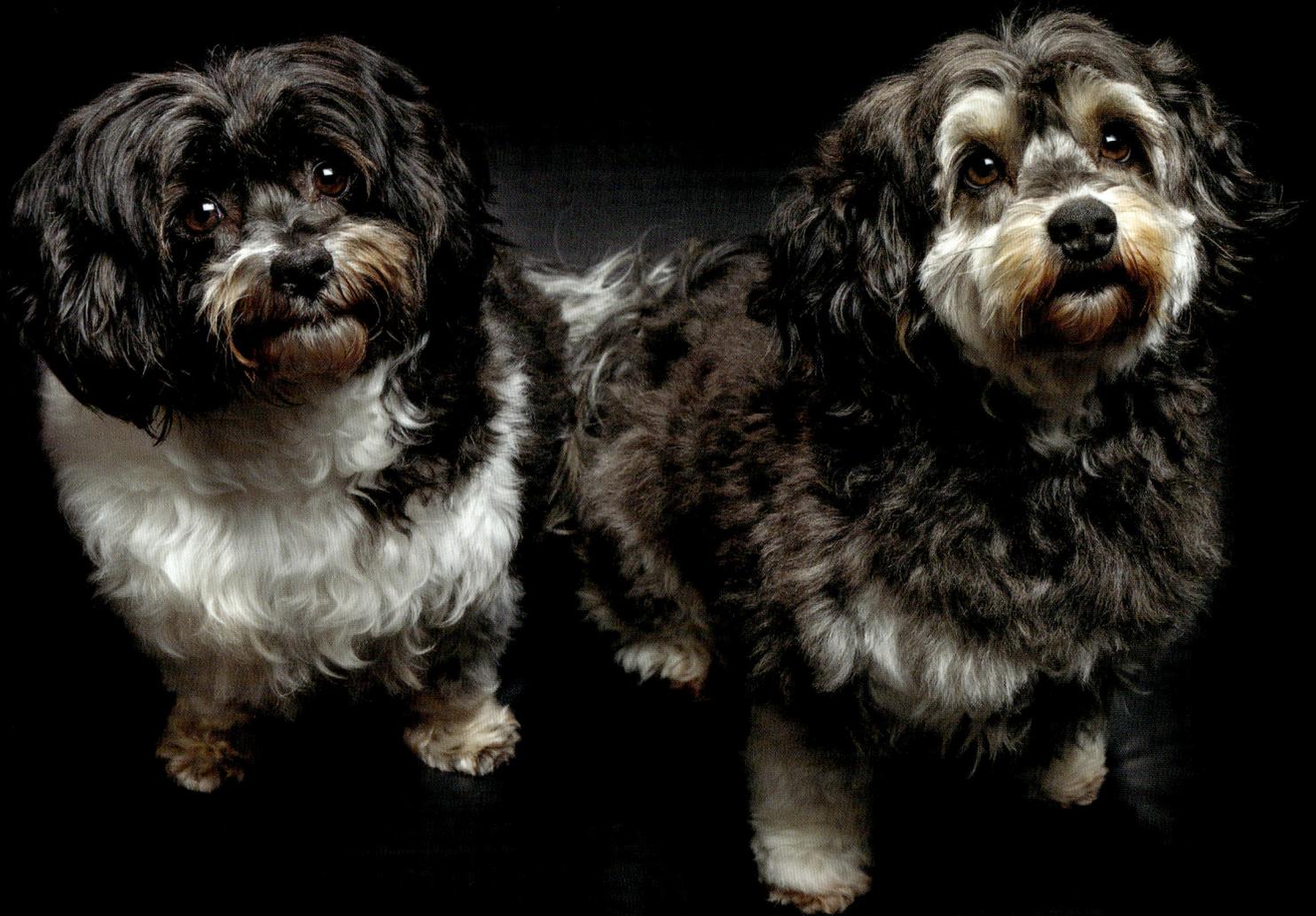

A letter of thanks to you, Lilly and Murphy,

You are not really our dogs. Seven years ago we were asked to care for you when your 'real' mum moved. We welcomed and loved you, not knowing what to expect, not having cared for small dogs before. We soon learned that size doesn't matter and so our journey began.

Ball-obsessed Lilly, we love your craziness and stamina, chasing every ball thrown, muscles taut. Low energy Murphy, we love watching you zig-zagging through trees on the scent trail. Thankyou for the happiness.

Lilly, our policewoman; you take life so seriously walking so close that we feel your whiskers on our ankles. Murphy, we adore your laid-back attitude and how you teach us about letting go of the small things. Thank you for the life lessons.

Do we meet your needs? I wish I knew what you think as you daydream in the sun, twitching legs running to where? On a hunt? Catching prey? Eating what nature intended? I think deep down you are still primal.

You would flourish with alpha leaders, no words needed. Silent dog language, easily understood. I hope you understand we try our best. We humans tend to complicate life.

Life with you has been a joy. Now entering your senior years with frosted faces and different needs, you'll never have to travel these years alone. We are privileged to be your advocates, monitoring your health and wellbeing, and your ability to cope. We will watch to see that your movements, minds and interests don't wane. There will come a time when your circle of life reaches a full 360 degrees and we will be right there for your final journey.

Lilly and Murphy, the love you have bestowed on us is spiritual and felt from the heart. Your little glances, odd winks and happy smiles have blessed us with years of laughter and worth. I hope this letter makes you feel the love we have for you both.

A life without dogs is a life we will never know. Thank you, kidlets, from the bottom of our grateful hearts.

Your forever foster mum and dad

xxxxxx

To the most loyal dog of my life my beautiful boy Blade,

My world would not be half the place it is without you traveling by my side for all these years.

From the moment I picked you up for the first time and you cuddled into my arms I knew you were my best friend. Now 12 years on and still looking and playing as a pup, that has not changed. My heart only grows bigger for you.

There are days you amaze me with your agility and energy. For an older boy you're doing well; it is me who has to slow you down to make sure I have you with me for so many more years to come. We know you are no angel (the kitty tray cleaner) but to me you are my angel.

Through the great times and rock bottom times, you have always been there to welcome me home and be my constant companion. With the very recent loss of my dad and even the loss of your younger sister, Tia, you have always given me the look of love, encouragement and loyalty.

Tia loved you so very much and always had your back. No-one was allowed to hurt her family or you. She was your little pocket rocket sidekick and we know how much you loved her and miss her too.

Your daddy and I are beyond lucky to have you as our fur baby. We love you now and forever

xo

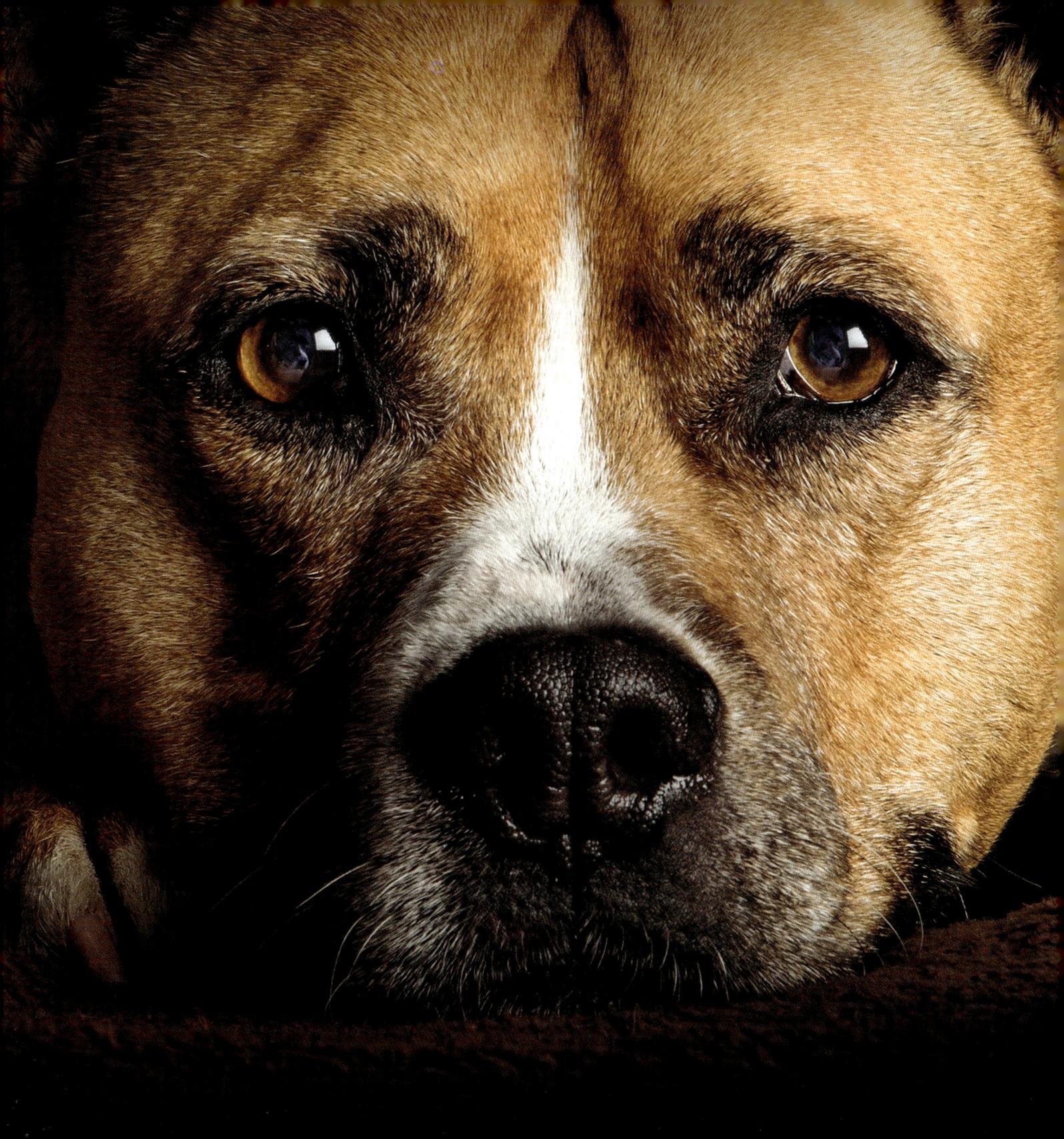

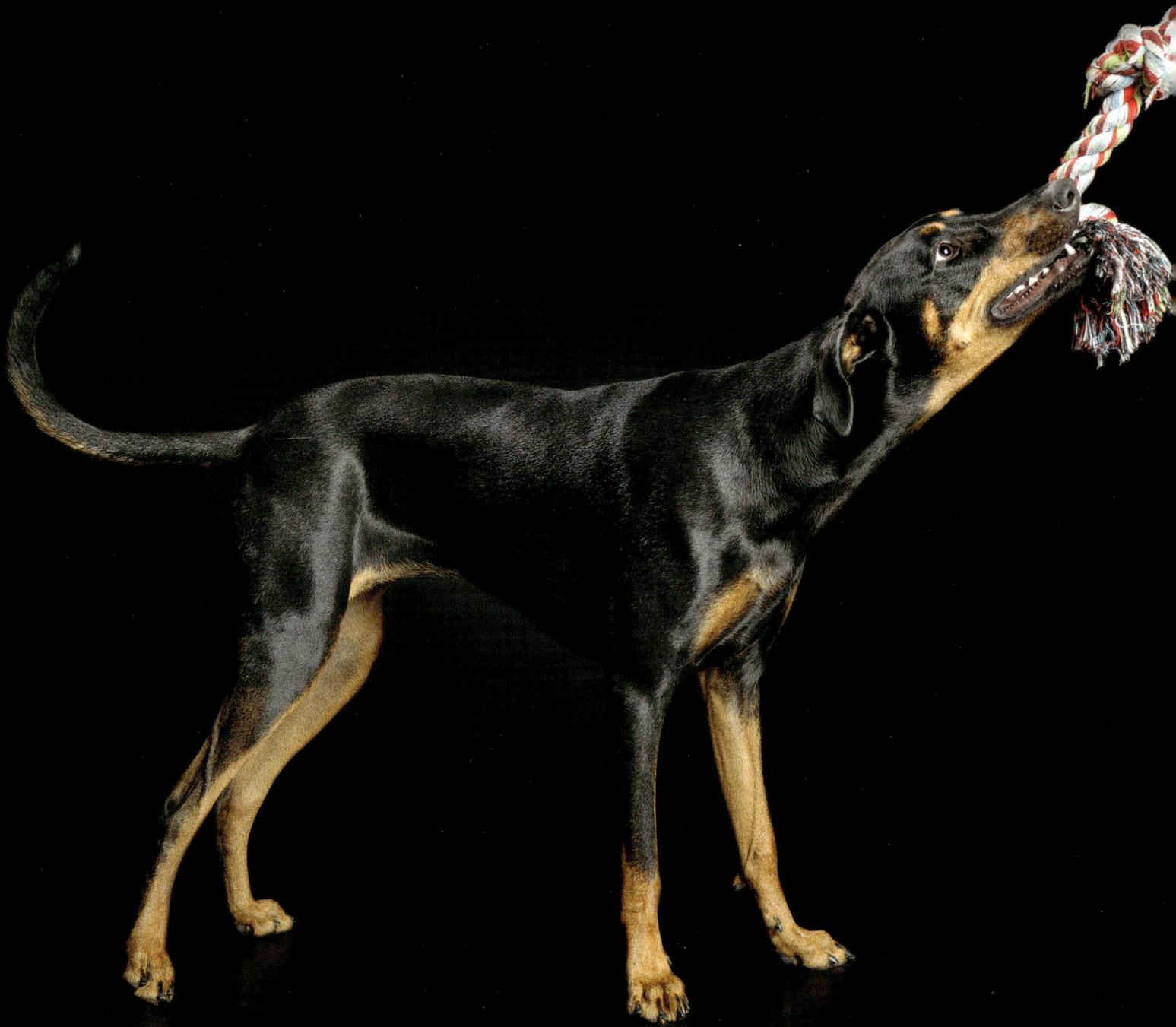

To dearest Molly,

It's time you knew — you're adopted. Your mother and I are not your real parents, although we love you like our own. To think it almost didn't happen.

When you were ready for adoption we didn't feel as though we could provide you with the environment that you deserved; we were working long hours and weren't sure how much time we could devote to you. When we heard that your brothers and sisters had all been adopted, and that you were facing the possibility of going to the puppy orphanage, we couldn't reconcile with the idea, so we took you in. I'm so grateful that we did because you have brought us so much joy and we can't imagine our lives without you.

Even when you have been a bit naughty, we have eventually been able to look back and laugh; like when you stole the barbecued chicken from the family at the beach and swallowed it in two bites. I was so mortified at the time, but now it's just a great story (except for the family who lost their chicken lunch — they might still be going to counselling). Or all those occasions on which you and I have been walking at night and you have been frightened by a shadow or a leaf, and spread your legs like a starfish, refusing to move. Haven't we had some strange looks from passers-by as I carried you home? It's not often that people see a man carrying a full-grown Doberman like a baby!

And what about the time when we were driving from Adelaide to Brisbane for Christmas and you decided that you didn't want to be in the back of the car anymore, so climbed into the front? That was a bit scary, It's hard to concentrate on driving when you have a big tail whacking you in the face. We bought you a seatbelt pretty soon after that, didn't we?

For each of these times, there have been hundreds of moments that make us love you even more. The cuddles in the mornings, the way you welcome us when we get home, the way you look all curled up after I've tucked you in and kissed you goodnight.

People think I'm over the top when I call you my angel-sent-from-heaven-to-make-Daddy-happy, but I think they just don't understand. Don't worry that you're adopted, you're still my special girl.

Lots of love from Daddy

Dear Chilli,

Despite the high-pitched Chilli voice that we monolog as your humanoid response in a 'who's a good girl?' conversation, there are some things that you just wouldn't know that makes you our perfect girl.

Chilli, will you ever know how cheeky you are? You rumble from room to room, stopping only to mangle an unfortunate underpant, sock or shoe. Those doomed pieces of clothing are never to be seen intact again, only appearing in the vengeful poos that you leave on the yoga mat.

Chilli, will you ever know how spoilt you are? You scatter your ever-growing mound of chew toys around the house and rejoice as we accidently step on a 'squeak' toy, as the noise must surely signal that it's playtime. Your pleading eyes melt us into an exhausting saga of fetch and chase, until you contently plod away into your private villa-of-a-kennel to sleep away your non-existent worries and sorrows.

Chilli, will you ever know how energetic you are? Your love for the beach has no boundaries. Spending most of your time tumbling in the surf, chasing those uncatchable turkeys that must smell oh so good or trying to yank down board shorts in a never-ending game of tag. There is no such thing as too long a time spent causing mischief at the beach.

Chilli, will you ever know how precious you are? Your delighted licks and cuddles makes waking up on those cold early mornings our new favourite time of the day. Our lives have never had so much laughter, excitement or love until your teddy bear face came into our family. We are truly smitten to have you as our little princess.

Love

Mama and Papa

Dear Luna and Astra,

You came into my life at a time I needed you the most. After losing my dad, there was something missing in my life. Turns out that was you two beautiful fur babies. You two made me whole and happy again. Every day you fill my life with joyful, cheeky smiles, intelligent looks, sweet cuddles and lots of laughs. From watching you two zoom around the house without a care in the world, to cuddling up with you for some quiet time, everything you do puts a smile on my face.

My favourite part of the day is coming home to your overexcited greetings, stories of what you have done and gallons of kisses. You two make me feel truly loved and cherished, and I can't thank you for that enough.

Even though you can be super silly and downright naughty sometimes, I would not change a thing about you. Although, I sometimes do wish you would stop stealing off the kitchen bench (I am talking to you, Astra). You spice up my life with your antics, and you make our house feel like a home. There is nothing quite like having your own personal husky choir on hand to perform duets for you, and definitely nothing as special.

Watching you two have a chat whilst chewing a bone, or playing the way huskies do is definitely in my top ten favourite activities. However, nothing beats the quiet moments, where anyone could see how much you truly do love each other and how happy you are with your lives. Although, the massive smiles on your faces when you get to run around the property and play with the horses is definitely up there in your happiest moments.

Luna and Astra, you are my truest and most special companions, and you are the world's best dogs (I might be a little biased). I definitely won the lottery when you two came into my life.

Lots of love to my special babies

Emily

Dear Redley,

As a dog of great value, Redley, you wear many tails. Tim's favourite is your 'helicopter tail' accompanied by 'crocodile eyes'. You sprawl carpet-like, while your plumed tan and white tail revolves around and around. Your darting eyes scan left and right, beneath twitching, fringing brows, as you plead for a romping game, or a snuffling walk, or that playful tug-of-war which, invariably, you win.

Your pleadings are never in vain. You get me moving out of my chair. You make me laugh or shake me out of a dark mood. You know when sadness and grief threatens to descend, for that is when your sad tail thumps, thumps, thumps on the floor. Your head is pressed against my knee and your nose demands pats from my too-still arms. Your worried eyes peer into mine to make me see beyond empty bedrooms.

You are Tim's and my greatest friend. Our family is the three of us. You are our fur kid, our greatest blessing for you arrived when the non-fur kids could not.

When either of us is unwell, or when the bleakness rears its head, your only desire is to comfort us. All you ask in return is for hugs, belly rubs and companionship.

When Tim collected you from the RSPCA Alice Springs, you rarely left my side. You sat, curled like a comma, in your own office chair, as I researched astronomy facts or star-lore. Your jaunty tail flagged your path, as we strolled through the sand dunes and spinifex clumps. You explored the desert scents in the early dawn, the scurrying tracks and slithering trails of the night dwellers, marked out in the cool red sand.

You are our teddy bear with long legs, still at our side after many years and many towns. Your smiling countenance and swishing tail still signals our daily walks. While your stride is slower now, and your eyes are clouded with age, your proud plumage, that magnificent tail, is still held high as you lead us into each day.

Fur-Ever loved x

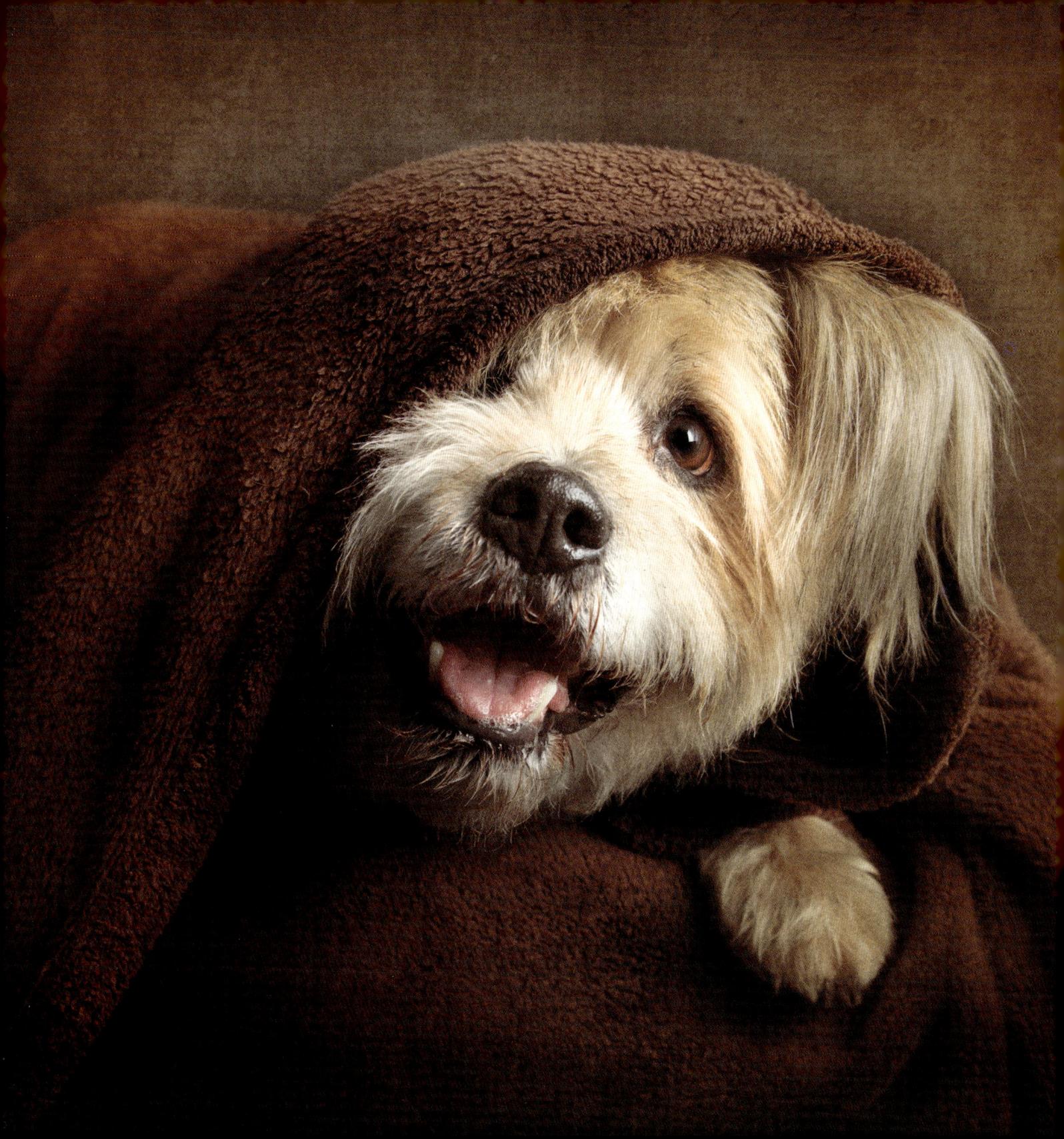

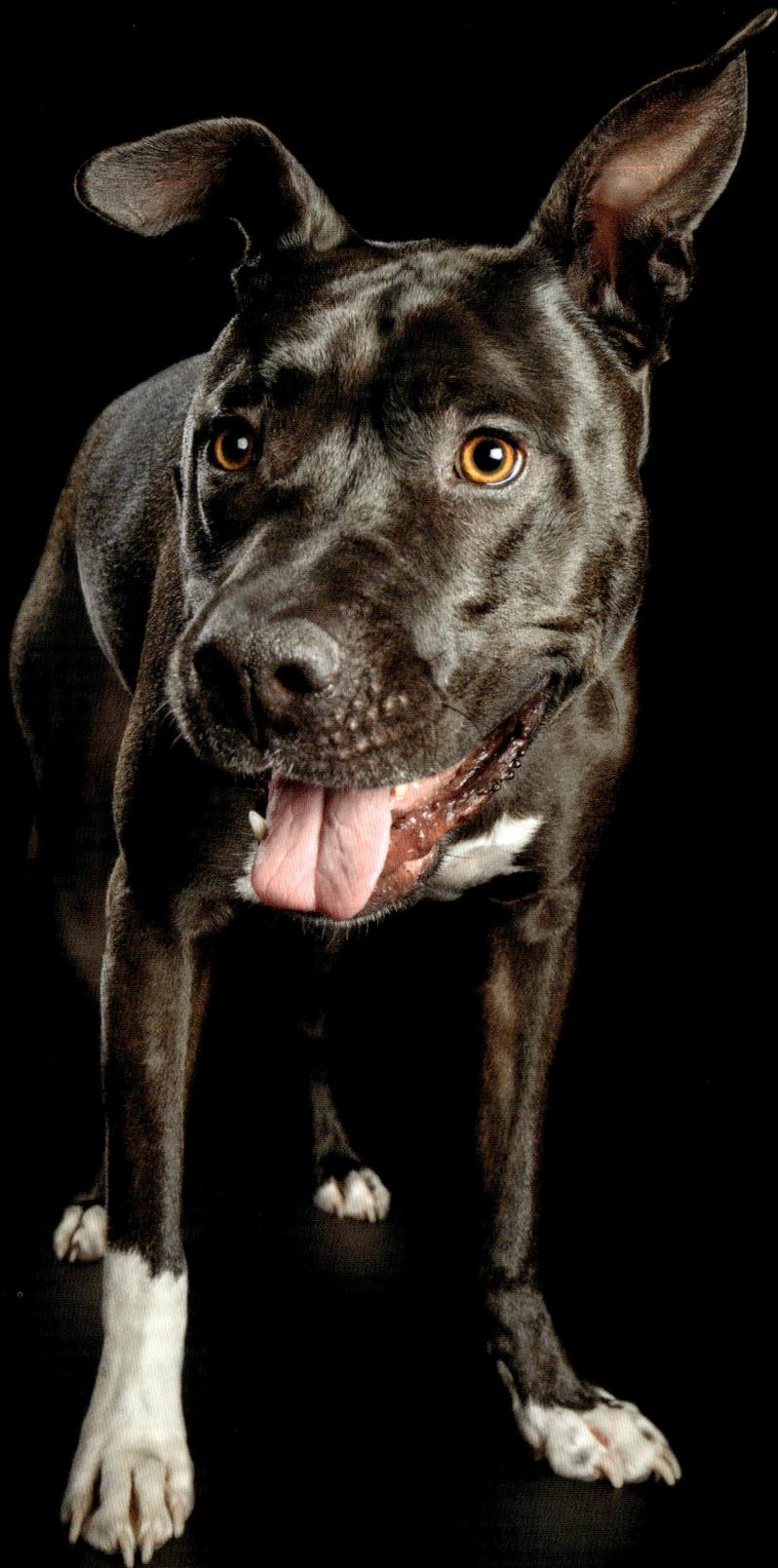

There is this boy, who stole my heart ...

I knew from the moment I looked into your eyes that I would never be the same. I knew I would become a better version of myself and I would never love anything as much as I love you.

You became my best friend within a heartbeat. You taught me to love, to trust, to laugh. You taught me patience and compassion. No matter what time of the day it is, you are always there to pick me up when I'm sad and remind me of the simplest things in life. You may occasionally have an accident or two, and you are always hungry. You may have four legs, a constant wagging tail and two floppy ears. You may sit on my head at 4 am in the morning so I will let you underneath the bed sheet so you can cuddle up to my feet. Wrench, to others you may be just a dog but to me and your dad, you are our everything.

Looking at your dad holding you in one hand the day we first got you became the moment I realised I had started my own family. You made us learn to love each other more and above everything else, we realised that sharing a love for something else was just as important and fulfilling.

I believe you choose us that day we first met because you knew we needed you more than you needed us.

I love you Wrench.

xoxo

To my darling Jem,

I am struggling to put into words how much I love you and how wonderful it is to have you in my life. I don't know where to start, so instead I think I would like to share our story of 'love at first sight' with the readers of this beautiful book.

I recall the moment we first met as one of the most beautiful experiences and strongest memories in my life. We were simply meant to be. Katrina from Friends of the Hound, who had rescued you, thought you might be my prefect match. Of course, I wanted to meet you first before agreeing to adopt you. So I drove to Noosa where you were in foster care with the wonderful Kate and Ad. As Ad opened the security screen door where you had come to greet me, you jumped up on me at full height and gave me a kiss on the cheek. Ad was most apologetic saying that you had never jumped up on a visitor like that before, but from that instant I knew we were meant to be together. It was like you said, 'There you are. I have been waiting for you!' It was most certainly love at first sight for both of us.

You have been with us for longer now than you were in the racing kennels, but I still wish we had the first four years with you also. You are the most loveable dog with the sweetest personality and I cannot imagine life without you.

May we have many, many more wonderful years together darling girl. You mean the world to me. My sweetheart, I love you so much, you are my heart dog.

Esther

xoxox

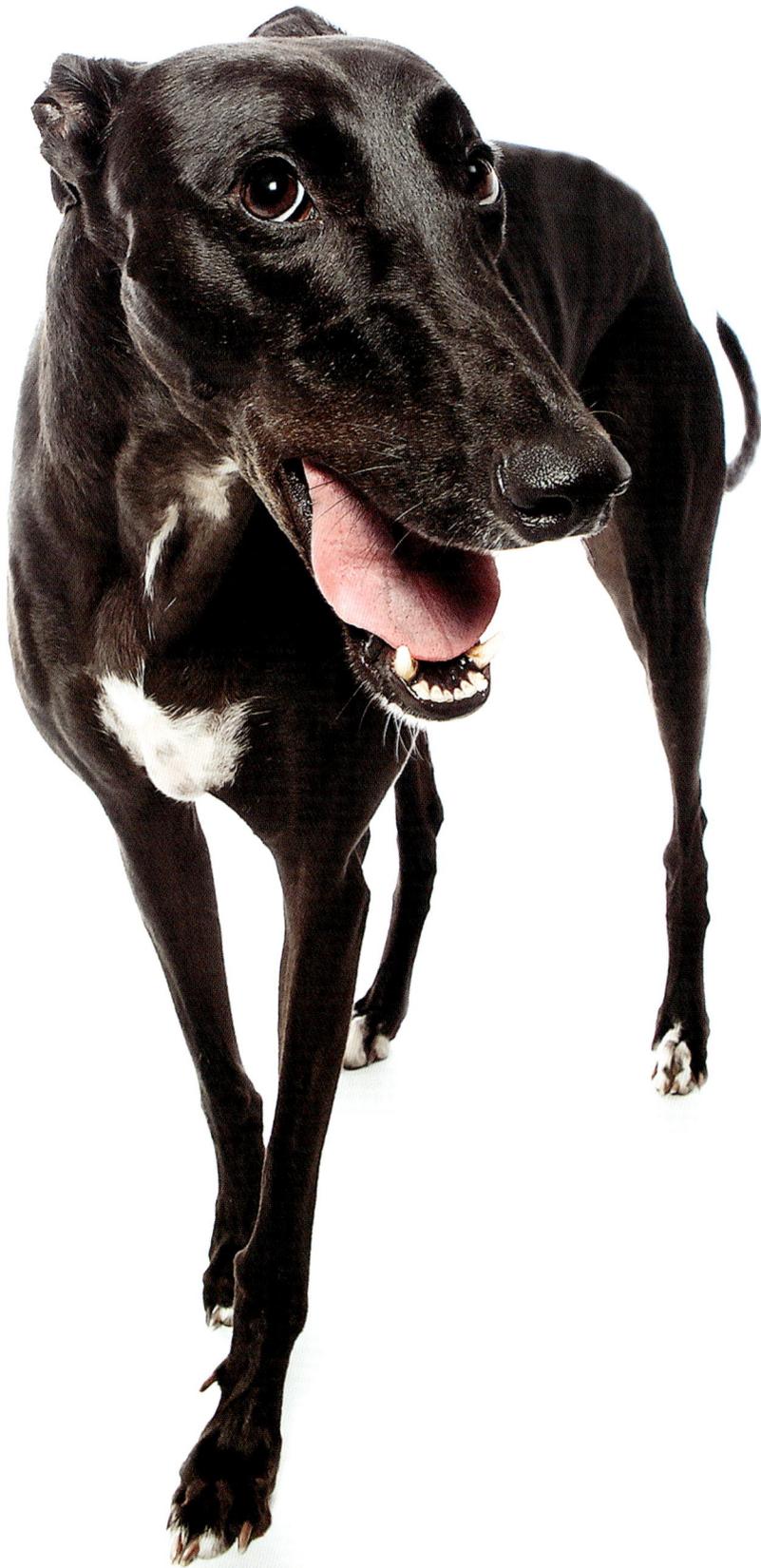

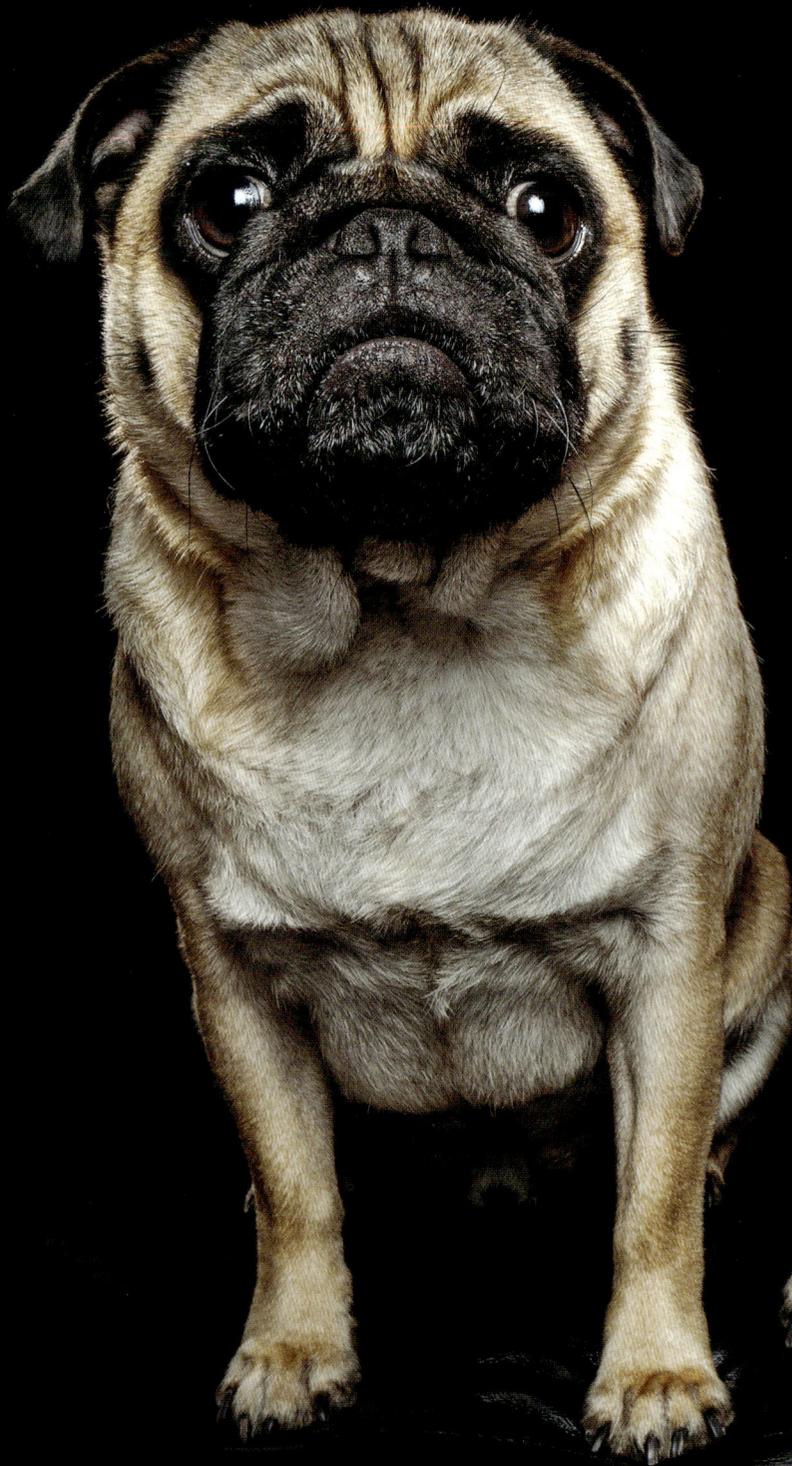

To our fur-ever loved babies, Smash and Ned,

Quite simply, you are the light and loves of Mummy's and Daddy's lives. It didn't seem to matter that we couldn't have human babies because it meant we met you.

You are true brothers from the same litter but are more than that, you are best friends — an amazing bonded duo yet so totally individual.

Our handsome Smashy, your name was picked even before you were born. You darling, are one in a million. An independent boy but one who loves his 'moochies' and a little clown that fluffs the cushions to make yourself comfy. We could watch you play for hours thrashing your favourite Happy Kissmas toy and watch the happy wag of your limp banana tail all day long. Your loving eyes get us every time.

Ned Kelly, our 'little squidy', the introvert and lap pug of the house. You are always never far from our side nor far from our ears at sleep time. There is something so soothing about falling asleep to your puggy snore. Mummy and Daddy love nothing more than the 'Neddy Lean' and the sight of our little 'bug eyed Bill'. You always give big love.

Seeing the two of you with rested chins on each other's backs is just heart warming. There is no doubt we did the right thing having you with us together.

Our hearts burst with love each and every day for our boys and you have truly enriched our lives and left puggy paw prints on our hearts forever.

Love always

Mummy and Daddy

Dear Cyril,

You are 'one of a kind'.

I remember when I first saw you as a mature dog I thought – why would someone call a dog 'Cyril', and I was determined that when you were mine that was going to be the first change – a new, more appropriate name.

When I brought you back to Brisbane with me and you settled in, your uniqueness became apparent. You have this wonderful large head and short, muscular body and the most beautiful eye colour. I remember the first few times I watched you eat your food – when you lowered your head to the plate, your back legs raised off the ground. It was hilarious; the size of your head actually made you top heavy.

You are well behaved too. You came, instantly when called (which for a Frenchie is unusual in itself) and you are kind and loving. You win over every visitor and wait patiently after pushing your head through their legs for your pats and head rubs.

You have a high-pitched whine when you want attention (which is not a very masculine trait) and you just love people. You are always happy, do everything that I ask of you and you make everybody smile.

You have performed your duty well and have produced some of the most beautiful-looking and kind-hearted puppies and because of this, you have made a lot of very nice people very happy.

Your extraordinary good looks, which you pass on to your progeny, has helped win Ken a gold medal and the title, Pet Photographer of the Year 2016.

You continue to amaze me – and now over three years later I would never think of changing your name from something as unique as Cyril.

ooxx

Our darling Indigo,

You came into our lives when you were four years old. Little did we know how different life was about to become!

You wore a tag on your collar engraved with the name 'Lucky' – but it turns out we were the lucky ones. Having adopted you sight unseen, we wondered what we were getting ourselves in for when we met you for the first time at the airport. You bolted out of your crate and took off like a shot out of the freight terminal. You had no idea who we were but thankfully we came prepared that day – one sniff of the liver treats in our pockets and our friendship was forged.

From that moment, we won your trust and you won our hearts. You have been part of our family ever since. You really are a little human wearing a Labrador's fur coat. You give love unconditionally and can always be counted on to give your 'sup-pawt'. One look into your big brown eyes and all the troubles of the world melt away.

Your favourite things are spending time with your humans going on walks and visiting Grandma and Grandad at the coast to swim and body surf and then roll in the sand afterwards. There have been many times we thought that you should change your name to Sandy!

The arrival of your adopted 'brother' Murphy, the black moggy, three years ago seemed to have your snout out of joint at first but it turns out living with Murphy has its advantages, as you have been known to sneakily steal his food when no one is looking.

You may be moving into your senior years but to us you are ageless. You still love to chase the ball, eat treats, wag your tail and give your unconditional love and support to us. You are one in a million and will forever hold a special place in our hearts. We look forward to spending many more happy years together as a family. We are so lucky to have you! We love you sooooo much (Lick!! = Kiss)

Love always

Mummy and Daddy, aka Jo and Chris

xoxoxoxox

Our fur-ever loved letter to Schnitzel,

Loyal, cuddly, compact and sweet

There must be royalty in your veins as you are so regal in all that you do. Be it perched on top of pillows while watching TV or while you lounge gracefully on a poolside sun lounger. So why wouldn't our little princess drink her cuppa tea from my grandmother's finest bone china cups?

You have the natural ability to melt our hearts, just by seeing your sad face at the gate. Those pleading brown shining eyes saying it all. 'Please, pleeease can I come too? I will be good I promise.'. What can we do? 'OK come on then, get in the car.'

A cuddle pup, is what you are. Reversing your bottom into the slightest gap between us is your forte. The tighter the spot, the happier you are. Even in bed you like to stick to us like Velcro, moulding your long body into ours, elongating your neck on our pillows. It's the most amazing warm safe feeling with you next to us.

We love our perfect dog Schnitzel.

Our fur-ever loved letter to Parmigiana,

Massage hound, overly enthusiastic greeter and dedicated fly catcher.

You are a master at manoeuvring yourself into a position to receive a belly rub, ear stroke, leg pull, toe squeeze, chest nudge or even a tail tweak. You fall blissfully into a trance, eyes blinking slowly at first then gently close your eyes, head soft, body floppy, you totally relaxed — more than any meditation session I have ever done. Sometimes you are a stealth massage hound, sneaking into your position before the masseuse even knows what's happening.

You greet us so enthusiastically with the loudest excitable screams and yips like you haven't seen us in years. 'I missed you soooo much' interpreted through licks, wags, circle work and happy moans waiting for a cuddle. You make us feel like royalty. Stop! Is that a fly?

We love our massage hound, Parmi.

xxoo

To my sparkly brown-eyed girl (21.09.05-03.06.16),

I miss you every minute of every day. I'll love you forever and never forget you.

Our souls collided on 6 March 2005. You were eight weeks old and a little bundle of brown fluff. You were always a character and you made me laugh every single day. From the word go, we were a team. Inseparable. Where I went, you went and where you went, I went.

Then you became paralysed from IVDD (intraveterbral disc disease) in October 2010. Within an hour of getting your wheels, you were off and running.

You inspired me with your courage and your unflinching 'never say die' attitude. No matter what, you never gave up. Who needs four legs, when two work quite well.

I believe that you arrived in my life for a purpose. My outlook changed, my career changed, my vision changed, all under your watch. You were a small girl with a massive impact.

Heads turned when you rolled by. You brought a smile to complete strangers every day.

The beach was our happy place — digging holes, running in the waves on the edge of the water and watching the sunrise most mornings.

I miss the sand in my car, the smell of your fur, the happy wiggle when we sang songs together.

There is now a much brighter star in the sky at night. Miss you my girl.

Jude

To dearest Skye,

The day I picked you out as a tiny, fluffy, cheeky six-week-old cattle dog puppy pulling at my shoelaces, I couldn't possibly have imagined how you would change my life and fill my heart with so much love I thought it might burst.

Words cannot do justice to the amount of love, fun, entertainment, companionship and joy you have brought to me (and all who met you) over nearly 16 wonderful years. You don't know how many times I watched you dreaming, your little feet twitching and cute little barks escaping your furry little mouth. How many hours of my life were spent watching you and our gorgeous kitty, Sampson, rumbling like, well, cat and dog. Despite you being three times bigger than him, you were never too rough and he could always count on you to stand up for him outside if any other cats were picking on him.

There were so many reasons to love you. I loved that you were gentle with old people and little kids, that you were always eager and ready to go at a moment's notice and that you were the most easy going girl. You never batted an eyelid, no matter how many stray dogs I brought home. In fact, you would welcome them by running around and playing with them. You were fast, really fast. No one could run as fast as you chasing your favourite frisbee. Have I mentioned smart? I always knew cattle dogs were smart but you were amazing. Picking up on the slightest clues, you often knew what I was going to do even before I knew.

Skye, my beautiful sweet doggie, you were the best furry friend a girl could ever have asked for. The world is a much brighter place, having had you in it. As Winnie the Pooh said, 'How lucky I am to have something that makes saying goodbye so hard.'

xxooxx

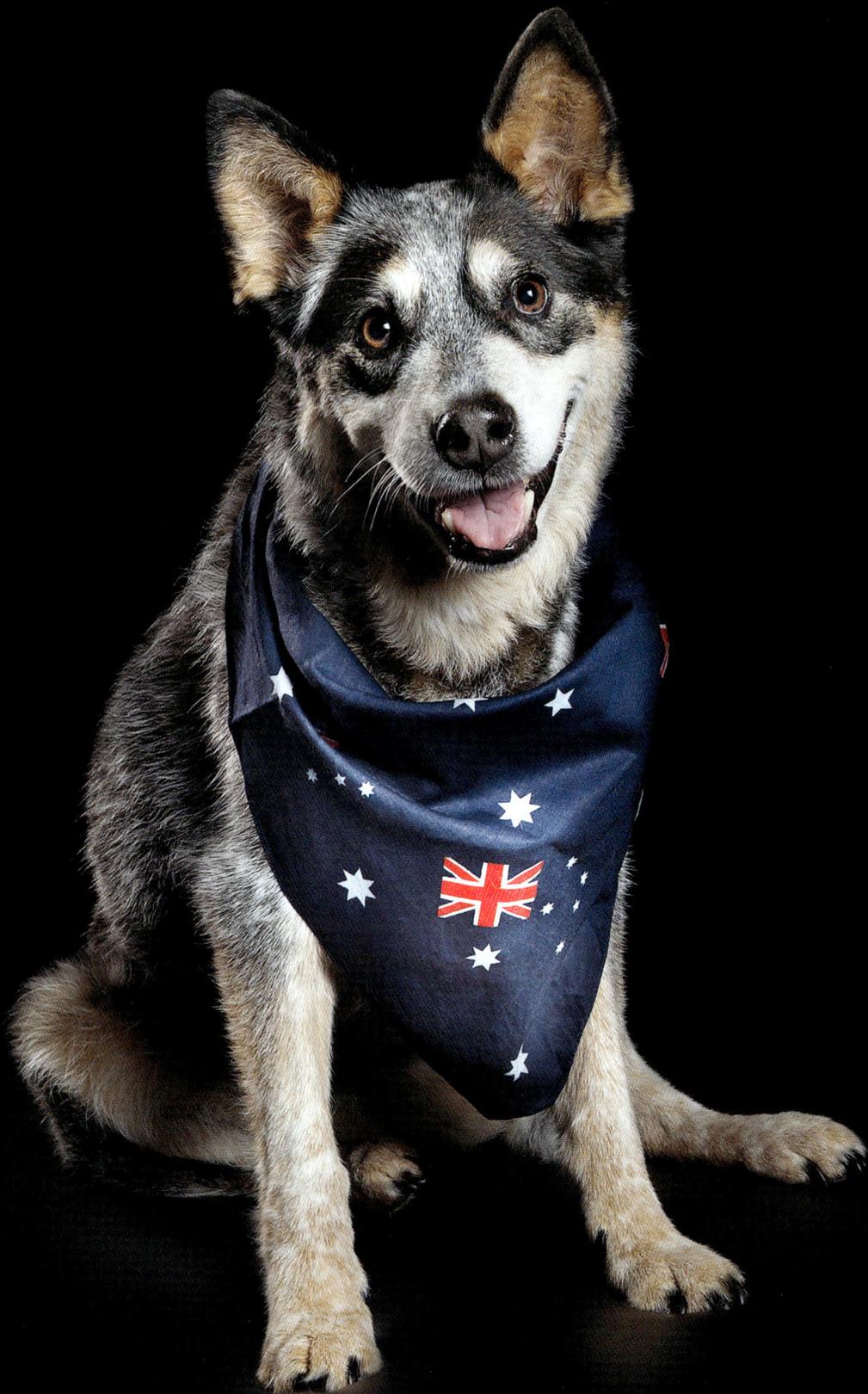

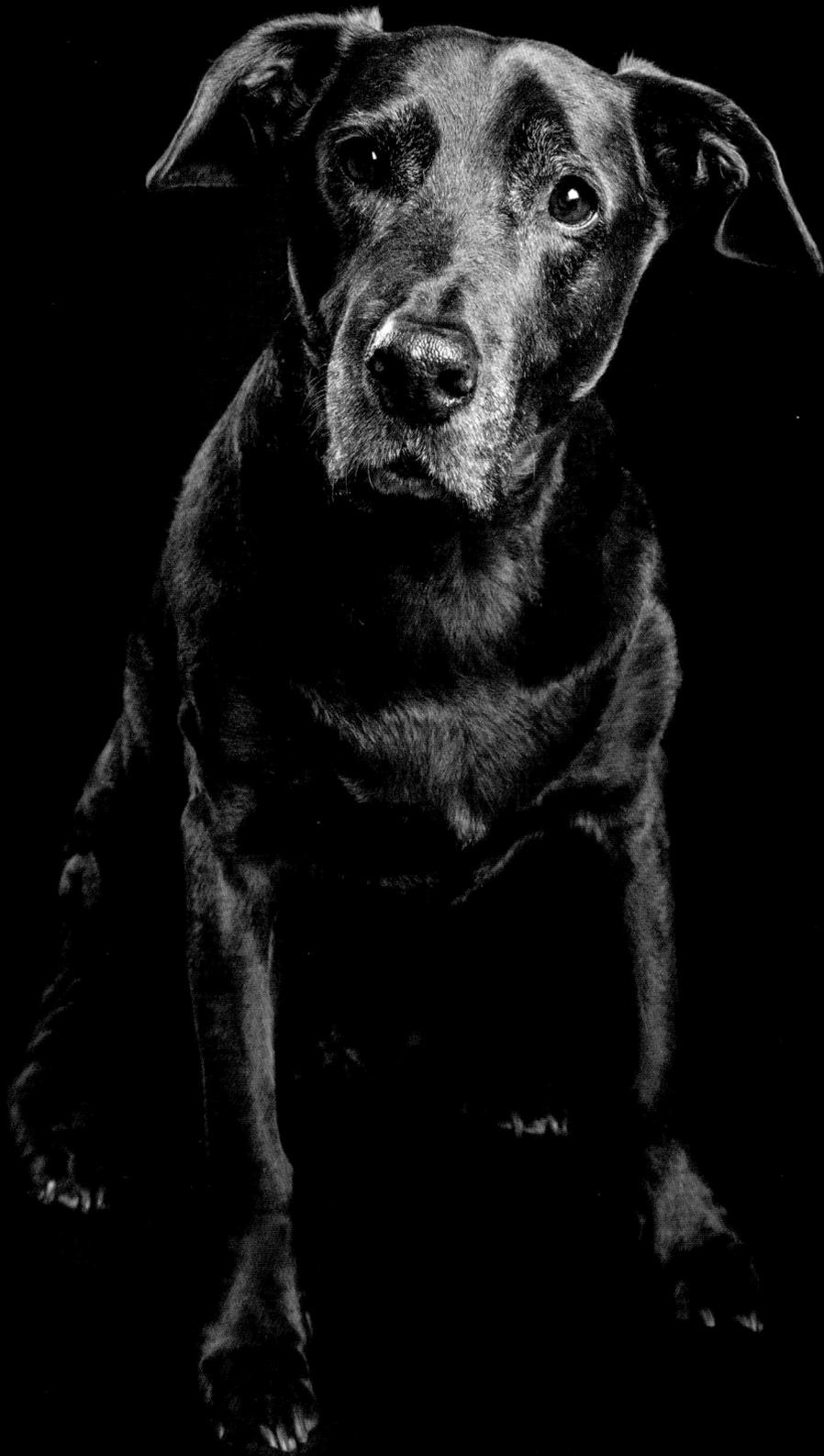

My beautiful Bro',

How totally blessed am I to have shared fifteen years with such a soulful, loving companion.

I have learnt so much about dogs in sharing my life with you, but have learnt so much more about myself.

I have learnt that I can love so deeply, that your happiness is my happiness. Your sadness is my sadness. Your pain is my pain.

As your candlewick burns shorter, I have learnt to slow down and take five more minutes in bed to enjoy lying beside you, just watching you sleep and listening to you breathe. You no longer bounce out of the way or turn quickly, and my pace has slowed to give you the time you need navigate the world these days.

Through all your life, and especially now, I have learnt to put your needs before all else. The other end of the rainbow is much the same as the start. My days and nights are planned around caring for you, and I would gladly trade any freedom this costs for more days and nights with you.

It is hard to watch your body grow tired, and to see you struggle with things that were once so easy for you. The loss of your lifelong companion last year took its toll on both of us, but especially you, my dear friend. Your grief paled mine, and I learnt that true love is not an emotion that only humans feel.

And when your last flame flickers and ceases to glow, I know I will wish for one more day with you.

How lucky am I to know this now, so that I can take the time to cherish our moments together, knowing that of all things I will feel, regret will not be one of them.

Thank you for sharing your life with me, my teacher, my soul dog, my friend.

xo

Letter to Tazer, The Boss,

To my beautiful girl, the most intelligent, tolerant and courageous German Shepherd I had the honour to know and hold as an integral part of my family. Your strength to protect us from pending danger and your compassion to sooth a strenuous day was immeasurable.

You made sure you shared your love with each family member. We had so many cherished moments whether with a gentle head rest or our morning hug routine with your usual song and dance.

You were my shadow, you had my back, always alert and on watch. Even to this day our local courier drivers no longer come to our door but rather toot their horn at the bottom of the driveway to inform us we have a parcel.

You played a special role in the rehabilitation of other German shepherds and I would not have been able to do this work without you by my side. Your mere presence brought much comfort to myself, my family and the other dogs we had entrusted into our temporary care.

You gave love, loyalty and devotion to all you encountered but it had to be on your terms. Your ability to calmly control any situation and take charge in any environment was just purely impressive. Sadly, you were taken away too soon after only five short years but I will treasure those years for the rest of my days.

Tears are the words I cannot use to express how much I miss you. I will hold you in my heart, until my end.

Justyn (Second in Charge)

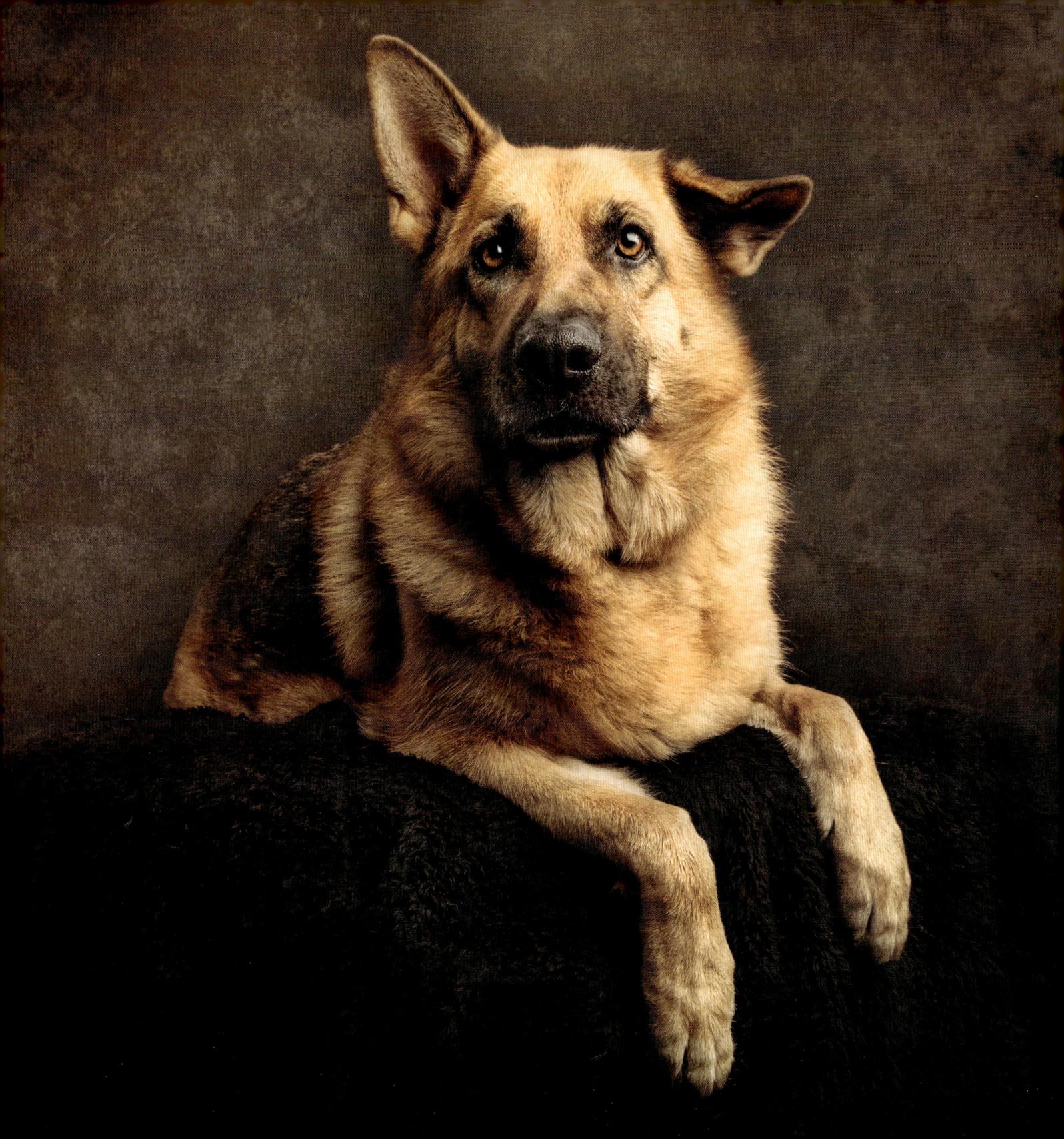

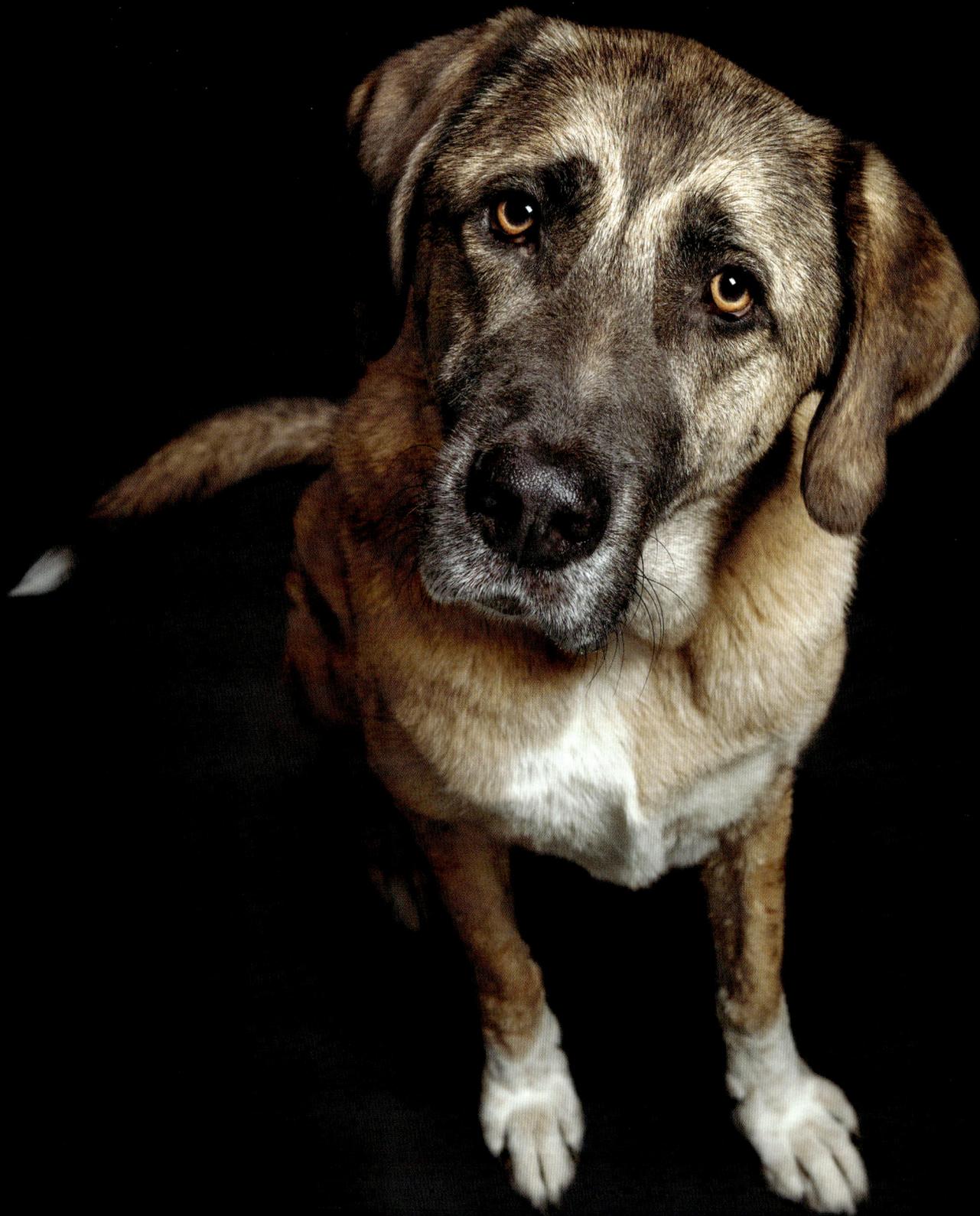

To my darling girl, Tash,

As I sit here with bittersweet tears streaming down my face, you're sleeping on your favourite lounge chair. Your white-grey muzzle is twitching while you snore, your tired legs are kicking out as you dream of the days when you ran and played with ease.

You don't know this my darling girl, but when you're sleeping I take comfort in listening to you snore, you sound a lot like a warthog, but I know you're comfortable, so I leave you be.

Do you remember the times we took you to the beach, my darling? You'd eat our lunch and frolic in the water without a care in the world. You loved the car, you'd take up the entire back seat and leave wet nose prints all over the glass, but we knew you were happy – you told us with your eyes.

I will never forget when I met you, my darling girl. You looked at me from your cage and my heart broke. Who could have ever put you there? I'll never forget the way you led me to the car even though you'd never been in it. You knew you were coming home with me, you were my girl and I was your human.

I think about our time together often, you were a mature girl when I brought you home and you're twelve now. I know it's tough on you, I can see it in your eyes that you're tired.

You'll never know how many times I wish that you could speak to me, so that you could tell me if you are comfortable, so that I could know that you feel safe or if there is something you needed from me.

I want you to know that, above all else, you were and still are so loved.

Your best friend forever

K

To my dear Sargey boy,

I knew from the day I picked you that you would steal my heart. Not only did you steal my heart but you stole my dresses, underwear, shoes, thongs, lipsticks and basically anything you could wrap your mouth around that was mine.

I will never forget the day I came home to find my bed had been chewed five layers deep just two days before I was due to load it onto a truck for our new life up north and all you could do was smile at me showing all your teeth.

You are the most stunning black beast and I am so proud to call you mine. Watching you with Alaya just melts my heart, attending to her every cry and smothering her with your big kisses.

You have eyes that will make anyone fall in love and, despite what most people would think of your breed, all you really want to do is cuddle up under the blankets for hours on end.

I have watched you usher children away from the deeper waters at the beach and use your body to push children away from the road when the parents were not paying attention; you have a beautiful sense to when a child is in danger.

Sarge, you have a way of making me feel like the most protected woman who ever walked. You fill my life with so much love and happiness. One day you will no longer walk this earth with me however your paw prints will forever live on in my heart.

Thank you Sarge for teaching me about life, love and patience.

Love you now and forever, my boy.

Love always

Mum

Dear Issy and Alf, aka The Goons,

It's your humans here. We just wanted to tell you how very much we love you and that we wouldn't be without you for anything on earth.

When we began to write this letter, Dad (yes, we do say that in this house) and I started to reflect on the years we have been blessed to have you, and got to pondering that while we wouldn't be without our beloved Goons, we are without a few other things because naturally, you always have and always will come first. Here's just a few of those things.

A new roof — disappeared when you needed hip surgery, Issy.

A new car — disappeared when you needed paw surgery, Alf.

A new deck — disappeared when you needed knee surgery, Issy.

A new gate — disappeared when you had your 50th ear infection, Alf.

A new 'kennel' for us all — that went on the back burner when you got cancer, Issy.

On the plus side, you have certainly helped us meet the neighbours — especially the one who likes to give us advice about dogs 'in the wild'.

I never have the heart to tell him the closest you two have been to the wild, is when you had to stand on the nature strip for an hour because the other neighbours set their house on fire. No roughing it for these Shar Pei, thanks.

When your dad had a terrible accident, you two kept him going, nursed him when I had to go back to work, dragged him out of bed every day and generally gave him a reason to keep putting one foot in front of the other.

The lost roof, car, deck, gate and kennel are mere possessions, whereas you two are our hairy-legged lifesavers, total clowns, master entertainers and the very centre of our universe.

Love and noseboofs

Mum and Dad

Dear Rory,

Your story with me started with a call from Dr Tim, your favourite vet, and his fateful words: 'I've got a puppy who's had surgery and needs a foster home with a yard.'

I decided to go and meet you to see how we would get along. As I sat on the floor of the vet's and let you introduce yourself, your backstory was revealed.

Being a Shar Pei puppy, you had rolls and rolls of skin to spare. You had so much that skin was covering your eyes and they became infected. Which is why the breeders brought you in – at just five weeks of age – and asked Dr Tim to put you to sleep.

Fortunately he didn't, and instead convinced them to surrender you. He then conducted some 'cosmetic surgery', where you got an eyebrow lift and a chunk of skin taken from the top of your head.

When I met you several days later, you had a string of stitches around your ears and across your forehead, plus the little one in your eyebrow. You were gorgeous and seemed totally unaffected by all you'd been through.

My heartstrings were pulled so I took you home so that you would have the opportunity to be a puppy and run around in a yard.

When I took you back a week later, Dr Tim was 'coincidentally' away. By the time I saw him, you'd been living with me for a couple of weeks and I'd fallen in love. When he said you didn't have a home, and it'd be great if I wanted to keep you, your fate was sealed.

As you grew, you lost your rolls but developed a depth of character that's unrivalled. I gave you a fur-ever home, but you've given me so much love that I think I'm in your debt.

Thank you so much Rory.

Love always

Mum (Kelly)

My dearingest, darlingest Bollo,

Every once in a while, life puts somebody exceptional in your path – you are a fine example of one of the few exceptional 'people' I have met. To think that once upon a time someone threw you away, left you to whatever, chained in an abandoned yard. Thanks to the RSPCA you survived, well most of you, because I do feel that a part of you died in that yard, and the Bollo that's left is not the dog that could have been.

But the dog that's grown from the skinny big headed doofus we took home that day is a dog that's thoughtful, loving, empathetic, smart, forever hungry, but most of all, caring. You care for the pugs, however hard they bite your bum. You care for the cats, however hard they try to ignore you. You care for our families, our friends, our guests; anyone who is loved and welcomed by us, is loved and welcomed by you.

You are gentle with the frail and the young, boisterous when it's time to play, cuddly whenever you get the chance, and forever hungry in case you have to go so long without food again.

When we first met you, you were scared of your own shadow. You wet yourself at loud noises, you shook at raised voices (whether on TV or in real life) and you hated loud music. We taught you to play, to swim, to go camping, to bounce in the creeks and to savour a pig's ear, and to trust that tomorrow we would still love you, that you would still have a home and family and safety and security. And dinner.

But you taught me so much more! You taught me about patience, about empathy, about kindness, about dogs, about being non-human, about being nonjudgmental. You taught me to be a better person, and I wouldn't be who I am today, as a person or as a photographer, without having known you.

You are a fine ambassador for the kindness, nobility and wonder of Dog. And for friendship, mateship, love and respect in any animal, you prove that these aren't just human qualities.

I will love you until the final breath, and I know you will love me too.

Furever loved xx

Beloved Clarry,

It's been three years almost to the day, my old mate, since our final adieu. Gosh, how I have missed your sweetness. Like really, really missed. As in still cry tears when I think of you. Not the ladylike, polite cry, but the red-eyed, snot-nosed ugly cry. Why can't I cry like a movie star? I thought we had an agreement that you would live until you were 150 years old?

But what a grand fifteen-year journey together. The miles we walked – must have been hundreds of them. The companionship we shared – me talking, and you quietly listening and sneaking in a cheeky lick when you thought you could. Speaking of which, if we could just talk about your doggy breath for a sec. Loved and adored, but dude, you did not have the ring of confidence. I feel I can say that now, without hurting your feelings because everything else about you was perfection.

Do you remember the day you came into my life? I do. Such a tiny little scruff, contendedly chewing on a toy, serenely observing your mad siblings. One look into those gentle eyes, and I was a smitten kitten. You were such a comfort and joy to me throughout the trials of life, giving me much, and expecting little in return.

One in a million, my friend. I found you and you found me. I will see you again. It was never 'farewell', just 'see you in a bit'. I hope you enjoyed the chicken nuggets in your final moments. I hope you know how much you are missed. I hope you know how much you are loved.

Until then, my beloved Clarry. Get the party started, and the bubbles ready.

Forever

Kerri

P.S. Sorry about Miss Sugar. I thought it would be nice for you to have a girlfriend. Bad call – you were right

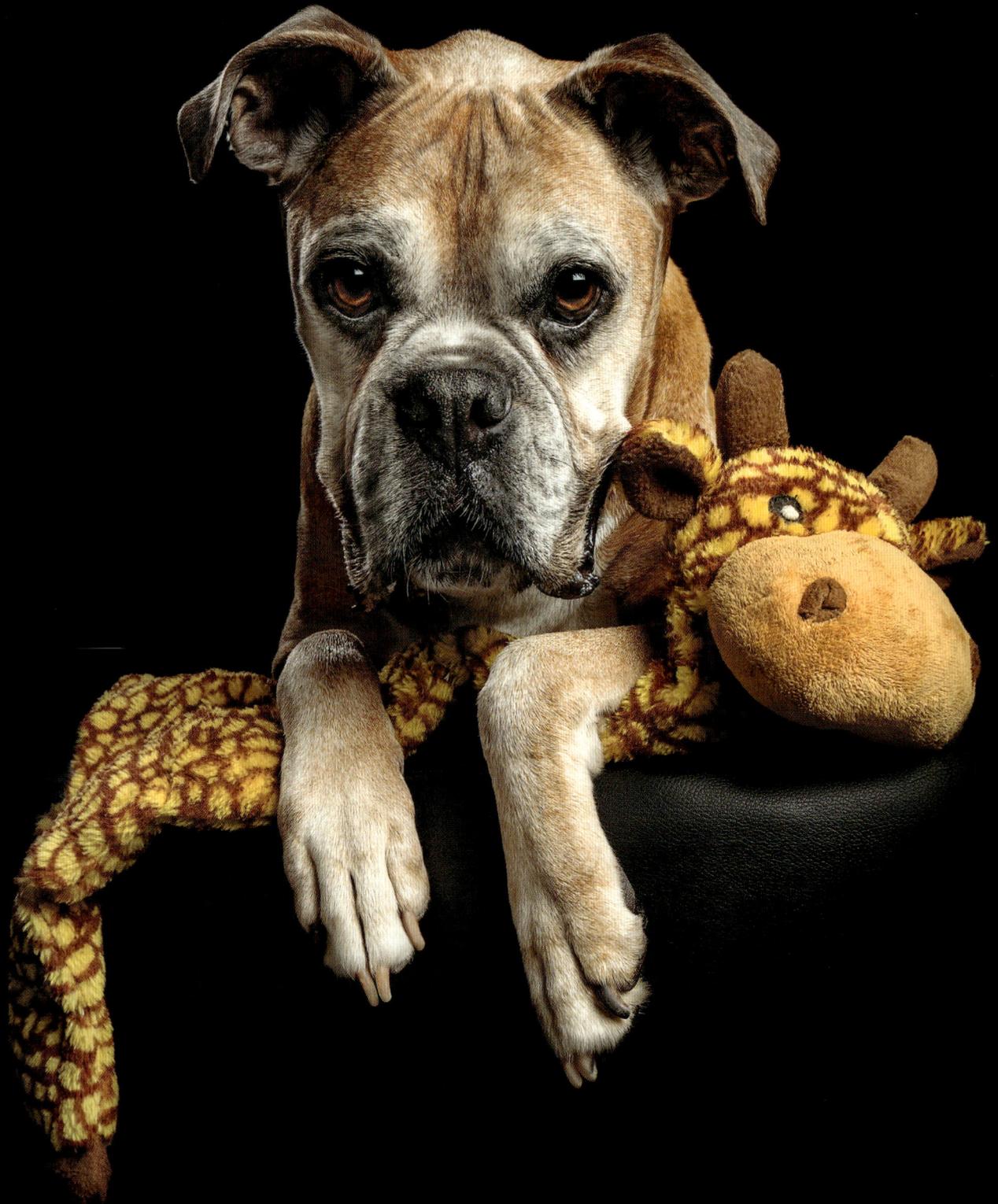

To our beautiful baby boy,

We miss the way you race to our side, huge smile on your face, jumping with joy when we arrive home.

We miss sharing our bed with you, your body keeping our feet warm, and the 'in your face' early morning boxer kisses

We miss the persistent huff, huff, huffing you used to subtly alert us it's time for a walk.

We miss your forever abandoned inhibition as all your faculties turn towards an encounter with a new friend.

We miss your pure passion for the destruction of cardboard boxes — Christmas will never be the same again.

We miss the smiles you put on the faces of others as we drive and your lips flap joyously in the breeze.

We miss the traces of you in our lives, those orange hairs, your footprints through the house and the cement-like concoction (drool plus sand) dotting our walls.

We miss the quirky moments only you could deliver — your faint howling at sirens, your race from the backyard bogey monster and your doggy talk.

We miss the 'no sleeping in, time is a 'wasting, let's get to the beach (and stay there forever)' holiday attitude.

We miss your shadowing our every move — the great apprentice chef, gardener, builder and couch potato.

We miss the noises you make — the conversations we had, the incessant squeak of your toys and your soft snores as you sleep.

We miss you, our best friend!

Dudley, you will forever live in our hearts.

Love and kisses

Mum and Dad

Dear Milo and Peaches,

You became part of my life at a time where I didn't think I was ready to open my heart to any other furry friends. I soon realised meeting you both when I did was meant to be and exactly what I needed to help me with Max crossing the rainbow bridge. You both had a rough start to life and needed saving too. So we all saved each other.

Milo I met you three days after Max left – you locked eyes with me and cried. From that moment you had stolen my heart. You were such a quiet shy boy when we got home. Little did I know you would flourish into a confident, happy, smiley boy, especially when you met your soon to be sister, Peaches.

Peachey when I met you at the RSPCA you weren't available for adoption but I took you for a walk and played with you. I fell in love that day but I knew Max wouldn't cope with another fur-legged friend at home. It was certainly meant to be when I found out on Milo's adoption day that you were also available for adoption.

The next day when the two of you met was heart-warming – how much you instantly bonded and brought out each other's personalities.

Today, more than six years on, you both give so much love, keep me fit and provide endless belly laughs.

If there were one thing I could ask of you, it would be to love your kitty sister, Rhubarb.

Lara

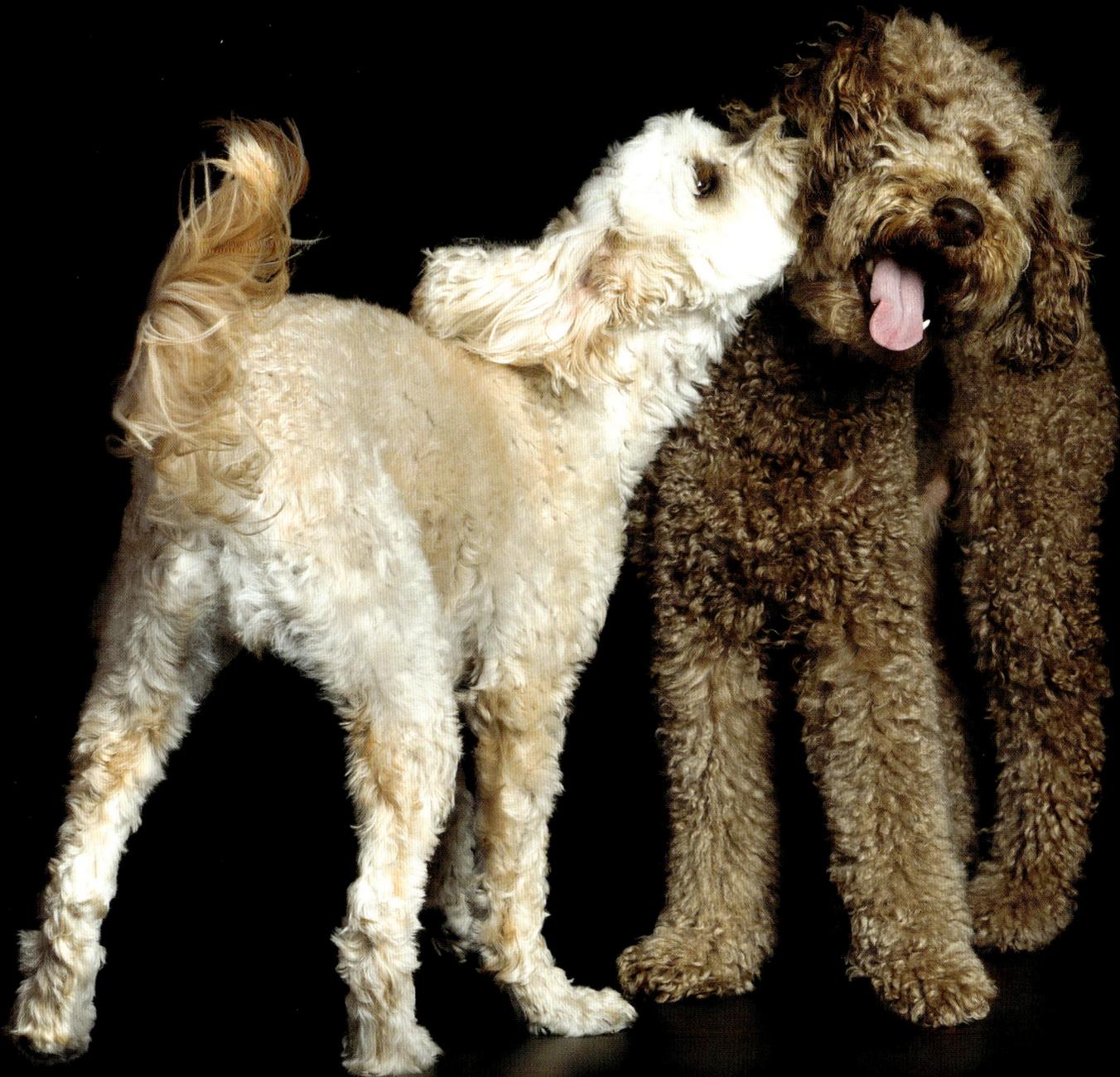

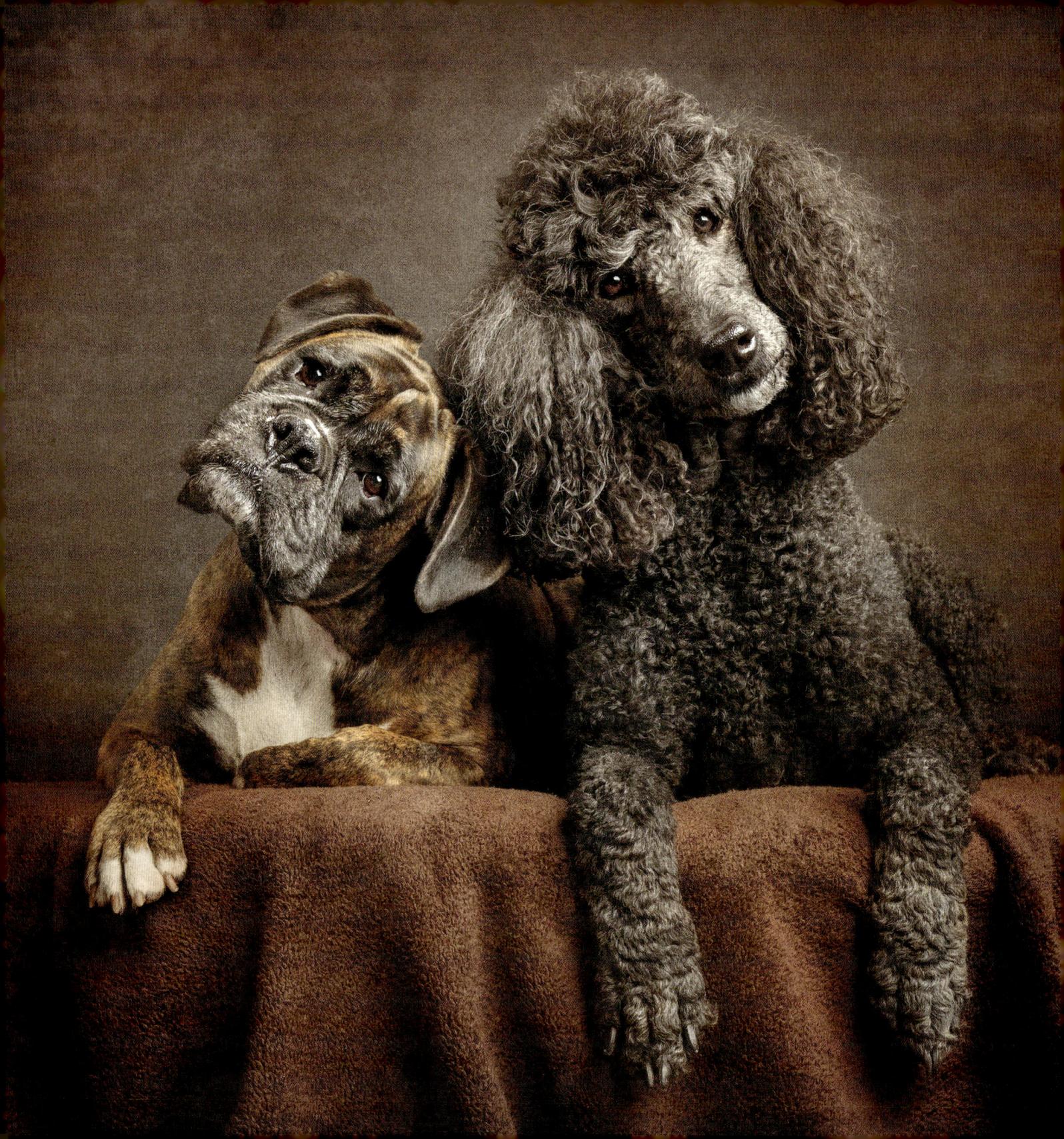

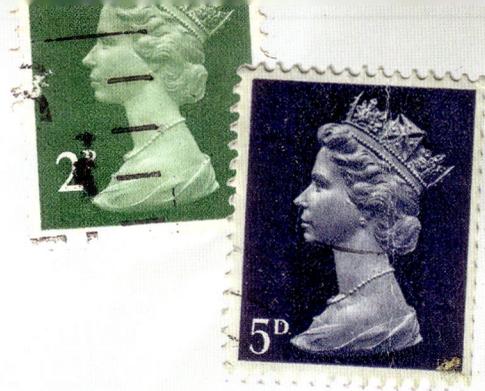

Dearest Mia and Coco,

When we first saw you, Mia at the farm, and Coco when you arrived by plane from interstate, we did not to know the joy you would bring. You have become our sunshine.

Mia, you are smart, sensible and reserved. You have grown from the five-month-old puppy used to sharing a kennel with other dogs, initially happy with a solitary approach, to one who now loves her creature comforts; the lounge, the cushions, cuddles with Dad after dinner, sleeping on the bed and of course, sleeping in on weekends.

You are so gentle with Coco; we love how you lick her face and nurture her. You have taught Coco manners and Coco has taught you to live in the moment and have fun.

Coco, when we met, you were eight weeks old and initially bound for another home, but fate intervened in our favour. You were so tiny, you couldn't even drink from a bucket. You are now much bigger with absolutely no size awareness. You sit on our heads, have no personal space, go to sleep on our feet and tickle our faces with your whiskers to wake us up. You are a 'pocket rocket', a clown; you are so funny, enthusiastic and loving. You can sit better than any dog we've ever met, thanks to Grandad.

You make us laugh every day. We are so blessed that kidney failure did not take you from us last year. When we think of you we think joi de vivre, the exuberant enjoyment of life.

At the dog park, Mia is the gazelle and Coco is the lioness. We love watching you race around enjoying the freedom of open space and delicious new smells.

You are wonderful sisters for each other, and together, we are family. We wish this could last forever.

You love each other, you love us, and we could not love you any more.

Love from Dom and Lara

xxxxxx

To the furriest pieces of my heart walking around, Nismo and Angel,

You guys make me feel like we're living our own Groundhog Day, every single day. No matter how my day has gone, I am guaranteed to receive the same welcome home — an over abundance of unbridled love and excitement with a healthy dose of leg sniffing from you, Nismo, and the classic 'I'm so excited I just can't hide it so I'll run around in a million circles' dance from you, Angel — every ... single ... time. You'd think after all these years I'd have learned how to deal with the onslaught of two powerful little nuggets, but no, I just brace myself and hope for the best.

I sometimes think about the life you may have had if someone else had become your family. We've had some truly testing moments, and I'm not sure if others would have kept their 'forever" promise to you. But it just confirms to me that you were always destined to be a part of our family, and I will be forever grateful for that.

Nismo, I love your soulful eyes; I could stare into them for days. I feel like they've experienced far more years than you've lived.

Angel, I love the way one ear always flops down and makes you look like butter wouldn't melt in your mouth (not that it would ever have time to, Miss Speedy Eater). It reflects your eternally youthful personality perfectly.

Nismo and Angel, you are the best partners in crime for our family. You constantly top your human brothers' best friend list, and you complete the love in all of our hearts. You won't always be here (I'm still in denial about that) but you have changed my life forever. We all love you so very, very much.

Love you puppies

Mummy

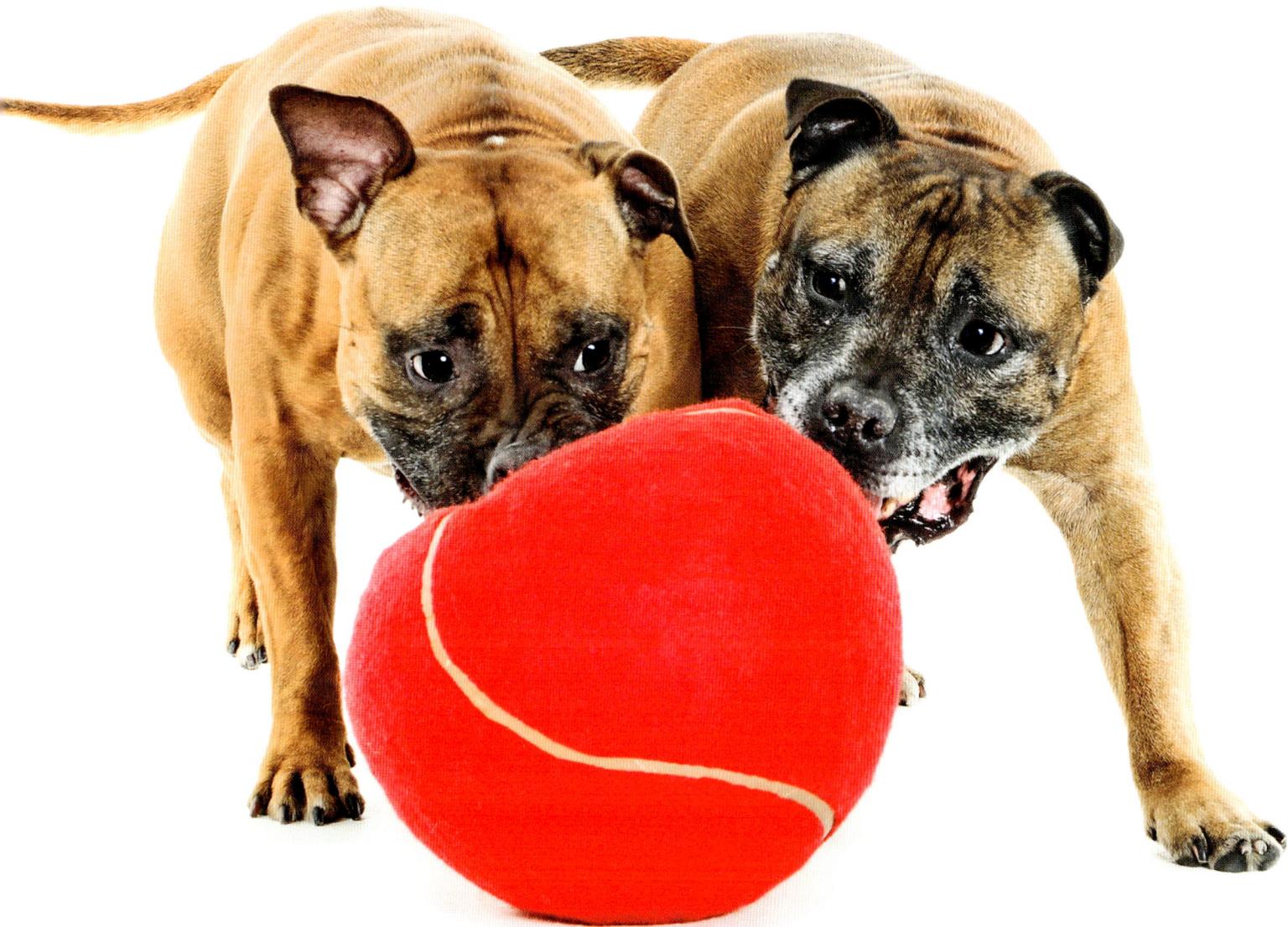

Katniss,

My darling you came into my life when I was grieving for my Brittany – she crossed the rainbow bridge in January 2014. We had seventeen years of growing up together. But it was time to see if I could love again and after many disappointments, I found you the runt of six puppies. I saw you when you were five days old. You were put into my hands and I was told this is the runt girl. I just looked at the tiny precious handful that pulled at my heartstrings and that was it – I was in love again. I didn't even look at your litter mates.

I saw you every week, watched you get bigger and stronger and then the call came early – I could bring you home. You were six and a half weeks old I didn't know what to do with you as you were so very tiny weighing only 850 grams. But your aunty knew that all you needed to be big and strong was the 'red stuff' (steak) and you grew into a strong healthy girl, even though I wanted a pretty girly girl to wear a pretty dress just like Brittany., Instead, I got a very cheeky independent and very bossy girl that said 'I hate girly things' – my tomboy had arrived.

I love you so very much my sweetheart girl and even though Brittany and I grew up together, you and I will grow old together. I can't wait to see what the years hold as you're my constant companion, my best friend, the heartbeat at my feet. A girl who is 'ruff and tuff' and so very funny as you have the best bark/howl I have ever heard. You are my Katniss, my girl on fire, the cuteness will be ever in your favour no matter if you are six days old, six weeks old or six years old.

I will love you forever

Mummy

Severus,

You were the biggest surprise. I had no idea you were waiting for me that day in November 2008. I came home from work and you were that thing in aunty's bathroom. Your aunty plopped you into my arms and said, 'Merry Christmas'. Aunty got you because I was sad as I had lost my three Chihuahuas – one every six months – and she thought I needed a new fella. I called you Severus as it looked like you were wearing a black mask. As you got older, your mask came off and my sexy white face boy was underneath.

You kept me on my toes early on with trips to the vet with different accidents because you were such a silly, strong, OCD (yes, obsessive compulsive disorder) naughty pup, the worst being the 'jogger' incident. You were playing with my jogger and somehow the shoelace caught around the top of your mouth and you yelped. That meant a trip to the vet that morning, but all it needed was a snip of the shoelace to release you and you were fine

In January 2014 we were all very sad as our Brittany crossed the rainbow bridge; you lost your pack leader and your aunty lost her best friend.

So you kept your eye on aunty while I was working and you became her nurse, the two of you became inseparable. On the 1 July 2014 Aunty brought home Katniss, a little fluff ball and we were worried you would hurt her, or bite her but you were a true gentleman and even though she stole your toys, you were a good boy and played with her, all 850 grams. I was very proud of you as you took Katniss under your paw and showed her the ropes but now Aunty has a tomboy not a frilly lacy girl to dress up.

So my darling as your namesake said, I will love you always.

Mummy

To our beautiful Archie Bunker and Jinx Moo Moo,

This is a letter to express our love for our beautiful fur babies that we absolutely adore. The moment we met you both, it was love at first sight. We knew you would be a big part of our family but we couldn't have anticipated just how big.

Everyday it's so hard to leave the house to go and be an adult when all we want to do is stay and play. There's not a day goes by your mum and I don't wake up with smiles on our faces because of what you both represent in our home – love, loyalty and above all, friendship.

From the enormous greeting we receive when arriving home to the sneaky loving smooches we get when least expected, our love for you both fills our hearts and warms our home. These feelings will never fade.

Archie, you are such a beautiful soul. Every part of you is bursting with love to share. You're the heaviest lapdog we know – you're a big boofhead with a ton of personality. You're our squishy face goofball.

Jinx, our little princess, our shadow. Your loyalty is amazing, always right by our sides. Not a lot of people get to see your sweet side but your mum and I know it's there. Call us crazy but we actually enjoy listening to your cute snoring. We melt when you look into our eyes with your floppy ears and your big smile. There's never a dull moment with you around – we always know to investigate when it's too quiet.

We love the mischievous personalities you both have and we wouldn't change that for the world. Your paw prints will be forever in our hearts.

We love you both more than words can describe, more than the stars in the sky and the water in the sea.

Love from your human mummy and daddy

Dear Jazz and Indy,

When you came into our lives we were heartbroken from the recent loss of our beautiful girl, Jessica, and the loss a few years earlier of our beautiful girl, Jemma. It was hard to imagine that we could possibly be able to feel again the love we had for our girls.

But that changed the moment we held you both in our arms. We knew then that we could love both of these little, defenceless, beautiful bundles of joy just as much as we had loved Jessica and Jemma.

From the moment you both arrived home we knew you were both so different. Indy, you have grown from that confident little puppy into a prim and proper poodle. Jazz, you have grown from that timid little puppy that would hide under our chairs at puppy pre-school to be lovable, but so mischievous.

Indy, you love your own space but you also love to cuddle. We love how you drag your bed around the house, even though there are beds in every room (we understand you need the 'right one'). We also love your obsession with tennis balls. You are so gorgeous walking around the house bouncing your tennis balls and catching them again, until we get the hint and throw the ball for you. We know you would love to keep chasing the ball even though our arms get tired or Jazz steals the ball from you.

Jazz, you want to be cuddled 24 hours a day. Then this mischievous streak comes out. You scared us to death by deciding to eat a rock and needing emergency surgery. And your 'no care' attitude when it comes to training has definitely given us lots of challenges but we love you just the way you are.

Jazz and Indy, you are such a huge part of our lives. We could not image life without you both.

Lisa and Darren

my dearest Goldie,

I lay on the floor at the vets with you and I think about how incredibly lucky I am to have you as my fur baby, best friend, most loyal friend — you coming into my life was meant to be.

I was supposed to get a Schnoodle pup, but my sister went to look at it and fell in love with the pup. Then I got a phone call to tell me there was a nearly four-year-old golden retriever that I could look at.

A few weeks later nanny and I went to see you. As I walked into the breeding kennel, I saw you on your bed in the corner and all your darling little puppies came running up to the gate. You raised your head and put it back down. I could have one of the puppies but when I went in to give your tired body a pat as you stood, I met your wagging tail and I was in love.

Goldie, one of the most lovely things you have given me is your sixth sense of my bipolar. I remember many dark times, tears and fear of the unknown, but your many licks, cuddles and those beautiful brown eyes always made me feel safe. It was a trying time for me over those years of instability but you were with me all the way and if anyone could make me smile, it was you.

There are many beautiful stories, funny stories, many about your wonderful ways but the best thing is your unconditional love that will never die.

Goldie, today I look into your eyes and know it will be for the last time. I know we both know this is the right thing to do. Happy 19th birthday for a couple of day's time. Miss Goldilocks, you wagged your tail when the vet came in to show your golden love, you gave them tears. I love you forever. Goodbye my golden girl.

xxoo

My darling Diesel,

As I sit here writing you this letter, you are looking down at me from your beautiful canvas portrait. I can see that you are ready and waiting to hear what Mummy has to say.

You, my baba, were the best thing that ever happened to me. Fifteen years of wonder and awe.

As a tiny five-week-old puppy you were destined to be raised as a vicious guard dog. I couldn't let that happen my boy as I needed you just as much as you needed me.

Mummy had been in a very dark place before you and I fell in love. You were my reason to get up each day. I couldn't ever let you down.

Remember when that big car ran over you as you napped behind the front wheel? Only eight weeks old with a broken hip and pelvis. Oh buddy, how scared we both were. But my brave boy, you recovered and prospered with Mummy always by your side.

I will never forget and always be grateful, my hero, for saving me before entering a diabetic-induced unconsciousness. You used every means possible to keep me awake until the ambulance arrived – sitting on my chest certainly helped your mission.

Deesy, I miss you. I miss your heart and soul. You made the sun rise for me everyday. Your cheeky and loving nature put a twinkle in my eye and a skip in my step.

I can just picture you sneaking all the cherry tomatoes off the vines when you were on a little diet. You always made me laugh, little boy. You became such an expert at opening presents and checking your Christmas stockings every morning. Christmas day with you was just a joy to behold.

Your love and dedication to me was such an honour, baba. You healed me and taught me how to love and trust again.

Keep smiling down on me, Deesy, because without that my heart will never heal and my sun will never shine.

We were destined to be.

Always and forever

Mummy

xxxxx

My darling Poppy, aka Dolly,

The day we picked you up at eight weeks of age, was just the beginning of our complete and utter devotion to each other.

You joined Penny and Bunny at our home to make a nice little pack of three.

Everyone who met you remarked on how gorgeous your face was. You had very prominent eyebrows which captured people's hearts.

You loved the beach and at low tide we would walk you and your sisters for hours .We moved to Narangba with you, Penny and Bunny in 2008. You all settled in down here very well and we found many other 'crazy pug people' in and around Brisbane. We enjoyed meeting up with all the other humans and their pugs.

As time moved on, sadly Penny and Bunny crossed over the rainbow bridge and you became the pack leader to Sophie (your twin sister), Puddin and Sadie.

You relished this role and little Sadie became your guardian and companion as you aged. You adored children and in particular, our grandchildren. You loved going for walks around the new neighbourhood with your sisters. Children always stopped to pat the pugs.

I enjoyed many hours of contented cuddles and selfies of Mumma and Dolly. You were nicknamed Dolly many years ago, as I referred to you as my baby doll. You lived and loved life to the full for eleven years and one week.

It was because we loved you so very much that we let you go to cross over the rainbow bridge.

You were in my arms, being kissed and told that we loved you as you went to sleep for the last time. We will never forget you.

All our love

Mumma and Daddy, Sophie, Puddin and Sadie. Xxxxx

R.I.P. Pendidi Pretty Poppet: 23 August 2005 to 30 August 2016

Darling Groova,

You epitomise the saying, 'You don't choose your fur baby, your fur baby chooses you.'

I'll never forget that day during my volunteering time with the RSPCA. At only seven weeks old, with your long eyebrows and goatee, you 'hid' in a corner apart from your eight siblings. Our eyes met with instant adoration and immediately I knew that you were mine.

My partner requested a week's 'thinking time'. It was the longest week of my life. But you waited for me; you were always to be mine!

I've never felt such overwhelming and immense love. We've endured so much together and you've always been there to lick my wounds, support me in every challenge, and display immense delight at every homecoming, even if I'm gone for only two minutes. Your howling and singing welcome never gets old.

You are a champion in so many ways; being a Delta Dog visiting the elderly in their homes, rising to advanced obedience, mastering agility, a specialist at rounding up the chooks, and champion 'ute air surfer' – goatee, brows, and ears flapping in the breeze, eyes shut with gratification.

However, my favourite part of the day is to have you sitting in my lap for cuddles, and your smile that says 'we're home'.

Now, fourteen and a half years on, in my eyes you are still that heartstring-yanking puppy. I hope you know how much I love you and truly understand what our time together has meant; you are the love of my life and every day you are with me is a gift. You have slowed down through arthritis, have a few lumps, and need more medication – I wish I could take away your pain.

You have taught me the gift of unconditional, true love and the meaning of forgiveness.

I know I have been given the greatest gift of all – the gift of you groovy Groova! You accept me for who I am and we have endured so much together. You protect me when I'm alone, sleeping near to ensure I'm safe, forever my soul mate.

Every day I wake up and ensure you are OK, grateful for another day to spend with you. I watch you sleeping in the sun and wonder how I will breathe when you finally cross the rainbow bridge?

When the time comes, a massive piece of my heart and soul will go with you, but in my heart you will always remain.

Lisa aka Mama

Important life lessons we have learned from you, our dogs, Gemma and Leela,

Everyday, watching you both makes our hearts melt; you are the best reasons to face the oncoming day and to greet each sunrise out walking with a smile. Then, with eyes part closed and sun-kissed fur, you have a satisfying morning nap against the fence in the sun.

Lesson 1: Take the time to feel the sun on your face.

Gemma, always so gentle and so kind, you have a deep affection in your eyes. Your tail wags your abundant love for us; it always wags at a furious pace. It seems the best things in your life are your mum and dad (that's us), closely followed by Leela and the cats.

Gemma always so patient, Leela couldn't have a better big sister to watch over her and to keep her out of trouble.

Lesson 2: Always clearly express how you feel – actions speak louder than words.

Leela, you charge at life, bursting with energy and passion. Your exuberance sometimes gets you into trouble but never for long, as you're soon off again searching for the next great adventure.

Lesson 3: Live in the moment and appreciate what is in front of you – because, like food in front of a labrador, it doesn't last long.

To our Labradors, always loving, always caring, never judging and always protective.

Lesson 4: Be kind and love unconditionally.

xx

Maya and Blaze,

You have both come into our lives at different times. You are both so special and we love you in such special ways. You each give us unconditional love and affection and put a smile on our faces with every swish of your tails and each 'woo woo' you do.

Sweet 'baby' Maya, you hold such a special place in my heart. You share your birthday with my dad's and no matter what, I will always believe that my dad sent you to find me. I knew the moment I first held you in my arms and cuddled you, you were ours! You were such a tiny puppy for a Mally girl. We called you 'mini Mally'. Ha ha! You are a stunning and affectionate bubby and your beautiful big doggy sister, Sable, would be proud of you.

Bubba Blaze, you certainly challenged us! Apart from learning to be patient, you taught us how to laugh again, how to be silly and smile at all the little things. Your gorgeous puppy dog eyes and that stunning 'squirrel tail' that is so fluffy, bushy and beautiful — Mumma loves so much. Your 'woo woos' are music to our ears. We love that sweet, adorable curled bundle at the foot of the bed that is you. The way you look up with your gorgeous big brown eyes melts my heart each and every time. I love everything that makes you, you — it's what I hold so dear to my heart. The way you trip over your own paws and we say, 'Oopsy Blazey' and the way you run around with your 'schwipper' that is the only toy you have never destroyed. Ha ha! Your tenacious zest for being mischievous, gentle, loving, caring, affectionate and your gorgeous silky soft fur is what makes you our precious Bubba Boopy Blazey Boy!

We love you both.

Mumma and Dadda

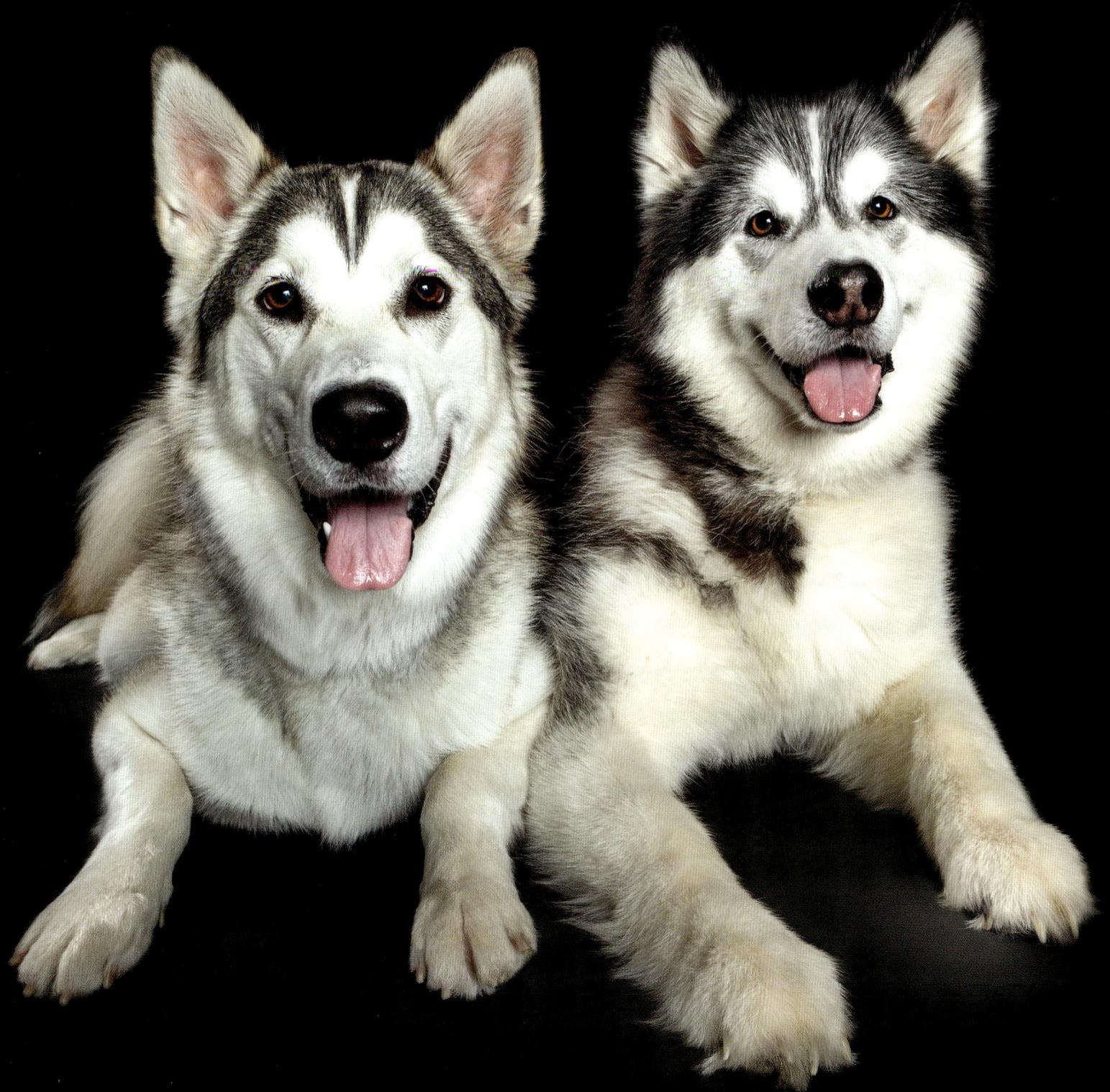

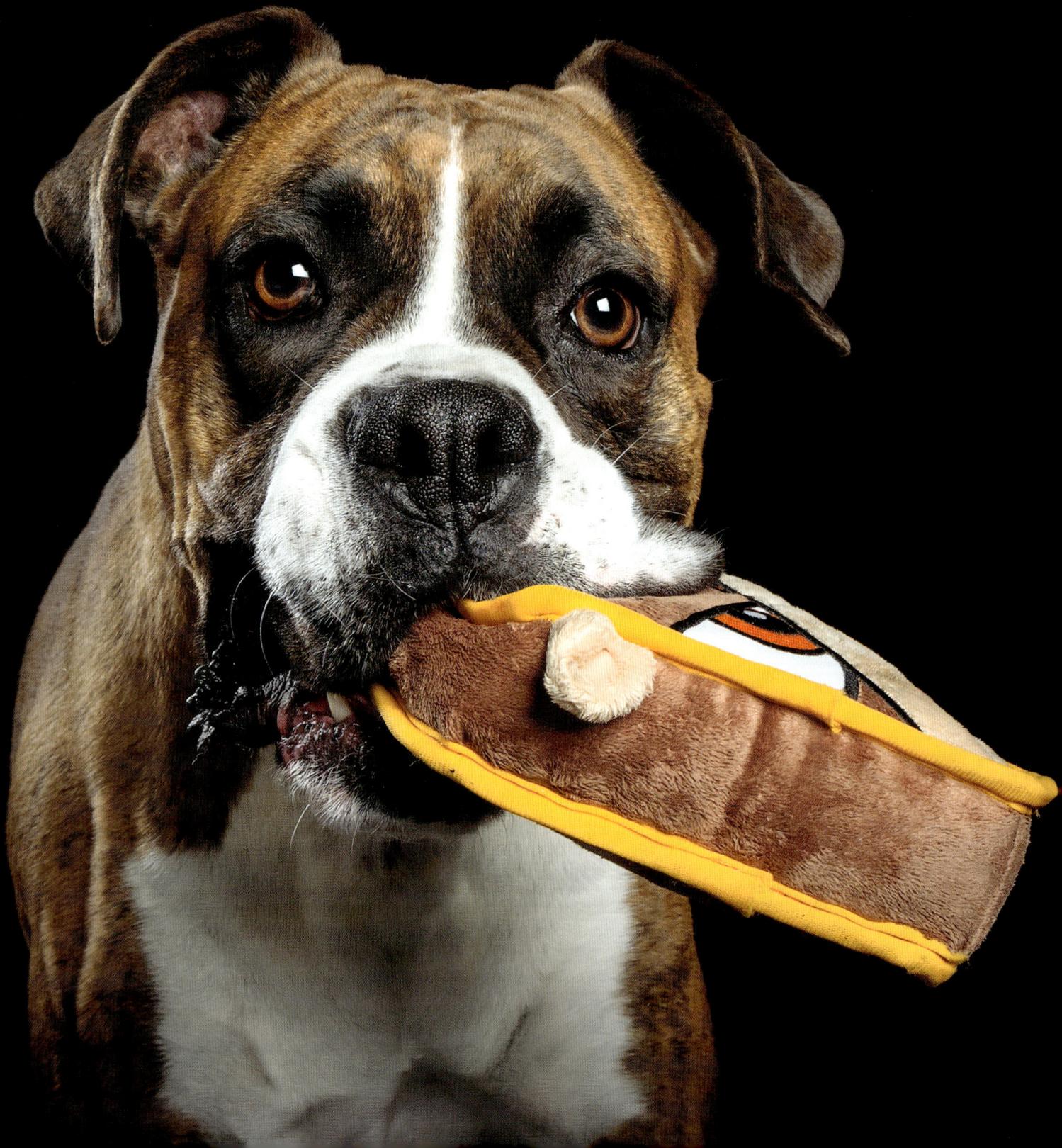

Dear Punchy,

I remember the first time I saw you from some photos I had sent to me, from your parents — you were so little. You had beautiful blue eyes and a cheeky look on your face. I knew from that moment we would meet each other very soon. After waiting a couple of weeks, you finally were ready to say goodbye to your mummy and daddy to start a new life with me.

In 2009 I drove to the airport and waited. I was so excited to meet you for the first time. You were so scared and little I just held you while you were shaking. I fell in love with you instantly. I knew it would take a bit for us to get to know each other better, but after not too long, we become best friends.

We went through the rules of the house when we got home. But within hours they went out the window. All of a sudden the lounge was yours, the bed and then the entire house. It took three mobile phones, four pairs of expensive sunglasses, a wallet and my bed linen to knock out those baby teeth but it worked, Punchy boy.

Then you started getting bigger and bigger and we started having more and more fun. You loved chasing toys and never giving them back so then I had to chase you which you loved. You love to run and play with your mates down at the dog park, sometimes we stayed late because you weren't ready to go home. Then we'd get home and you'd sleep and I must admit, mate, you snore really loudly. It makes me laugh; it's so funny!

It doesn't matter what kind of day I have had when I come home to you, you instantly make my day better. You're my best friend and my hero. I love you Punchy boy.

Love from your foster dad

Dear Max,

We had no intention of getting a black dog. We had our hearts set on getting another harlequin and approached your breeder with just that in mind. We met you when you and your litter mates were one day old. We held each of you in the palms of our hands. We cuddled each to our cheeks and when it came to you, I just knew you would be ours. You, the little black puppy with a white smudge on your nose. In that one moment, you changed our minds and our hearts forever.

From the day you came home, your indomitable spirit was evident. Your joy for life showed always in your face and in your waggy, happy tail.

You are the most beautiful dog to have ever graced our lives and you have been the most amazing companion to us and incredible foster brother to so many scared and anxious great danes that have come through your home. Your calm nature and your instinct of just 'knowing' what other dogs needed from you helped heal more dogs than our love and training ever could.

Your sweet cuddles with the starved Zena, your bouncy play with anxious Jett, your teaching Jewel how to share toys — all memories that we, and the dogs you healed, will carry with us always. Kaiser, Zena, Jett, Jewell, Emmett, Jett 2, Harley, Django, Nash, Bella, Gavin, Jett 3, Ayra, Frankie — all will carry your legacy of your kindness and love.

In many ways, we believe you picked us — at one day old and wise beyond your years — the same way you decided to adopt your foster sister, Belle, by sleeping with your heads on one another.

You are our soul dog. You have never lost your innocent curiosity about the world and you love everyone you meet, skin or fur covered. You still think you're the one-day-old pup who fit into the palm of my hand even now as your 70-kg frame sleeps on me in the morning. You are a great ambassador to your breed and you have left paw prints on our hearts that will never be replaced.

Thank you for picking us. We will love you always.

xxxx

Dear Audrey,

There we were, in the parking lot of a crossfit gym, taking each other in. Your shiny black coat, elegant face and amber-coloured eyes immediately stood out. You were surprisingly self assured for a dog that had just failed dog training.

Within days, you arrived like a tornado and made your mark around our house. You shed an impossible amount of black hair on the sofa, you vomited on our carpet, you ate our plants and used our cushions and Eames chairs as chew toys. Your capacity for destruction knew no bounds. Every morning you surprised me with another gigantic mess to clean up.

But somewhere in between cleaning up after you and intercepting you on your path of destruction, it became apparent that there is no better alarm clock than your cold wet nose after you head butt your way through the bedroom door. And there is no better comfort after a bad day than spooning you on the couch. The best thing though is seeing your face as you chase your friends around the dog park.

It didn't take us long to realise that the sofa was just Ikea, the carpet was ugly, the plants would grow back, the cushions were cheap and the Eames chairs were replicas.

In fact, the more time we spent with you, the more it became obvious that living life the way you do is a gift. You taught us that we should all strut into new surroundings open, fearless and happy.

So here I am writing this letter to you in our new local café, your paw resting on my foot. It's a cool little place where dogs can take a page out of your book, have a wrestle and be silly while their humans catch up over breakfast. It's called Black Lab Coffee. We named it after you.

Love

Your proud Mum and Dad

To Mason,

From the first moment I saw you in the pet shop window I knew I had to have you. My husband didn't talk to me for days, but you were so worth it. It didn't take long for you to melt his heart also.

From the first night you came into our lives, you didn't make a fuss, whinge or whine. You were always such an amazing, loving, calm dog with a huge heart. There was not a bad bone in your body.

I remember when you were a puppy you brought a dying baby bird inside from the garden and dropped it on your mat so gently. You looked up at us with your big brown eyes as if to say 'please help this baby bird'. After a while, we put the bird outside (there was no hope for this poor baby). But you didn't give up, you continued to bring it back in. That was the sort of beautiful heart and soul you had.

Everyone who met you could not resist your wonderful heart and beautiful nature and, of course, your beauty. We knew we could trust you with any one or any dog, be it a baby or a puppy.

Mason, you were always the best and are still number one in my heart. I miss you every day and even now, three years later, when I mention your name, I get all choked up. If I could have one wish it would be for you to have lived forever.

I loved every moment of our 15 years together. I will never forget you and will always love you with all of my heart.

Mason, you were a gift.

xxx

Dear gorgeous Junior George,

From the time your mummy, Rubi, fell pregnant, I was convinced that she was carrying our little man, Junior. Throughout Rubi's pregnancy I would tell you how excited we were to meet you.

On 13 October 2002, you and your four big sisters arrived. As I knew, you were special right from the start. You didn't walk like your siblings, but dragged your little body around like a seal pup. You had a birth defect with the only option being to have one back leg amputated and have a knee reconstruction on the other, so at least you would have one working leg.

After an overnight stay at the vets, you came home a new man. You were bounding up steps and if I wasn't careful, you would run so fast that you were hard to catch. A hip dislocation slowed you down, but after further surgery, you were on your way again at full tilt.

In 2006, Rubi, you and I moved to Brisbane to meet your new dad. Like me, Lisle was smitten with you, even though you weren't so fussed about him at first. You would sulk under the bed when Lisle was around, only coming out after he'd left for work.

But soon, you loved Lisle and became his best friend. Our family expanded to include a new big brother, Leroy, and a feline sister, Sofi. Life was great.

Sadly, your health problems weren't behind you. There were many other medical journeys to face, the biggest being cancer. The night we found out, Lisle and I cried because we couldn't imagine life without you in it. But in true Junior George style, you took multiple surgeries and radiation therapy in your stride. Again you proved everyone wrong and on the way won over more Junior George fans in Dr Rod Straw and staff at the Brisbane Veterinary Speciality Centre.

It was also during this time we could finally put a name to why you had crazy stretchy skin. Dr Straw diagnosed you with Ehlers-Danlos Syndrome. We now understood why sometimes it felt like you were falling apart when you bumped yourself.

Then you fell victim to a dog attack. Yet again, we thought you wouldn't survive. You spent two weeks in intensive care at the University of Queensland Veterinary Hospital. Everyday Lisle would visit you and spend time talking to you even though you were sedated. Each visit he would bring clothing with smells of home to remind you that we wanted you home with us. As you recovered, the loving staff would shower you with lots of love and roast chicken.

Life kept going and your baby sister, Reese, was born. You weren't so sure about this furless baby although she loved you to bits. Soon after Reese's arrival, we said goodbye to Rubi. We were worried how you would cope without your doting mum. While we were so terribly sad, you kept on going. Each day you continue to amaze us with the way you take all that life throws at you in your stride. The 13 October 2016 marks your 14th birthday — 98 in people years! Reese is hoping for a letter from the Queen one day soon.

Junior George. We ... love ... you.

Dear Peggy,

From the day I took you from my neighbours, we were inseparable and my life changed from that day on but still to this day I miss you like you would never believe.

I find it hard to write this letter to you, the tears have already started. There is so much I want to tell you. I talk to you often, hoping somewhere out there you can hear me.

It will be three years on the 24 October since I last held you before letting you go. The pain is still raw.

I am still holding onto you; your collar and tag still hanging from my review mirror in the car; your jumper is still in the cupboard; my mobile phone screen photo is still of you; Facebook profile picture hasn't changed either. I won't let you go.

You see, Peggy, my life changed when we came together. You were my first dog I called my own. You weren't a puppy. You were an adult dog with no hearing and a heart murmur. My neighbours left you outside to defend for yourself. I broke a paling from the fence so I could sneak food to you and over time I just opened their side gate and took your bedding, mowed the lawn and gave you fresh water. Your water bowl was dry with green algae.

The time came when I had had enough. I stormed over and banged on the front door telling them if they didn't hand you over to me, I would report them to the RSPCA. I took you home and we never looked back.

During our years together, you made me laugh, you made me cry. I worried about you 24/7. I was your helicopter mum. Well, that's what my friends called me.

So Peggy, nearly three years have gone by since I said goodbye. The first one and a half years I spent fostering dogs but I knew I was trying to find you. I kept trying but I never did and I never will, will I, Peggy?

Along came this white Poodle-Maltese cross. You know how I never understood poodles and always said I would never have one but this dog named Zoe, well, I have a strong feeling you sent her to me. I wonder if that's because we always made fun of them.

Zoe is looking after me, Peggy. She keeps me moving when I don't want too. Zoe will never replace you Peggy but she is helping me to keep going — there are so many days I wish I was with you. I wish we were all together.

Most of all, Peggy, I hope you are always walking beside me. The days when I go astray, I think of you and you help me come back.

Just don't ever leave me; let me know you are there. I love you, Peggy.

Mum

Dear Spud,

You are the best dog ever.

We love you so much.

We love your cuddles, your cute looks and sympathetic paw when we are upset.

We love how you jump and spin 360 degrees, all the while wagging your tail – that's just when we get home.

We feel so special and loved by you. We love the way you remind us its playtime by dropping the ball at our feet and giving us a gentle nudge. We love the way you give us the 'evil eye' during bath time, but still put up with it and (usually) don't jump out of the tub, providing we don't take too long, of course. Luckily, a treat or two never goes astray in bribing you to stay in just a little bit longer.

And now that we've mentioned treats, we had better talk about food. You make out as if we've never ever fed you. We're sure visitors must think that's the case, although we both know you are feed very well.

We love how you gently rest your head on a visitor's lap while pulling your sad face to guilt trip them into passing over a bit of their meal. And once everyone finishes their meals, we give you your much-loved 'din-dins' which you inhale in seconds (how you don't get severe indigestion is a mystery to us).

We love how you keep running back to your food bowl for the fifteen minutes after you've devoured your din-dins just to make sure some food hasn't magically reappeared.

We miss you when we aren't at home with you. We wish we had a dog phone to call you on when we're out; we'd let you know we love you even though we aren't there. And while we're on the phone we could check-up on what you're up to – maybe that could have averted some of your destructive moments like eating the chilli plant, the herbs and the barbecue gas hose. Sigh! But how can we possibly be mad at you when you make those puppy dog eyes?

Lots of love

Mum and Dad

My dearest Fly,

I always thought love was just a word for a made-up human emotion, and then I met you – my four-legged soul mate. I look at you and my eyes well with tears of joy, tears of pure love, a love I don't think I could live without.

You were only a few weeks old when I first saw you, a perfect puppy that I had dreamed of, thoroughly planned and waited for. You grew into the perfect dog.

We created a life of Agility together and made all our Agility dreams come true. Agility is a passion that we share together – there is no better team than you and I. You taught me how to handle and train, how to have patience, how to celebrate the little things and how to be completely grateful that I can play this sport with my best mate. You were my first Agility dog, and my first Agility Champion.

You have been by my side through so much joy and pain. Your loyalty never waivers. Every day you are there resting your head on my lap, forgiving all my faults, never judging me for my bad decisions and always there with a wagging tail to celebrate my victories with me.

In August 2016 I was diagnosed with cancer. When I came home that day you looked at me with sad eyes. I said "Don't worry buddy, I will beat this for you." You wagged your tail and ran off to get your ball. I know you will fight this with me and I know that you never leave my side. You will make me smile daily and you will bring laughter to my days. You will be my best medicine.

I will never have a dog like you again.

Till death do us part.

xxxxoooo

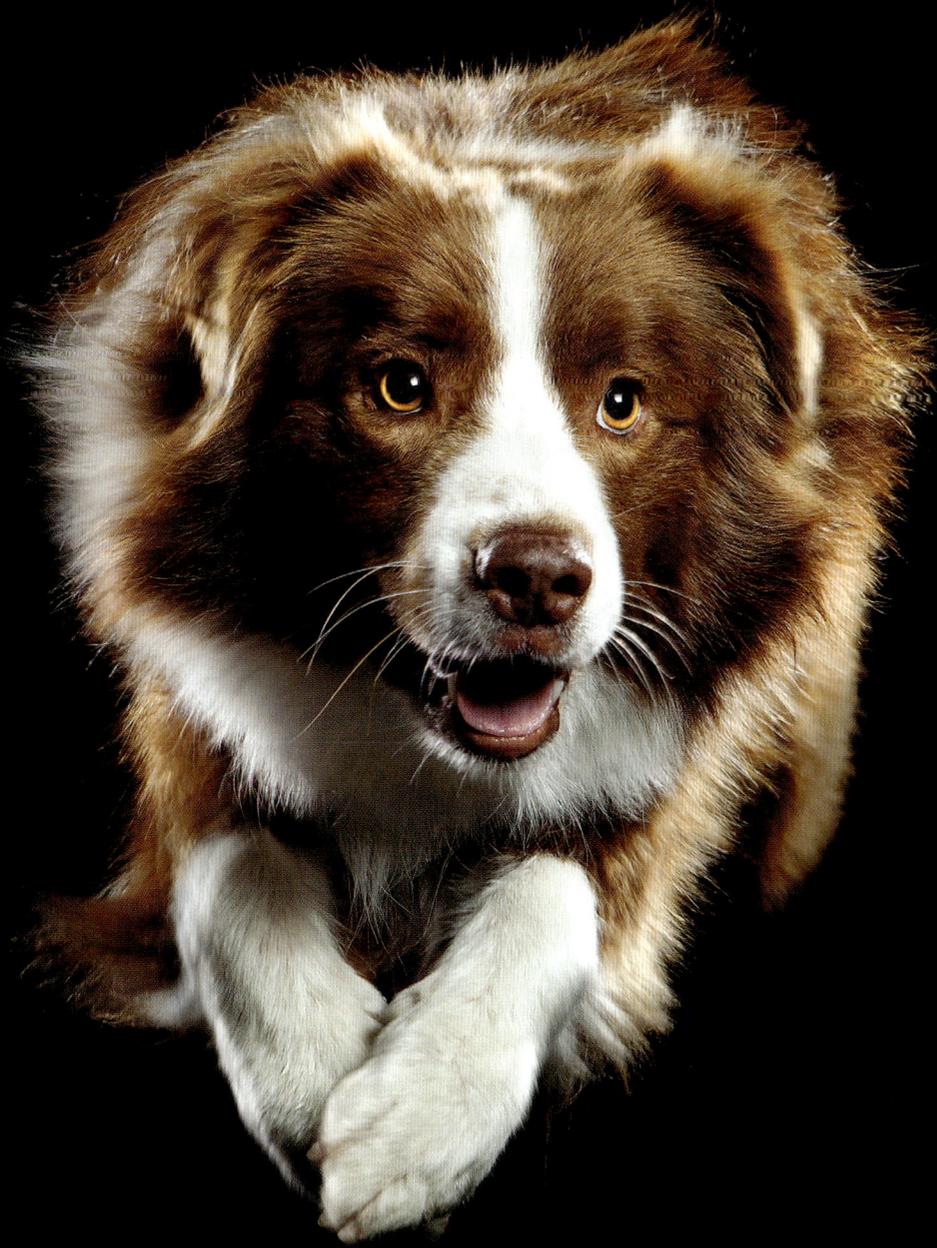

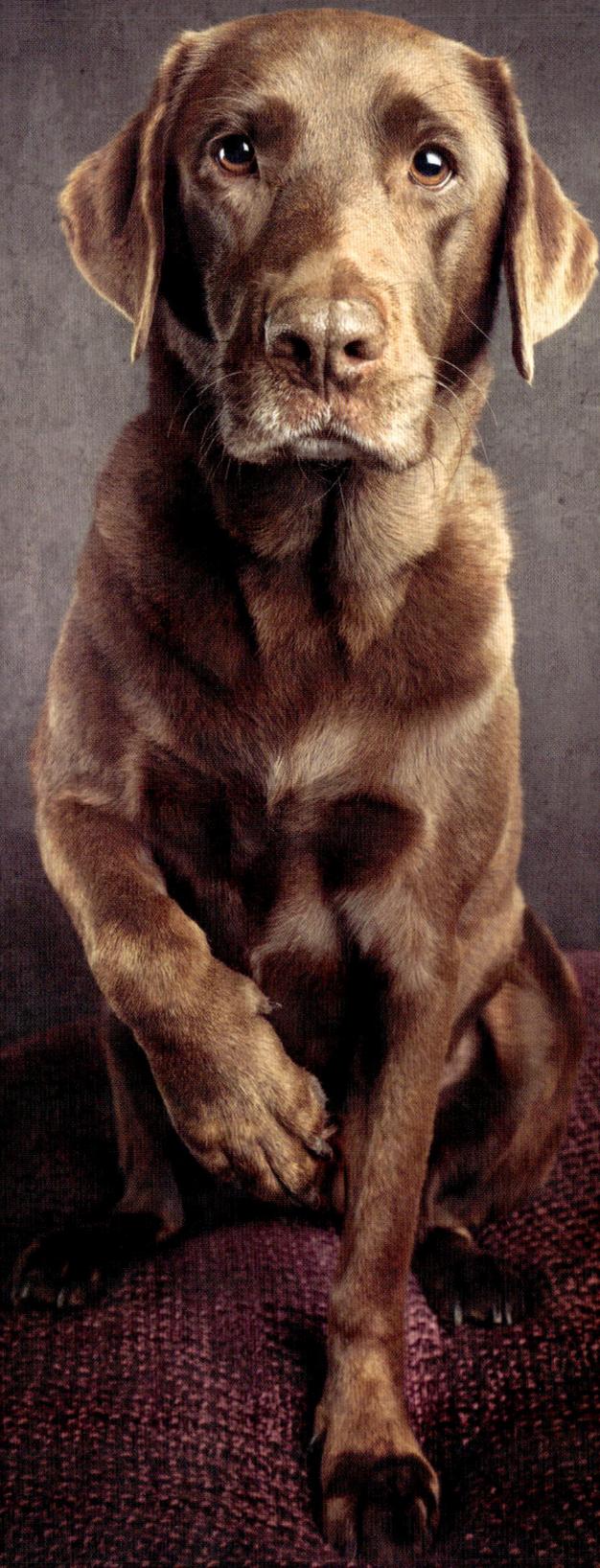

Dearest Molly,

We started talking about buying a dog shortly after we bought our first house. I had always had family dogs and James had grown up around dogs but never really had his own.

We spent months discussing breeds, names and visiting dogs that we found advertised for adoption. We travelled far and wide in our search, but when we arrived at the farm on that wet and dreary afternoon, we were greeted by your beautiful parents and ushered into the yard where you and your siblings were playing. We knew we had a hard choice, but the way you came up to greet us and how comfortable you were in our arms, we also knew that our decision was made and we would face the agonising wait for you to be ready to come home with us. We were and still are completely besotted with you.

Despite what we thought, we were less than prepared for the first night home, the toilet training and the chewed up shoes, but we were setting off on a journey with you that has brought us new friends, new passions and new horizons. Through you, we have learnt so much about animal training and the welfare of all creatures. Molly, you are not 'just a dog'. You have made our little family complete. Molly, you are the sweetest and gentlest and most loving soul we have come to know.

You have always made us so proud, whether you are learning new tricks, interacting with all the children in our lives or being so patient and sympathetic when I have had a bad day. You have been so welcoming with the succession of foster dogs you have allowed into your home and a model mentor to each one. Your bum wiggling tail wag brings us joy and your soulful eyes cut right through our defences and lighten our hearts when we are down.

Thank you for always being there for us and for being our best friend.

We love you so very much Miss Molly.

Nina and James

To my Lulu, aka Loopsy-Lu,

My first impression of you on your adoption profile were your eyes, I could see so much emotion just from looking into them as well as how gorgeous you were to look at. I knew you belonged in my life and I had to be the human to care for you.

I didn't get the chance to watch you grow from a puppy but I know we have made up for that in leaps and bounds over the years. Watching you learn in a loving family and having a second chance has been the best for both of us. It has been a pleasure to watch you figure out your personality and not be afraid of things. Even though you push the limits sometimes, you are always an amazing dog and have deserved every 'good girl'.

You are such a gentle-natured dog. Everyone who meets you loves you immediately. It could be because you greet them with a big smile and a bit of talking upon arrival or because you make them feel special by leaning on them as you try for never-ending pats.

You came into my life at a troubling time and have helped me heal because of your love and protection. The amount of love I have for you knows no limits and even to this day when I hear you snoring or see you dreaming while you sleep, my heart melts and I smile. You have always belonged to me and will always to the end of time.

Forever and always your loving owner and best friend.

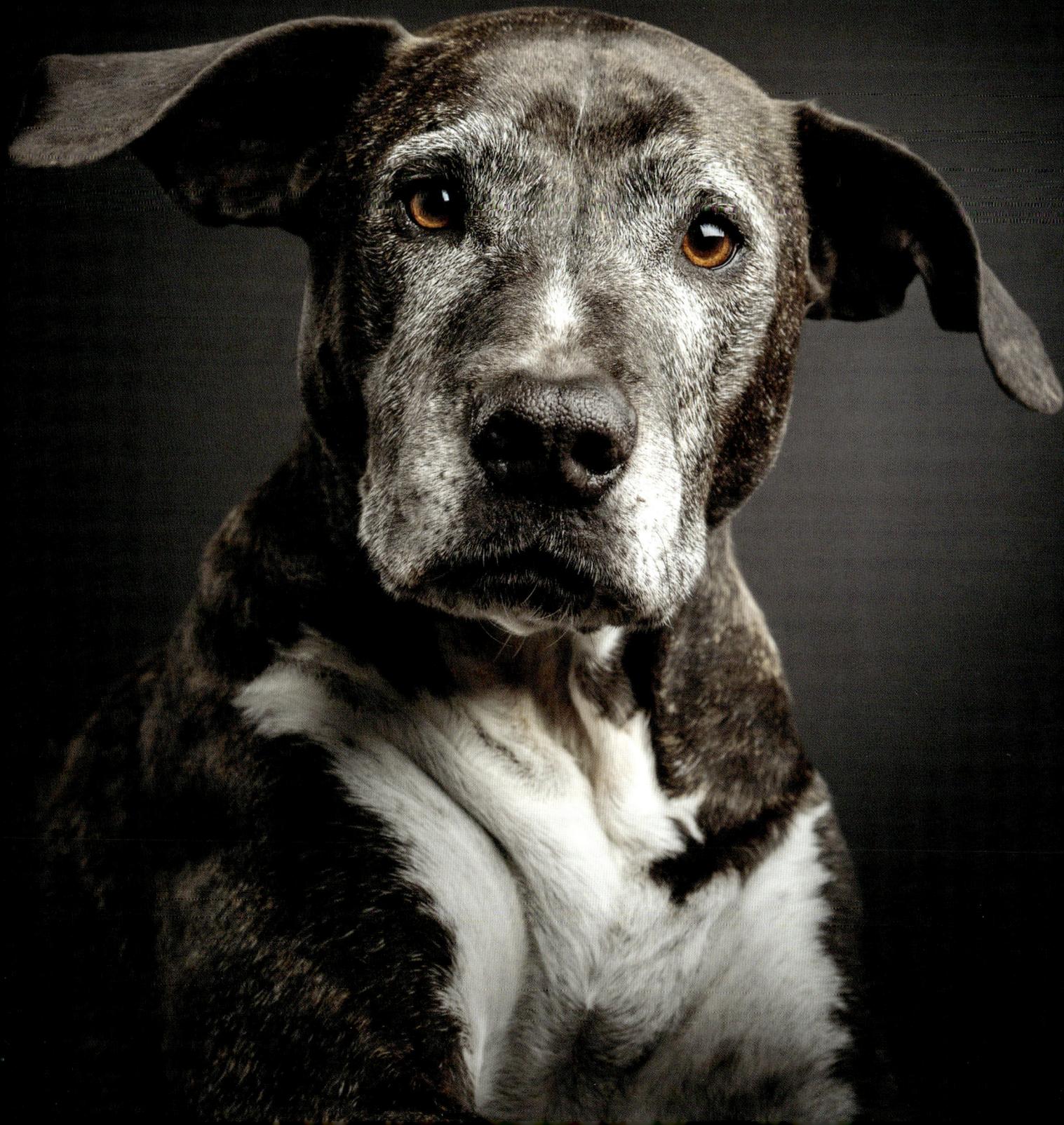

My dearest little Chardie-girl,

You entered the world on 18 November, 2015 and became part of mine approximately three weeks later. That year, 2015, had proved to be a difficult one for me and finding you represented the light at the end of a very dark tunnel. The moment I saw you, you jumped straight into my heart.

From the patch of white fur shaped like a heart on top of your head, those big brown soulful eyes to the little curly tail at the other end, I fell in love with you. Then began the long wait of three weeks until I could bring you into our family home. The text messages and photos I constantly received kept my heart happy during this time.

New Year's Eve arrived and we were off to pick you up. 'Excited' is an understatement of what I was feeling. Once back home we introduced you to your new, but old, fur-sibling, Patch. Now Mr P, as we affectionately call him, has sixteen years of wisdom to share with you in his own time and he is doing that slowly – sharing his wisdom with you.

I'm not going to lie. He wasn't very keen on you when he first met you but once he realised you weren't here to take his place in his dad's heart, he decided he could put up with you.

Piddly puddles, wet nose kisses, puppy whimpers, window nose art, cheeky antics, dress ups, funny little growls and barks now fill my much lighter life.

Puppy preschool and car trips to soccer games and trainings fill our time and bond us and make us even closer. Most mornings your wet nose wakes me and your little face waiting at the front window every afternoon when I come home from work makes me smile inside and out.

Your unconditional love has shown me many lessons and truly brightened my world. I am proud to be a 'Jackie' mum.

Love you forever.

Bless you

Mummy Pen

xo

Dear Molly,

Let us start off by saying how much we love you and how lucky we are to have found you.

Remembering back to the day you came home when your Mummy walked through the door with you, I fell in love with you right at that very moment. Boy, was I the happiest aunty in the world to have finally met you. It had been a long day at work that day waiting for you to finally arrive. Our little ball of fluff we called you.

Molly, you have grown up into such a fun-loving little girl and we cherish every day having you in our lives. There is certainly never a dull moment in our house for all of us.

We love how you give us the most amazing cuddles and how you seem to manage to find all the tissues and socks in the house and always without fail let us know when someone is either walking past or at our front door (your mum always says you are waiting for your next victim).

Molly, we understand that we won't get to have fur baby dates with our friends' puppies as you are just a one puppy family but that's OK. We do though love our walks together and how you always manage to lead us home your own way or how we always have to steer you away from oncoming doggie traffic but that just makes our walks more interesting.

We love you very much and would not change a thing.

Love always

Mummy and Aunty Pete

xxoo

A letter to Cobe, my dearest boy,

A lot of things can happen in fourteen years – and in the last 14 years you have been there with me, beside me, for most of my adventures. You have been with me through relationship ups and downs, beginnings and endings, career changes, new friends, old friends and many, many miles travelling together – ours is about the closest a relationship can be.

We now have your daughter and son in 'our pack' – but one of my most favourite memories of all time was that very first trip we took together all those years ago – 1650 kilometres, just us in the ute from Mt Isa to back home.

You had never seen the beach before, that endless stretch of sand that was all ours that afternoon – and those waves that just kept on rolling in, no matter how hard you ran or barked at them. We had hours there that day; your expression was priceless when you first saw all that water, almost asking 'who left the tap on?'

We still have that beautiful photo on the wall of you skipping over the water hell bent on bailing up those pesky little waves.

So here we are all those years later, both a little bit wiser to the ways of the world, but both still ready to enjoy those new experiences with a big bounding stride and smile. Your eyes might not be the best these days, but there are lots more miles for us to travel together yet – more camping trips, more days at the beach, more afternoons enjoying a quiet snuggle up.

And there is so much of you in your kids, I see shadows of you in them every day.

The person who gave you to me all those many moons ago is a long time gone but you and I are still here together. You have changed me and I have learnt from you. You remind me to see the good in the world, the true meaning of loyalty and to always keep smiling. I am looking forward to enjoying your twilight years in our new home. No matter how grey you get around your muzzle, you will always be my 'baby dog'.

With love always

Prudence

To my special Indy,

They say dogs come into your life for a reason and I am convinced you came into our family to teach me to judge less and listen more.

Together we have been visiting a children's hospital for over five years. To others I describe pet therapy as 'providing a distraction', but I know it is so much more. When kids are around you, for a brief moment, they are not sick inside a hospital, but just a normal child, patting a dog, chatting away about their life outside the hospital. Many times parents have told me you were the reason their child smiled for the first time in weeks.

During our first visit to the hospital I saw a child relax and gain more control over his muscle movements as he patted you. I realised just how special you are and how important pet therapy is.

I often tell people that when we enter a hospital room, I can see from your body movements how that visit will go: sometimes kids love it when you are silly and do lots of tricks and other times they just need you to be there and sit quietly while they give you a hug. When I walk into that room with you, I only see what is in front of me but you clearly pick up on so much more. You have taught me to walk into situations with an open mind, to not judge or make assumptions based on what I see on the outside and treat each person with the respect and attention they deserve in that moment.

Thank you for the joy you bring to children in the hospital as well as to our home. I hope we can continue our work at the hospital for a few more years while you are part of our family.

Fur-Ever Loved x

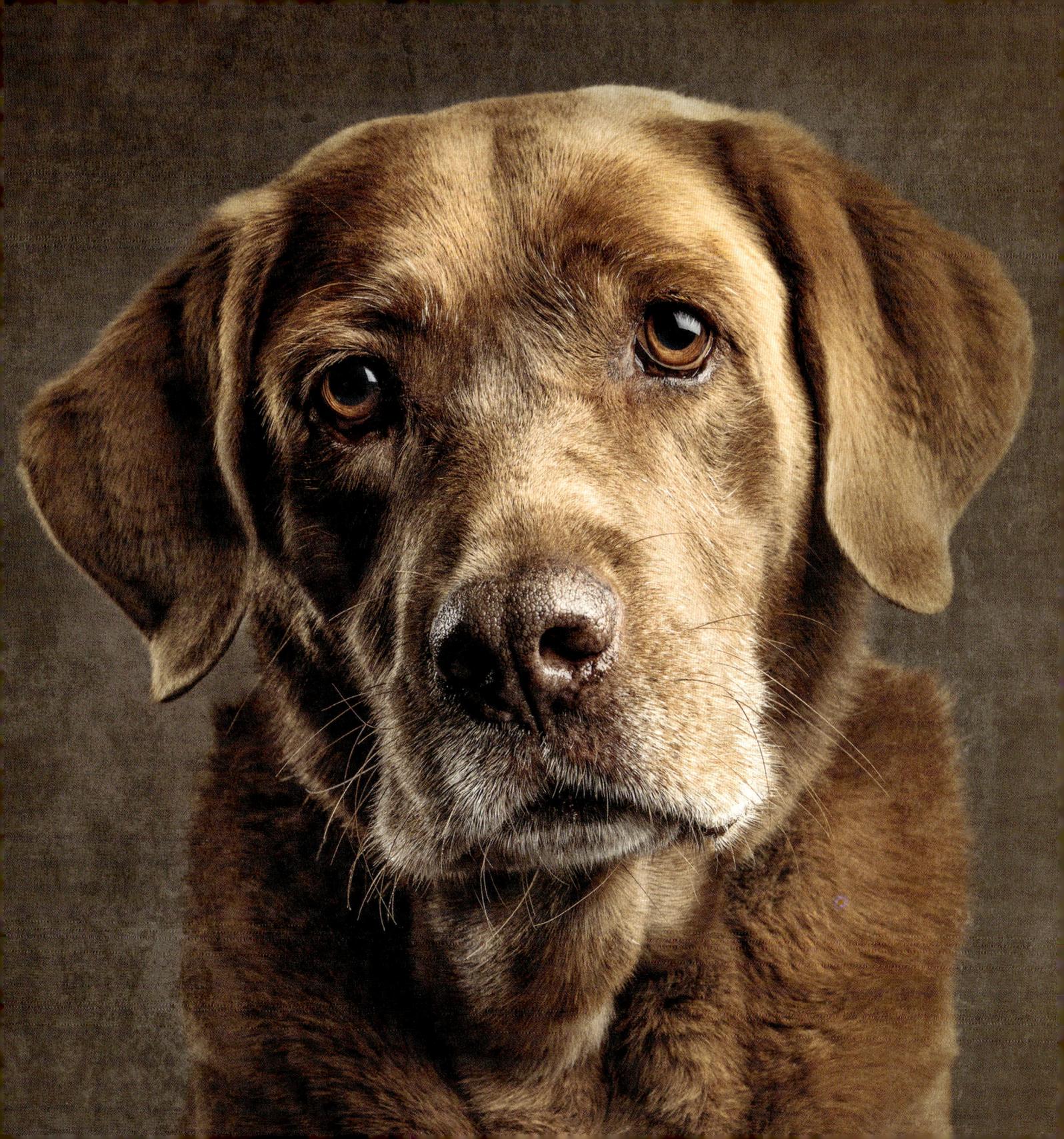

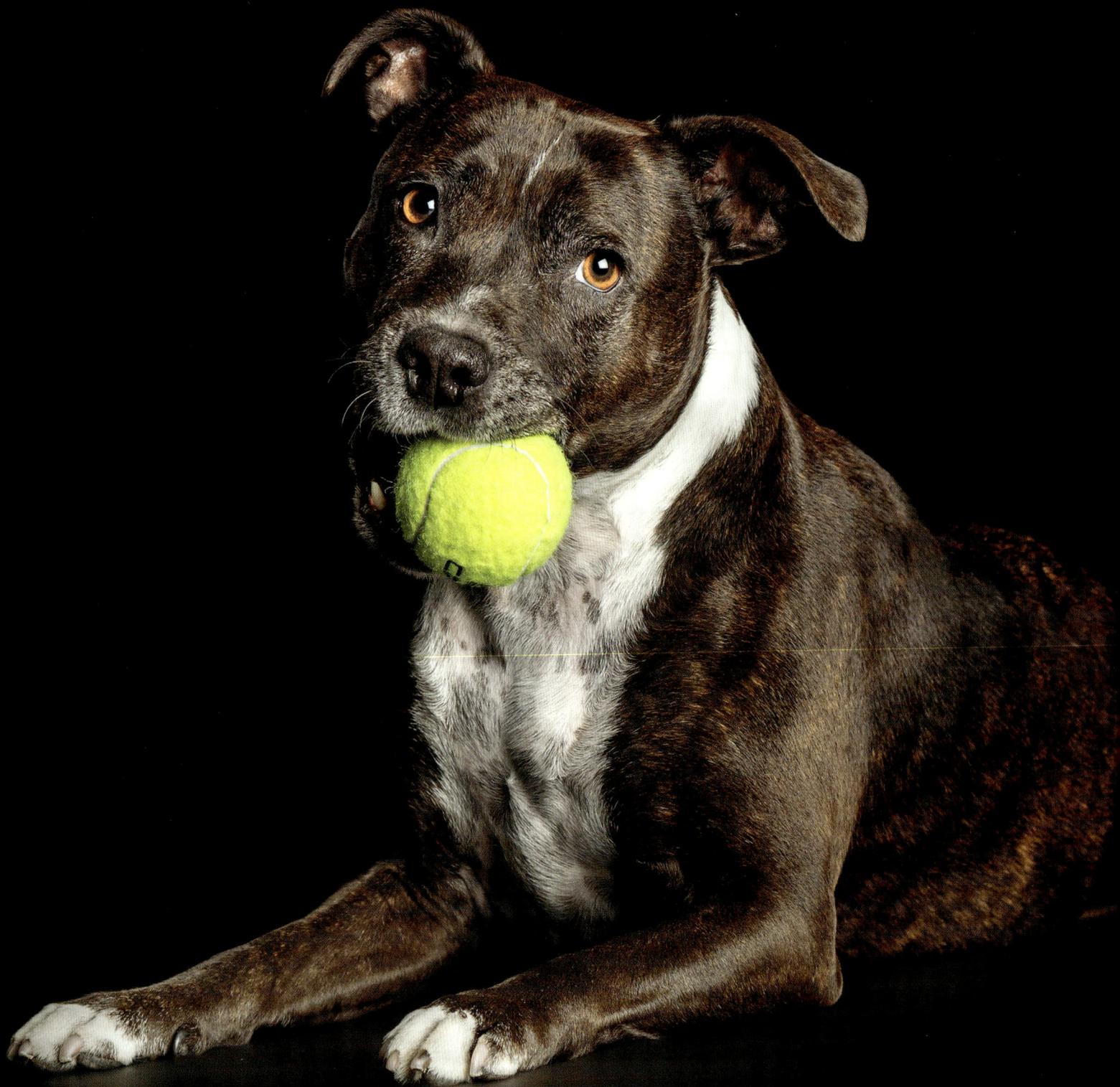

Dear Miss Poshy,

You are by far the greatest gift I could have ever received on Christmas morning of 2008. Staring into your little eyes for the first time, I knew you were mine to raise and become my best friend.

Because of the little white paws you carry with pride, you were given the name, Posh, which you most certainly live up to.

From the get-go you have had a personality like no other dog I've ever come across. You really are one of a kind. The minute I wake up in the morning you brighten up my day with your morning cuddles in bed and desire to get up with me so you don't miss out on your slice of cheese to start the day.

Some of the many things that you do to make me laugh are when we are sitting in the lounge room and all your toys are neatly put away and you want to play with them but, as you have so many because you are spoilt rotten, you have to take each and every one out and fill the lounge room floor with toys to play with. At the end, you always end up with the tennis ball. When it has been raining and you need to go do your business outside, you must walk on the concrete path and then tip toe onto the smallest piece of grass to not get your feet too wet. I love it how you must have a pillow under your head when you go to bed at night or when have a midday nap on the couch.

You are always willing to try anything as long as you have me right by your side. From swims in the surf, going for a ride on a jet ski, going away to pet-friendly retreats, shopping at Bunnings. You're never fussy with food and you let me put wonderful outfits on you for Christmas day.

So thank you for being my best friend, listening when I really needed someone, making me laugh, brightening up my every day with your cuddles, kisses and unconditional love that you give me. Your initials tattooed on my ankle are a constant reminder of how much you mean to me.

Love you forever

Sam

Levi, our beautiful Princess Diva,

From the moment we picked you up, we knew you were going to be trouble — always the strong, independent, stubborn, grumpy girl. Five years on and you are much the same.

Why everything has to be on your terms or not at all is mind blowing, even down to the amount of time you are willing to have love and affection from us at any one time.

Why do our hearts melt when we look at you; why do we love you unconditionally? Well, you are our grumpy girl, you fill our hearts with so much love, the mischief and laughable things you do, from the head tilt, the clacking noise you make for additional chicken, the settee dash, the cuddles and kisses you give only at night, telling us all is forgiven for today. And tomorrow will bring new challenges, all with love.

Kaiser, our Mr Perfect,

Since adopting you two years ago, we hope we have put right all the wrongs of your previous life. We hope we have shown you what true love is and that not every human is the same. You had endured so much that to trust again would take time.

Now your big brown soulful eyes tell me you have unconditional love. I am never far from your side and I am forever grateful. I love you with every part of my being. I am yours, you are mine; the bond is unbreakable.

We can honestly say you are the most beautiful, perfect and gentle boy. We love you from the bottom of our hearts. Our only regret is that you didn't come into our lives sooner.

Love you both now, always and forever

Mum and Dad

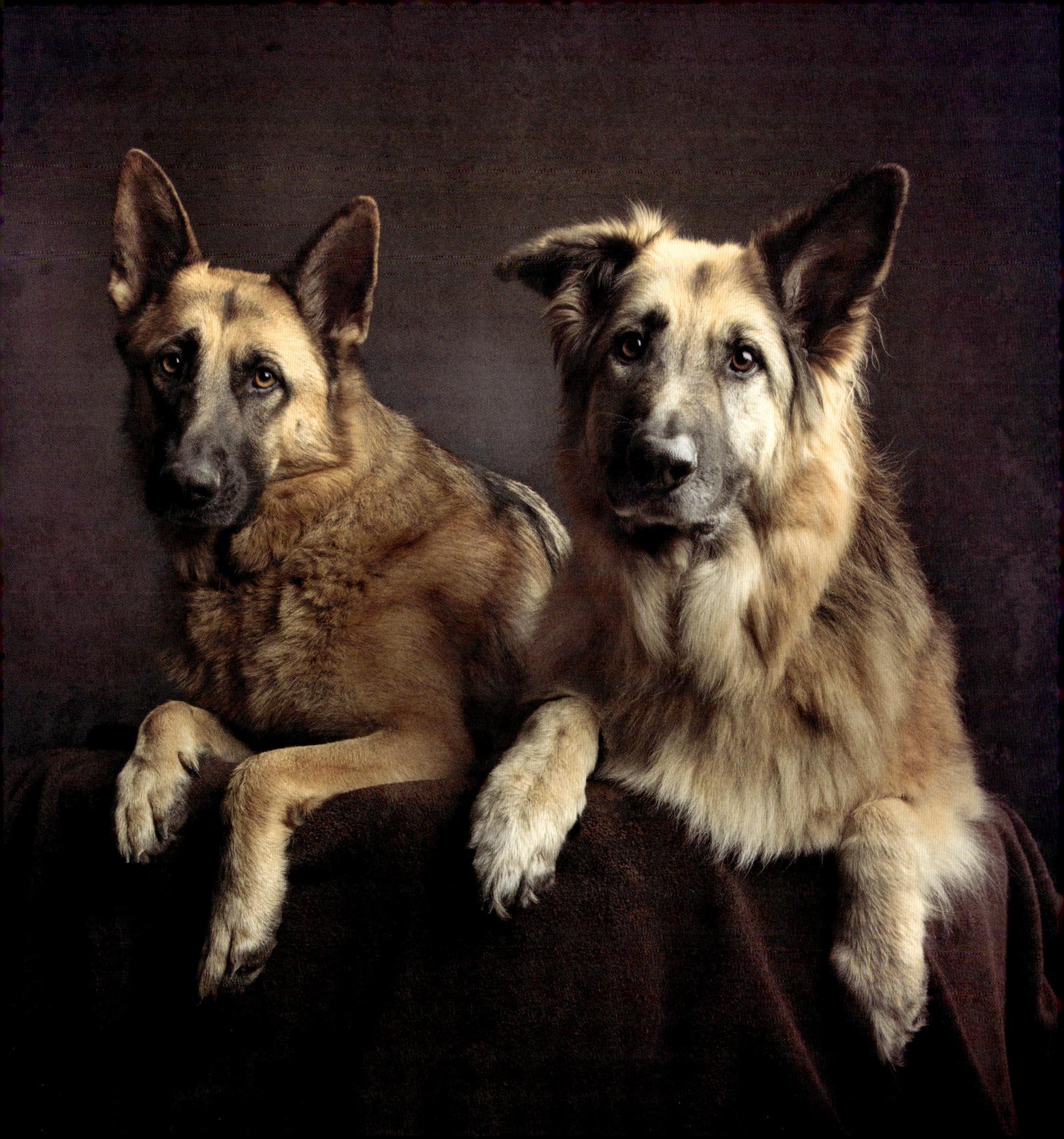

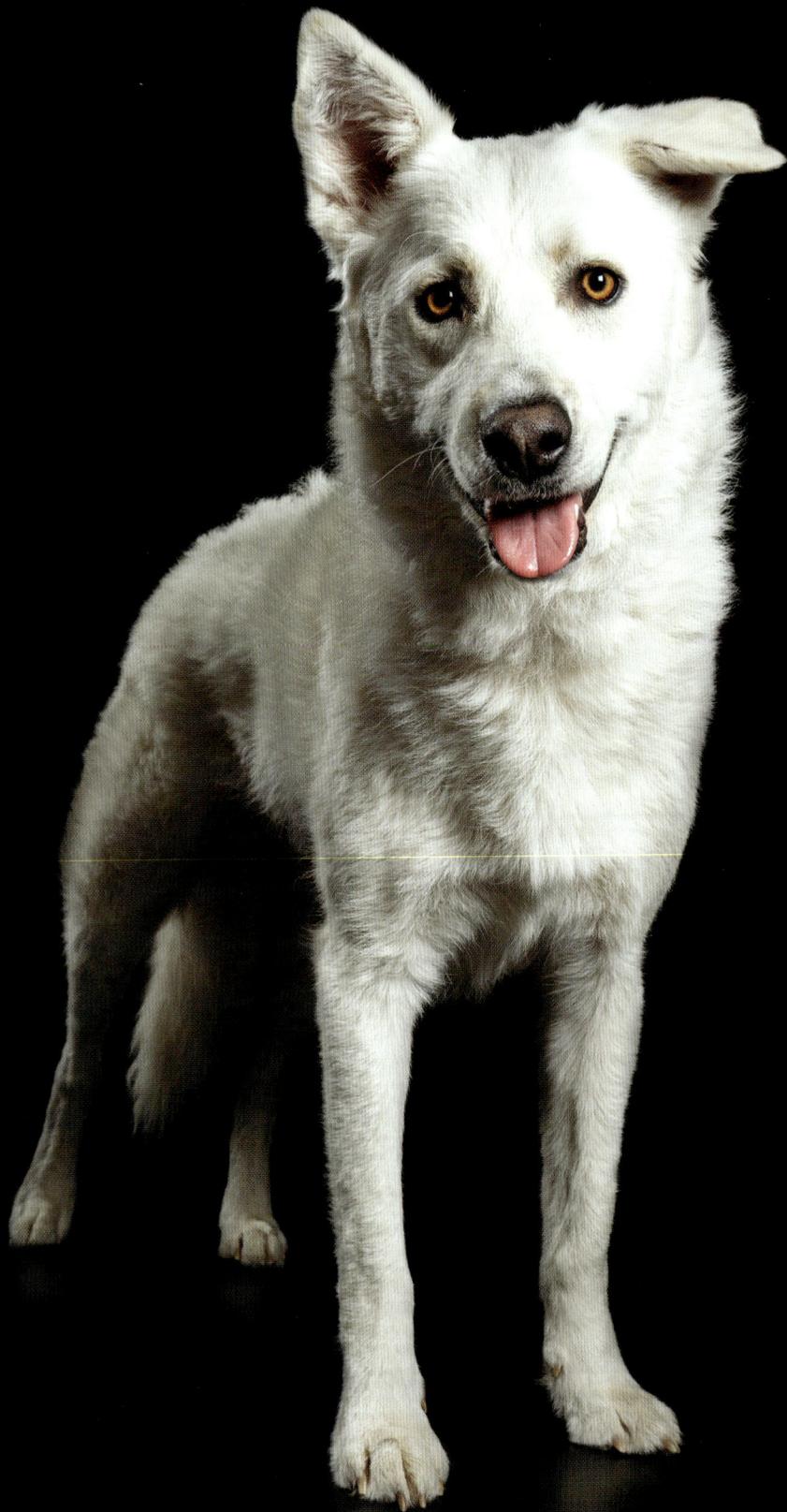

To my beautiful baby,

Dash, I remember bringing you home as a scared little rescue puppy. It was my first year of vet school and you were my foster dog. While we worked on getting you healthy and socialised, you were my constant companion through every study session.

Of course, this meant you were my anatomy model, my dog-handling practice, my canine actor in video assignments and much more. You were the most patient man, you never once complained. When it came time for you to find a forever home, we both knew you had already found it.

Your smile and your wagging tail is the first thing I see each and every morning, and I can't imagine how dull my days would be if they didn't start with our morning walks.

Over the years, you have been my gym buddy, my workmate and my fellow adventure enthusiast. Thanks for the camping trips, the mornings at the markets, the beach days, the road trips, the summers interstate, the café dates, and for being by my side through all of life's highs and lows. Thank you for loving my friends and family as much as I do and thank you for welcoming each and every foster dog or cat into our home (even if it meant you had to share your mum for a little while).

Dashman, thanks for being there day in and day out, always plonked beside me so that I'm never out of your sight. I love the way you're so incredibly gentle, loyal and wise beyond your years. You will be a gentleman until the end of your days and I'm honoured to call you my best friend. Our house would not be a home without you.

I love you big guy.

xxx

Dear Tigger,

You came into our lives such a funny little man, aloof but fearful when separated from us, trembling so much. Striped like a tiger, Tigger seemed to suit. As you aged, you grew more accustomed to your cuddles, not sought as a puppy. Now as the elder statesman of the house, you often like to lay contentedly on mum's lap.

In your youth, you ran so very fast. At the track, the sound of the lure racing around the course, your ears would prick up; your ever-attentive eyes would seek the prize. All else faded from your mind except the thrill of the chase and the joy of the run; always the leader of the pack.

But now, as your twilight years approach, the speed has faded, but the joy of running is still there; your eyes still sharp although a little frostier than in your youth. The two youngling whippets that now share your abode run off into the distance, with you still chasing, the joy still there.

You have always been a gentle soul, not demanding, but as age creeps up on you, you become more set on the creature comforts you want and deserve like when your head shares dad's pillow, tucked in warm for the night.

Like any old man, you have become a little cantankerous and are not afraid to grumble when one of the juniors tries to steal your spot, but a quiet bark or low growl has them vacate rather quickly.

Your bright eyes that greet us every day will always hold a special place in our hearts. Though the day you cross the rainbow bridge will shatter our hearts, the joy you have provided us sharing your journey is immeasurable and we will be forever grateful.

But until that day arrives, our hearts and bed will always be yours.

Love always

Mum and Dad

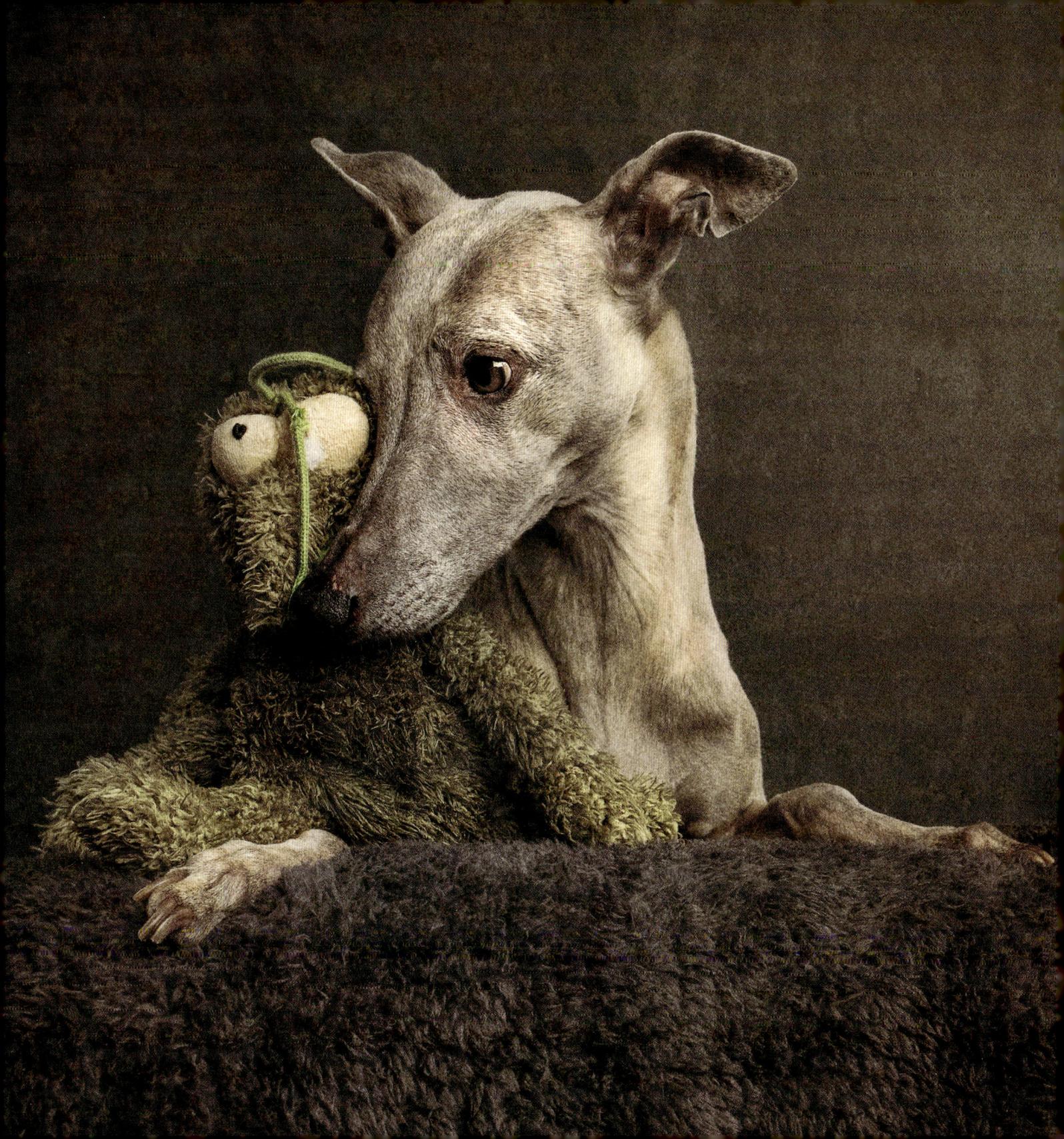

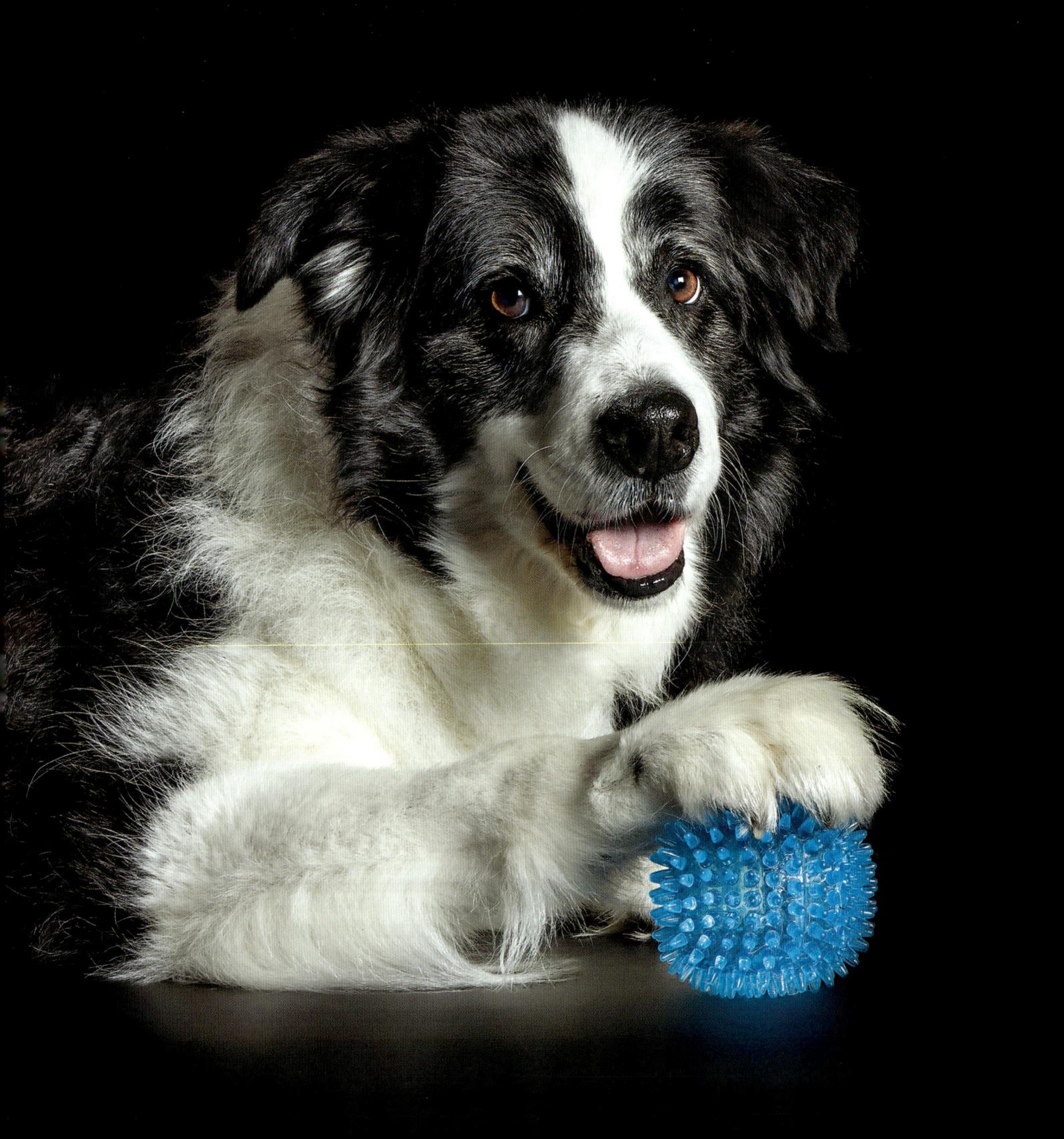

Dear Brodie-Boy,

I want to let you know that you are my best friend, my best mate. You were only a few weeks old when I first met you and you were the cutest puppy I had ever laid my eyes on. At that time I was not looking for responsibility or commitment and was going through a difficult phase of my life. However, when you first put your paws on me, I was hooked. Your unconditional love was instantly felt and in turn I knew there was nothing you could ever do that would make me stop loving you back.

You went with me everywhere that I went. Always by my side or patiently waiting outside the store I was in – no lead required. You're companionship was just what I needed and everyone who met you was touched by your obedient, kind, gentlemanly nature.

Since then life has brought many changes. I lost a lot of weight and we started running together. You got me through that difficult phase. When my dad became sick with cancer there was not a day where you did not lay by his side as he sat in that armchair until he got better.

We are now a happy family with my wife and her younger border collie and an old cat that is enamoured by you. You're twelve years old and slowing down but you still have that spark and a spring in your step. So our hearts broke to hear the news you had an aggressive form of cancer. Your Mum and I shed a lot of tears that night.

We have truly had a great adventure together and as I know that all life must end, please know that I feel much heartache in thinking that I could never repay you for the happiness or love you have given me. Every cuddle, every tennis ball throw, every tail-wagging moment is forever etched in my memory and will never leave me.

Love always to my best mate and the best dog in the world, my Brodie-Boy.

Dad

Dear Jack,

The day you came home I knew that you were my little treasure to protect and nurture. Initially, you were not to come inside, but I immediately began to sneak you in at night to cuddle. This was until one morning when Dad caught me, like a deer in the headlights, trying to put the squirming puppy out the back door to continue the illusion that you spent every night outside.

Unsurprisingly, you began to make yourself more comfortable. Soon you slept indoors, then on a spare couch, which became your couch. Of course, this was the go to place when you weren't making sure you sat next to whoever was in the room, but only if you could wriggle in next to their left-hand side, which was best for watching out for dogs on TV in case you needed to warn the family of danger.

As I struggle through an uncertain world, you have always been my one constant. Regardless of inner turmoil or daily pressures, you are always there. Whether it is simply sitting next to me on the bed, or following me through the garden with wagging tail, you never leave me alone, never judge or pressure me. Instead, you are unequivocally loyal, always inquisitive and eternally optimistic.

When my parents retired to a new house, my main disappointment was losing access to the laundry steps at the old house. Every lazy weekend afternoon after I finished hanging out the washing, we would both sit on the steps, and we would watch the world go by. It was nothing ground breaking, but it will always remain my favourite way to spend time, forgetting the circumstances and just observing things for what they are.

Originally, I was your caretaker, little one, but over time it has become abundantly clear that you have always taken care of me, and nothing can compare to your love which I will forever cherish.

xoxo

Dear Vinnie,

Thank you for not only stealing my bras but for stealing my heart.

Thank you for your tantrums when I forget to buy you chicken wings.

Thank you for the worry when you're sick and unwell.

Thank you for the drama like when you got a fish hook stuck in your lip at a friend's house and making a five-minute drive to the vet seem like an hour-long trip.

Thank you for being the cause on my OCD.

Thank you for the trust and the special look you give me that affirms you love me.

Thank you for making me smile when I'm feeling blue.

Thank you for keeping my feet warm at night.

Thank you for being able to hear a treat wrapper from a mile away and staring at me while I eat my Cornetto to ensure you will get the last bite.

Thank you for getting stuck in the doona cover and unmaking every bed in the house.

Thank you for giving me something to talk about when all my friends are talking about their kids.

Thank you for being the only subject in my camera roll and newsfeed.

Thank you for being the most obedient dog at puppy school but nowhere else.

Thank you for making me known everywhere as Vinnie's mum.

Thank you for the morning breath doggie kisses you throw my way.

Thank you for always waking me up at 2 am to go to the toilet or just chase rabbits.

And most of all, thank you for coming into my life, for being kind and gentle and loving.

I wouldn't have it any other way.

Vinnie, I love you.

xx

Dearest Miffy, Gizmo and Kya,

You are the last faces we see before closing our eyes and your kisses are our favourite way to wake up of a morning.

You are more than just pets, you are our fur babies and we would go to the ends of the earth for you.

In good times and bad our love has never faltered. We promised when you became ours that you had found your new forever home. We will never break that promise.

Every decision we make has you in mind, even when renovating the house.

Our favourite way of relaxing is ordering in and watching a movie surrounded by our fur family on the couch.

You're the reason for following my dream of working in the Veterinary industry and you inspire me everyday to give the best care to others.

We laugh that a long time ago we learnt we had to spell W-A-L-K and replace ride in the car with 'r in the c' when discussing our plans.

Anywhere is better with you, which is why we love taking you with us everywhere we go.

When you leave us, you will take a piece of our hearts with you, but it will ensure that you will always be with us and that you will never be forgotten.

I am grateful for all the hair all over the house, it means we never leave home without you.

You make our lives whole, our house would be so empty without you.

I love that we are happy to be uncomfortable just so we can snuggle with you.

Your love is so genuine; we can always count on your happiness to make us smile.

I love that whether we're gone for ten minutes or the whole day, we are still met with the same level of excitement.

It's your job to love and protect us; your unconditional loyalty has no bounds.

You can make any day better with a simple wag of your tail or the energetic enthusiasm we get from you every time we walk in the door.

Thank you for always being there

Love 'Daddy' and 'Mummy'

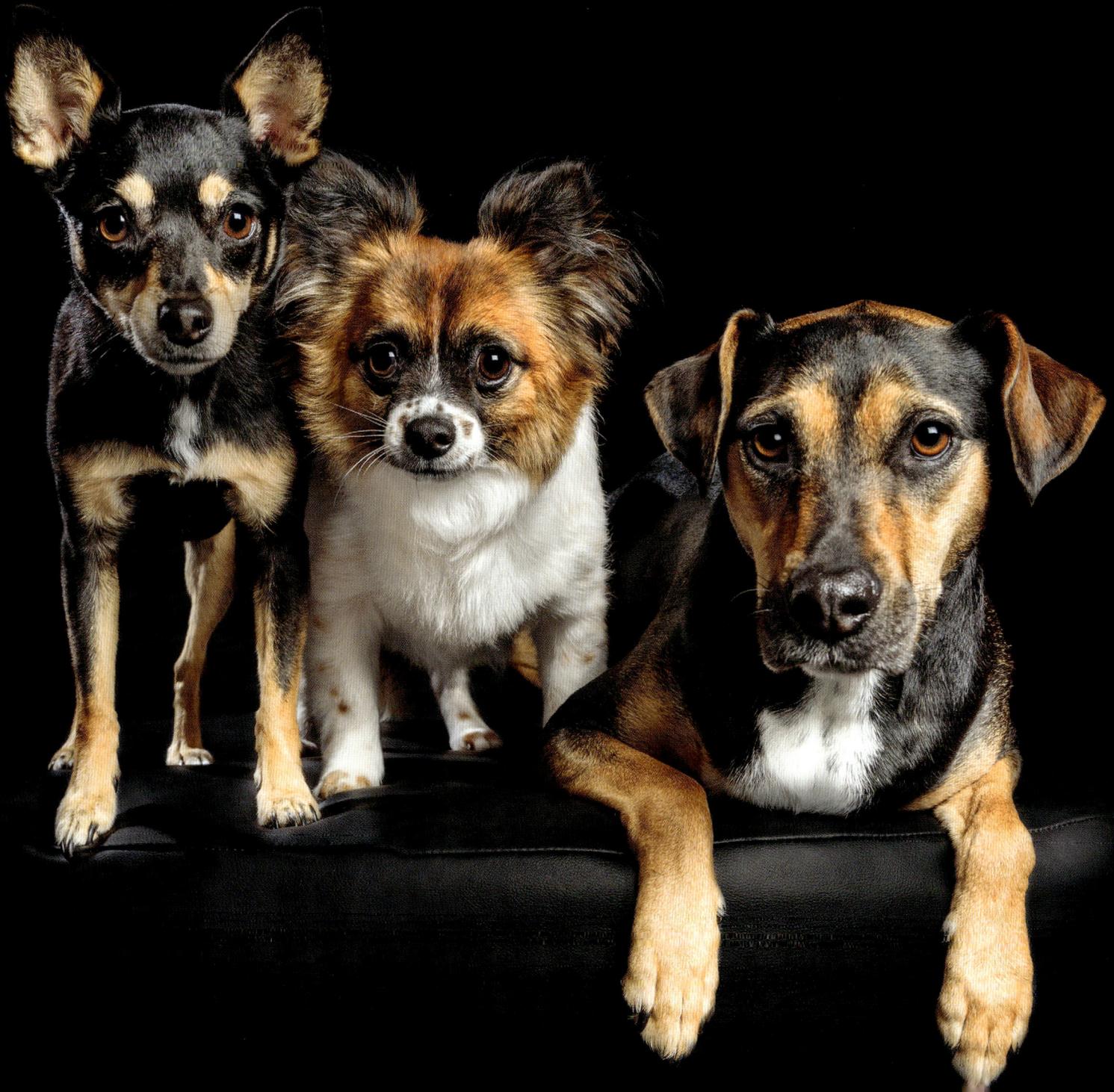

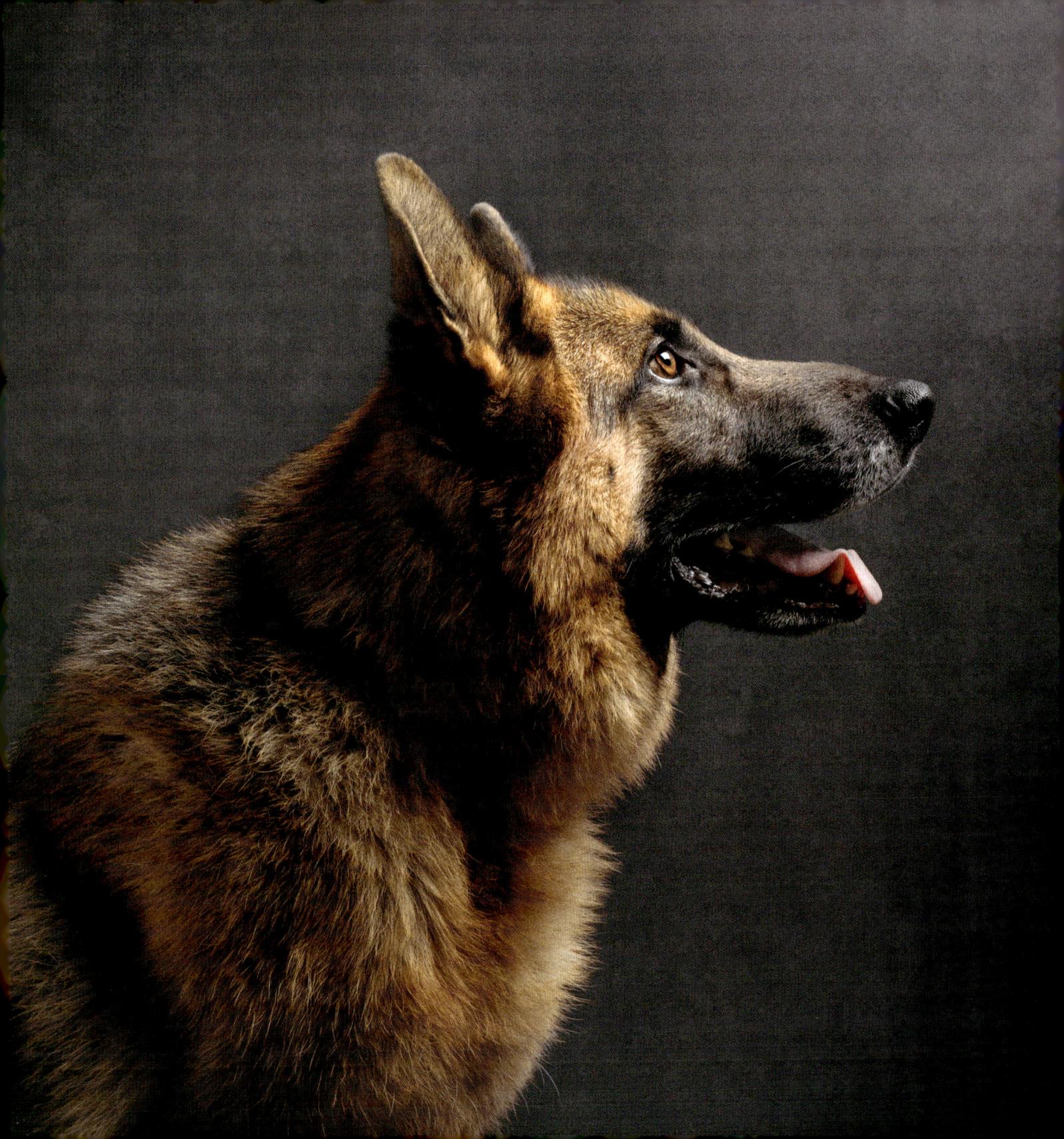

Dear Volcom,

'Volcom! Here!' This obviously fell on deaf ears as you playfully kept in hot pursuit of the raft of ducks up the canal. We'll never forget you bounding upstream and disappearing among the long grass and reeds, only to later receive a phone call from the council notifying us of how you inquisitively snuck up on a team of construction workers and demanded to be patted. No doubt this was done in your usual playful manner of stealthily approaching from behind and popping your head out between someone's legs while looking skyward for a cuddle.

This fun, loving and confidant attitude was what lured us in and made us instantly fall in love with you, even from the day we met you as a puppy. We were adamant that we were only going to view your litter, and concocted strategies to avoid an impulsive purchase. But what chance did we ever really have with you? It was evident from the way you fumbled your way over to us and only wanted to play and share affection that you were the perfect addition to our family. You essentially selected yourself, and we are eternally glad that you did.

You made your life an adventure with any opportunity you had, whether you were swimming in the ocean to randomly greet your dad while he was on the jet ski or ripping your sand anchor out to say hi to everyone along the beach. The dented tailgate from you excitedly jumping into the tray of the ute for many adventures still remains. Even on your final day, all you wanted to do was to play with the horses and run through the long grass and reeds again.

Tragically, your adventures have now come to a completion. Our memories of you are now stored in all the parting gifts you left us such as the dented tailgate and your favourite rock. We feel your absence every time we look for you outside, or when we open the side gate with anticipation of having you greet us with a wet lick to a hand.

Volcom, your loyalty has taught us to be more devoted to the things that mean the most to us in life. Your forgivingness, patience and unconditional love were admirable traits that we now attempt to emulate.

Volcom, you were quick to join our family and departed far too soon. We love you.

Miss you, Boofa.

xo

Dear Banksy,

Not a day goes by I don't look at you and think how incredibly lucky I am to have met you. I never knew it was possible to love anything as much as I love you and you came into my life at a time that I needed you so very much. You saved my life.

I'm sorry I repay you by dressing you in silly costumes and drawing eyebrows on you. I'm sorry I smother you with cuddles and can't go five minutes without telling you how much I love you, but I don't think you mind all that much.

If someone had of told me when you were a puppy that in a few years your best friend would be a sassy kitten who has grown up to be a sassier cat, I never would have believed it but the love you two show each other warms my heart.

I want to make some promises to you.

I promise I will continue to stand by you through all of our challenges, no matter how big or small.

I promise to listen to you when you are communicating what you need and learn how I can help you best.

I promise to always share my food with you.*

I promise to never allow you to go a single day without knowing how much I love you.

Of course, I know that you are going to live forever, but if this doesn't happen then I promise I will stand by you right until the very end. I will never leave you.

I hope that every human in the world gets to experience the love and friendship I have found in you, buddy. You are the silliest, clumsiest, cardboard-loving fool and I am so glad we get to share this life together. You are my world.

xxxxxxx

*conditions apply

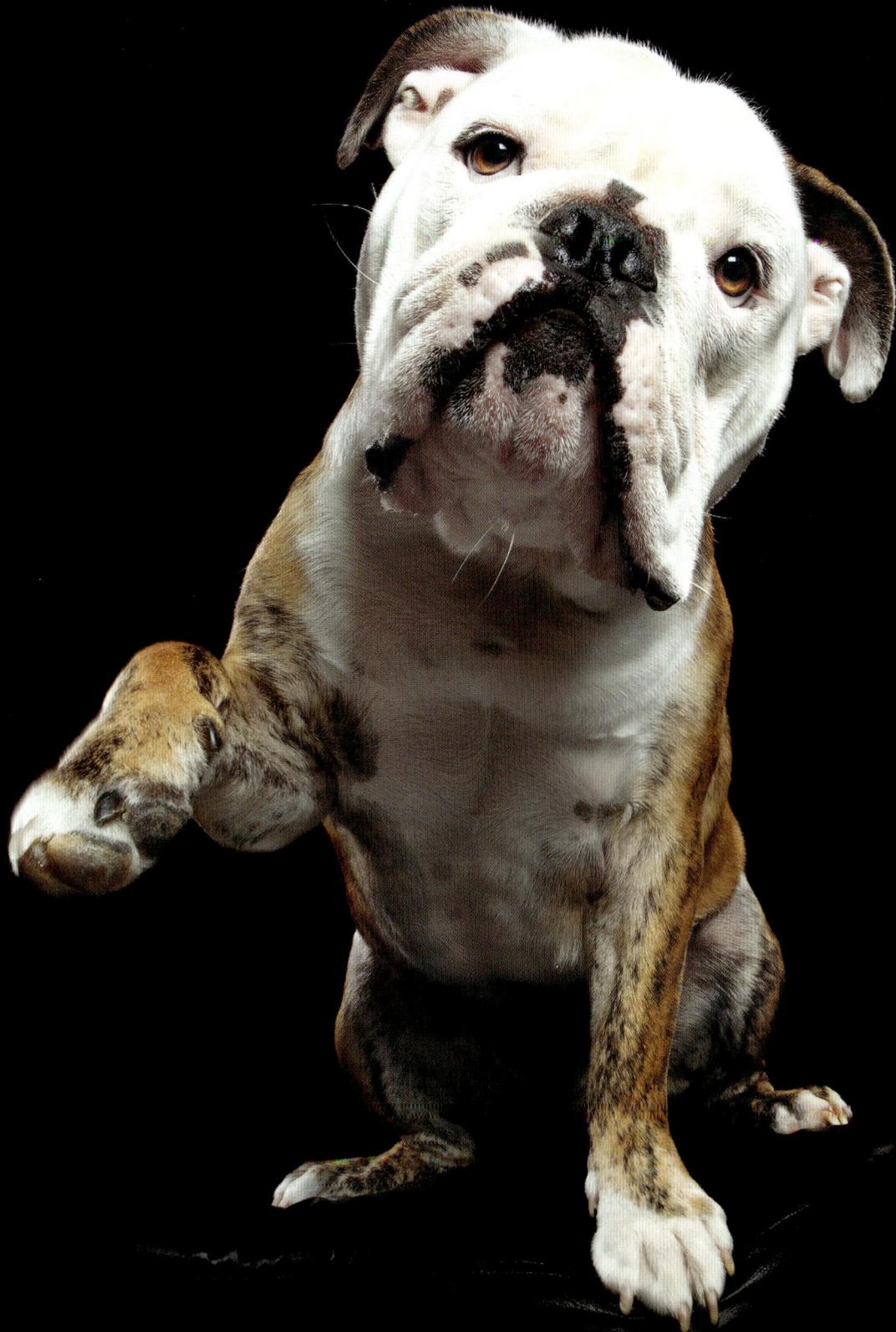

My dearest Frankie,

I will never forget the day you came into my life; so little, so handsome and so perfect. You were a moment of spontaneity that will bring me a lifetime of love. I struggle to find the words to say how much I love you.

Every day you make me feel foolish for never having had a pet. However, it only takes a second to realise that I was waiting my whole life for you. In our fast-paced world of technology and mayhem, you slow the clock down and allow me to appreciate the simple things, the important things like my little family. Above all else, I'm most grateful for your gift of pure and unconditional love.

I cherish the hours you spent curled up with my pregnant belly. You knew your sister was in there and you've been inseparable ever since. Thank you for caring for our baby, for sleeping by her cot, for making her laugh and for protecting her. She wakes up looking for you, she smiles when she sees you, she laughs when you play and I am filled with pride knowing she will grow up with you.

Frankie, every day with you is an adventure – you live for every minute. You're loud, you chew things you shouldn't and you're crazy, but you're mine and I wouldn't change a thing about you. I could not ask for a better dog.

Sometimes I tear up when I think of you. My one wish is that you could live forever, to be my boy forever and to protect your sister forever. I want to say thank you Frankie, thank you for choosing me to be your mum. Thank you for loving me.

Love Mum

Dear Charge,

My Boy, My Big Dog, My Best Friend. Little did I know the day I brought you home that you would change my life for the better. I have made some wonderful dog loving friends that without you I would never have had the chance to cross paths with. But most of all you have been my rock. The one who is always there for me and the one who sticks by my side in the good times and the bad (even when I get grumpy at you). The one who puts a smile on my face when I'm sad. The only one who can make me laugh even when I'm having a bad day.

I wake up each morning and realise how lucky I am to have the best dog in the world. They say a dog blesses you with the happiest days of your life and one of the worst days and they aren't wrong. It breaks my heart to even think that one day I will wake up and your big goofy brown eyes won't be there looking back at me. Each day you get a little bit greyer and I know the time we have left together gets a little bit less but until that day arrives I promise to be the best mum a dog could ever have.

You are my soul dog and no other dog will ever come close to being as special to me as you are. I love you more then you will ever know. You have a place in my heart that no one will ever replace. Thank you for being the best dog in the world. I LOVE YOU CHARGE!!

Together Forever xx

My beautiful Bailey. Just look at your face. You deserve so much; the best tribute ever,

I feel as though my words on a page can never do you justice. Your magnificent face and beautiful, kind eyes frozen in time and captured for the world to see, speak volumes. Your eyes say more about you than I ever could.

For your entire life you were a gift and in your own inimitable way you continually gave to us. Your love and devotion was truly one of a kind and you were always remarkable to so many who loved you.

I have missed you for eighteen months now and my tears still flow as freely as though it were yesterday when we said good-bye. I adored you with all my heart and from the moment I first held your tiny bear like body at six weeks old I knew you were so very special.

As you grew older the thought of being without you was unbearable. Me, without you, was incomprehensible and I just wanted "us" forever.

In your selfless way you stayed with me for nearly fifteen years until you were sure I was ready to let you go. Even our beautiful pussycat couldn't cope with life without you and we lost him with you just six short weeks later.

I am sure you knew how much I loved you. I am sure you knew how devastated I'd be to not have you around me anymore. Somehow, even after you'd gone, you knew what we needed and chose a special little soul to help fill that void. You knew she needed us too and would help your brother, Harlo.

You are strong in my heart and I have your beloved face around me, thanks to your Uncle Ken. At times it makes me cry, though mostly it is a comfort. I don't ever want to not see you. You were one in a million. My soul dog. My love. I was so truly blessed to call you mine.

I am so grateful to be able to share my love for you with everyone, forever.

My Bailey. My beautiful boy.

XXXX

To my Baxter and Rosie,

I have had many great teachers in my life. Some were inspiring and encouraging, some inspirational and motivating, but there are no greater teachers than you both. You teach us of trust, kindness, stillness, silliness and love.

Thank you for slowing me down, and for making time speed by. For bringing me back down to the ground, and for raising me up into the clouds. Thank you for waiting at the door for me every afternoon, for looking into my eyes and listening to my day with a toothless grin and a tail wag.

Thank you for not letting me forget to feed you one minute past dinnertime, or getting up one minute after the alarm goes off. Thank you for convincing me to let you on the bed, heads on the pillow, fur in my face with your paw pushed hard into my back.

Thank you for the laughter. For running around crazy after you've had a bath, for the butt wiggles and the ballerina pirouettes when you see your leads. Thank you for sharing your life, and for making my life. For living in my world and dragging me into your world.

During any day, good or bad, you are there. You are a constant reminder to me about what is important. A reminder to live in the moment, to try to laugh when you poop in the garage, and just to smile while cleaning up the mess you made when you knocked over the bin looking for scraps.

We don't know your beginnings, but you are safe with us now. Thank you for not letting your past hold you back for one instant. Thank you for bringing joy to our life, and for making us treasure every moment with you both. Thank you for being our dogs, our teachers, and our best friends.

Love, your Mama and Dadda

Lauren and Jerry

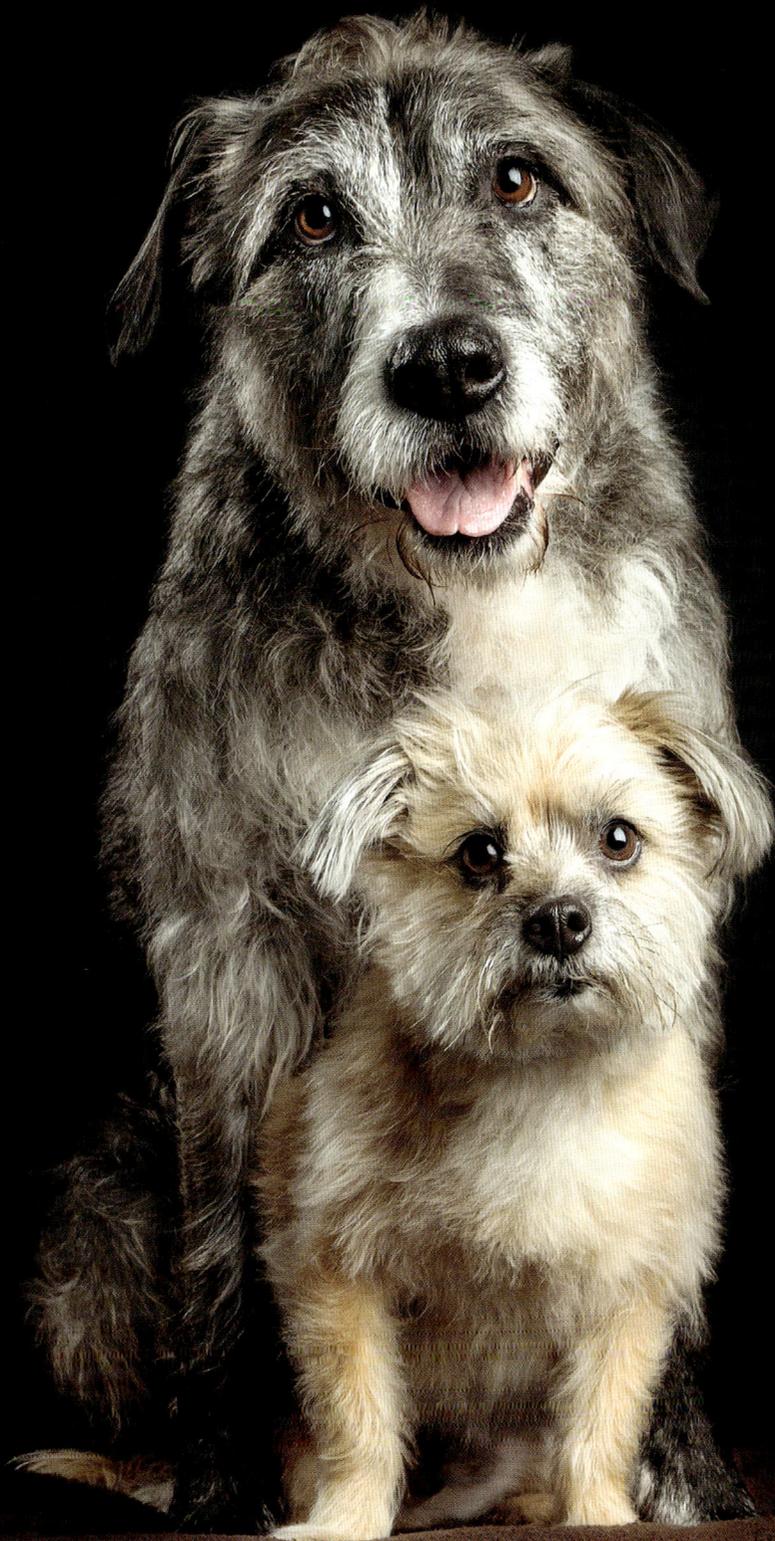

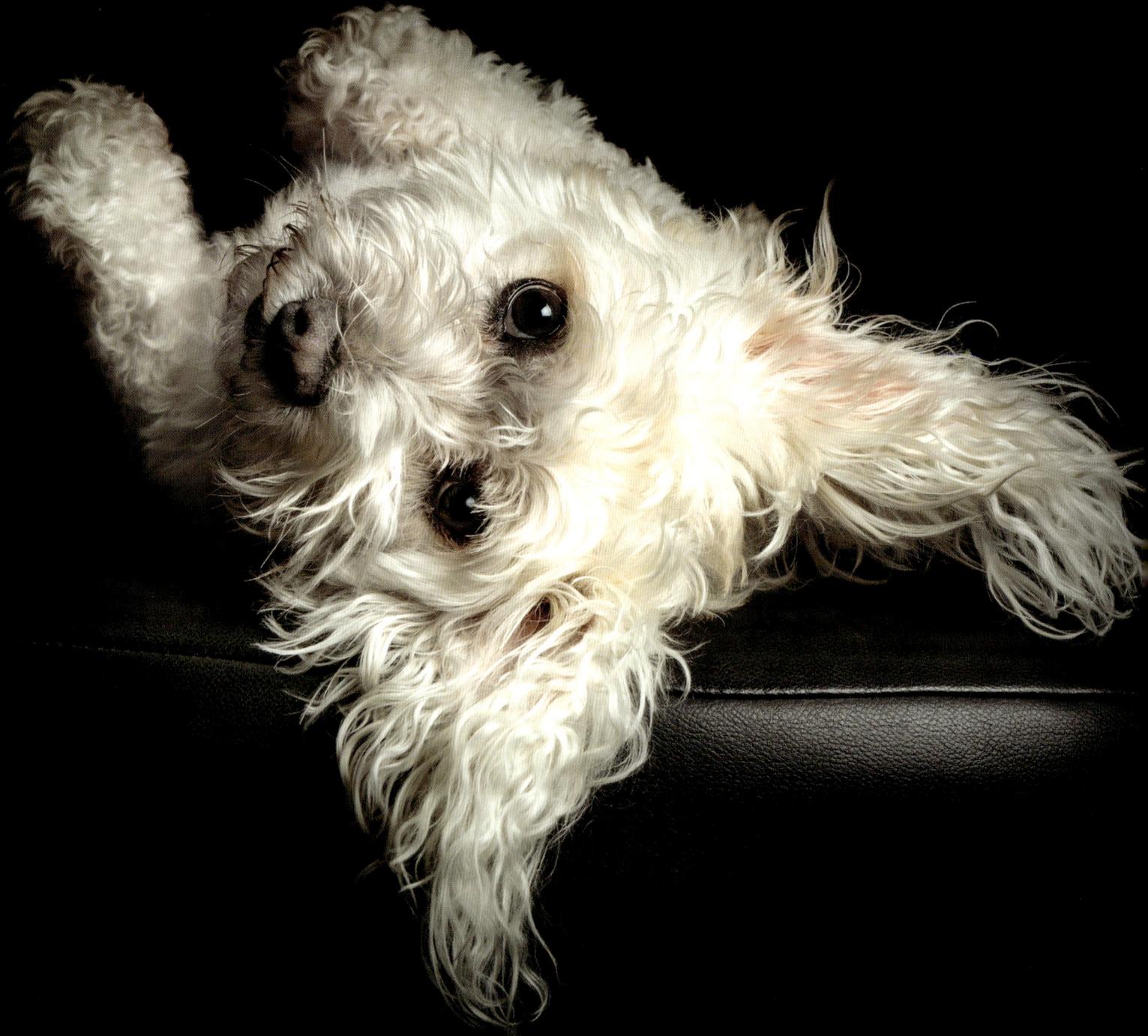

Dear Chloe,

You came into our lives in July 2003, a white ball of fluff, with splashes of apricot colour if we looked closely and full of love and energy. Born in Armidale, a maltese cross, your playful nature of all things crazy, made you a perfect fit for our family. I remember you running head first under the fishtank stand so many times, hitting your head on the way in — but always coming back out for more fun.

One storm-filled day, lightening struck a tree on our property and caught fire. You were sitting on my lap at the time and we all jumped and screamed a little. From that day on, you were scared of storms, but you could also tell us when they were on their way! You saved us numerous times from snakes with that familiar deep growl — we owe you our lives.

It didn't take long for you to show us your trade mark — your very large white ears; so large in fact that the vet called you the rare white eared bat!!! We didn't care, we just loved you every minute of the day.

You helped us through some very tough times, and your unconditional love for us will always stay deep in our hearts. You let me know when it was time to let you go. I was blessed with two children who gave me the chance to get professional photos of you two days before I held you as you left this earth peacefully and crossed the rainbow bridge, April 2016. I know you are now free of pain, but the pain in our hearts remains.

Thank you Chloe. Run free and be happy.

xoxo

Acknowledgements

This book would never have happened without my beloved wife, Beck, and not just because this book was her idea. She personally invited all the doggy mums and dads to contribute, and has really driven this project from beginning to end. She has been beside me, and often in front of me, for every step of my own animal photography journey and I wouldn't have reached this point without her. Thank you, my darling.

I would also like to thank Johnny and Alison at Zoo Studio for all their hard work and dedication helping to make this book a reality.

I would also like to thank all the staff at New Holland Publishers for their work, exemplary professionalism and for their continued faith in us.

Lastly but very much not leastly, I would like to thank all of our wonderful friends and clients (human and doggy) for writing these heart felt letters. It is their contribution and their moving tribute to the human/dog bond that has helped create this book.

My wife, Beck, would like to thank her mum and dad, Joyce and Dennis, not only for their support, but for fostering in her the love of animals with the menagerie she grew up with.

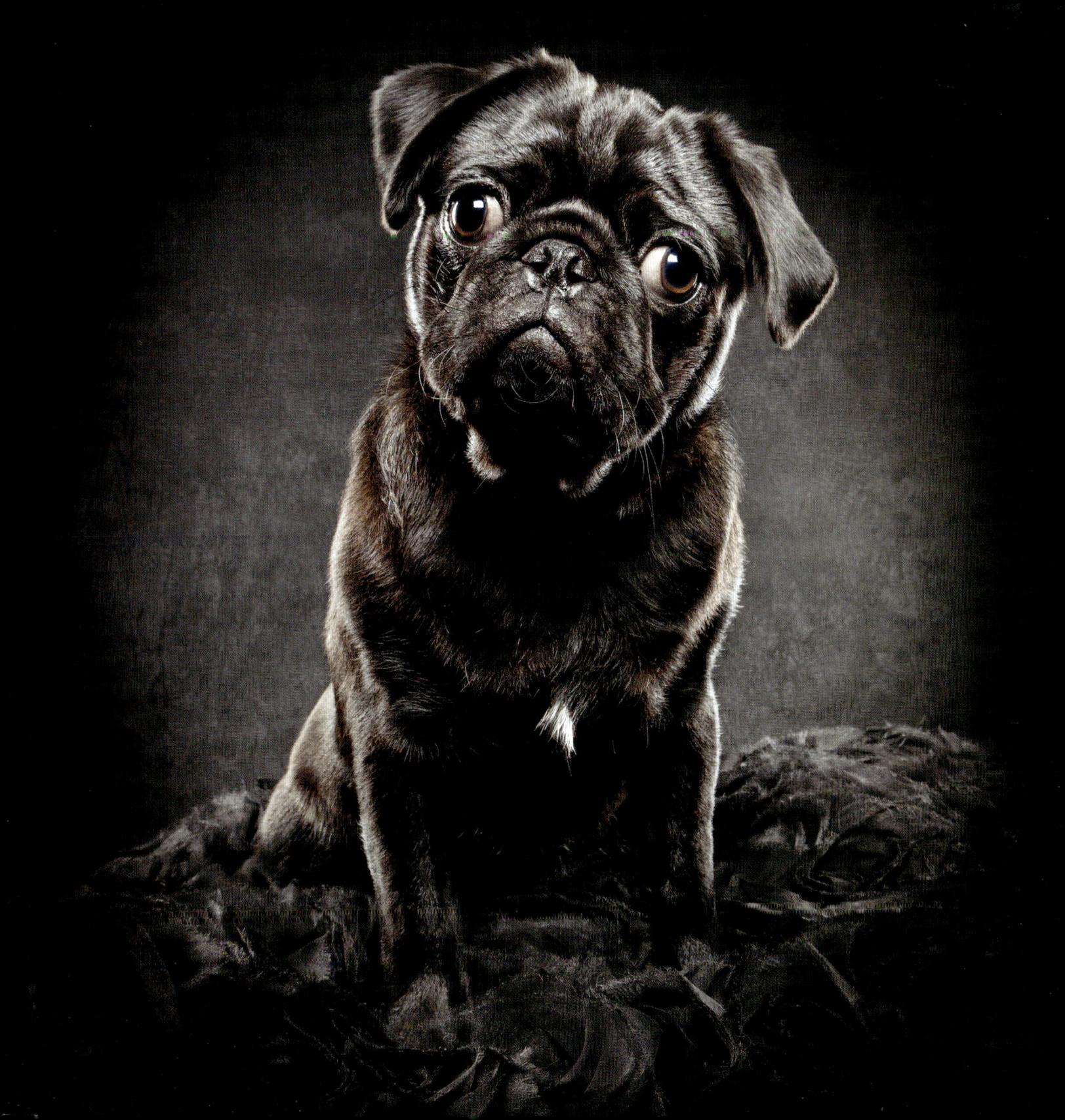

First published in 2017 by New Holland Publishers
London • Sydney • Auckland

The Chandlery Unit 50 Westminster Bridge Road London SE1 7QY United Kingdom
1/66 Gibbes Street Chatswood NSW 2067 Australia
5/39 Woodside Ave Northcote, Auckland 0627 New Zealand

www.newhollandpublishers.com

ISBN: 9781742579283

Group Managing Director: Fiona Schultz
Publisher: Monique Butterworth
Project Editor: Susie Stevens
Designer: Andrew Quinlan
Production Director: James Mills-Hicks
Printer: Toppan Leefung Printing Limited
10 9 8 7 6 5 4 3 2 1

Keep up with New Holland Publishers on Facebook
www.facebook.com/NewHollandPublishers

ZOO STUDIO

Note: Dog agility (p130) is a competition sport that involves a dog running a timed course of obstacles consisting of various jumps, ramps and tunnels (usually in numbered order) quickly but accurately. The handler directs the dog with voice, arm and body movements all involving close and/ or distance work. The handler is not allowed to touch the dog or obstacles nor use food/toys as incentives (these, however, can be used as training tools). Trials (competitions) are usually held over one day with Agility events (contacts, tunnels and jumps) and jumping events (tunnels and jumps). Games rings may be held as well. Novice, Excellent, Masters levels are based on the dog's abilities not the handler's. There are also Open events. This information is from the Agility Dog Club of Victoria website: adcv.com.au. The Agility Dog Club is open to all dogs and their handlers all over Australia; Queensland website www.dogqueensland.org.au

Note: Delta Therapy Dogs (p110) is a program that has dogs going into hospitals and other health care facilities to bring companionship to those who need it. Delta dogs (that need to have a good temperament) visit an estimated 20,000 Australians every week. Interested? Telephone: (02) 9797 7922 or email: info@deltasociety.com.au